Praise for the Myst
Lora Robert[

"The Liz Sullivan mystery series is American cozy
at its best, but it is even more than that."

—*BookBrowser.com*

"A refreshing and offbeat take on the female detective."

—*San Francisco Chronicle*

"Roberts knows the game and plays it well in this pleasing,
rewarding American cozy [*Another Fine Mess*]."

—*Drood Review*

"Roberts, who also pens the Liz Sullivan series, handles the
classic murder-in-a-microcosm with panache... Recommended."

—*Library Journal*

"There is some wicked fun in the depiction of the writers and
their interactions, and lovely descriptions of the California
seacoast. All in all, this is a diverting story in a
popular and beloved tradition."

—*Cozies, Capers & Crimes*

"Agatha Christie meets California writers' retreat in
Lora Roberts's satirical take on the publishing world..."

—*Publishers Weekly*

The Affair of the Incognito Tenant

MYSTERY FICTION BY LORA ROBERTS

The Liz Sullivan Series
 Murder in a Nice Neighborhood
 Murder in the Marketplace
 Murder Mile High
 Murder Bone by Bone
 Murder Crops Up
 Murder Follows Money

The Bridget Montrose Series
 Revolting Development (as Lora Roberts Smith)
 Another Fine Mess

The Affair of the
Incognito Tenant

A MYSTERY WITH
SHERLOCK HOLMES

Lora Roberts
Lora Roberts

For Joan — you're not incognito to me!

2004 · Palo Alto / McKinleyville, California
Perseverance Press / John Daniel & Company

A PERSEVERANCE PRESS BOOK
Published by John Daniel & Company
A division of Daniel & Daniel, Publishers, Inc.
Post Office Box 2790
McKinleyville, California 95519
www.danielpublishing.com/perseverance

Book design by Eric Larson, Studio E Books, Santa Barbara
www.studio-e-books.com

Cover illustration: Pati Sullivan

10 9 8 7 6 5 4 3 2 1

LIBRARY OF CONGRESS CATALOGING-IN-PUBLICATION DATA
Roberts, Lora.
 The affair of the incognito tenant : a mystery with Sherlock Holmes / by Lora Roberts.
 p. cm.
 ISBN 1-880284-67-7 (pbk. : alk. paper)
 1. Holmes, Sherlock (Fictitious character)—Fiction. 2. Private investigators—England—Fiction. 3. Sussex (England)—Fiction. 4. Conspiracies—Fiction. 5. Housekeepers—Fiction. 6. Villages—Fiction. I. Title.

PS3569.M537635A63 2004
813'.54—dc21
 2003010113

ACKNOWLEDGMENTS

Epigraphs for each chapter were taken from a facsimile of the 1898 edition of Mrs. *Beeton's Book of Household Management*. Many thanks to Valerie Wolzien for lending it.

One or two of the characters may seem familiar to those who have read Sir Arthur Conan Doyle's work. Many thanks to him for inventing such fascinating characters, who have taken on lives of their own. As the world of Sherlock Holmes is a fictional one, I have felt free to make up a whole village and its inhabitants, their homes and occupations, and the weather and scenery in which they live. No constraints of what actually happened in that spring of 1903 have impeded me in any way. All the elements of my book, including the Orb of Kezir, are likewise fictional. It doesn't exist, so don't bother looking everywhere for it. And if you do find it, remember, it's supposed to be mine.

Thanks to Rhys Bowen for her discerning British eye. Even further thanks are due my writers' group (Shirley Climo, Marie Faust Evitt, Trisha Hart, Karen Jessen, Alison Kibbrick, Hazel Lane, Diana Reynolds Roome, and Robin Worthington) for paying such close attention despite the many permutations of this novel they had to listen to over the past fifteen years.

Cast of Characters

Mrs. Charlotte Dodson, widowed housekeeper and mother of

Maxwell Sturges Dodson, AKA Stubby, eleven years old

Major Sir Arthur Fallowes, deceased owner of Larchbanks

Mr. William Bagshaw, his solicitor

Mr. Harold Bagshaw, nephew to Mr. Bagshaw

Mr. Sigerson, an incognito tenant

Mrs. Clithoe, cook

Thurlow, her father and retired gardener

Violet Wilkins, downstairs maid

Rose Wilkins, upstairs maid

Tim White, dogsbody

Reverend Hanover, the vicar

Miss Evaline Hanover, his sister

Mrs. Eurydice Hodges, village schoolmistress

Squire Rutledge, landowner and Justice of the Peace

Mr. Peregrine Simms, a dubious curate

Dr. Richard Mason, general practitioner

Dr. John Watson, chronicler of Sherlock Holmes

Constable Ritter, village policeman

Colonel Sebastian Moran, the second most dangerous
man in London

The Affair of the Incognito Tenant

The housekeeper must bring,
to the management of the
household, all those qualities of
honesty, industry and vigilance.

Chapter One

I STOOD AT THE DOOR of Larchbanks on a fresh May morning in 1903, breathing in the soft wind that carried the fragrance of new grass from the Sussex Downs. The sound of a carriage turning in at the gate had drawn me from my work in the library. The village hackney from the train station drew up and stopped in front of me; Mr. William Bagshaw, my late employer's solicitor, emerged from it. He took a moment to adjust his immaculate pin-striped morning coat and set his bowler hat more firmly on the pink scalp that showed beneath his thinning hair before turning to assist another man from the carriage.

His companion, however, needed no assistance. Though muffled in a scarf as if an invalid, he sprang nimbly from the carriage. His tall, well-knit figure was dressed conservatively in country tweeds; a peaked wool cap was pulled down to shade his eyes. The scarf hid all his features except for a high-bridged, hawklike nose.

Mr. Bagshaw had wired that morning to say he would bring a prospective tenant to view the house, and to name the train on which they would arrive. This was not the first tenant he'd found since Major Sir Arthur Fallowes's death two months previously. But none of the others had come up to scratch.

What was left of the staff, consisting of myself, maids Violet and Rose Wilkins and Mrs. Clithoe, the cook, had been on board wages since the major's death, until a suitable tenant could be found. By the terms of the major's rather peculiar will, I was guaranteed employment for at least six months, and I had made it clear that my staff were also to be allowed that grace time. It was a comfort to feel there was no need to hurry in seeking another position; and if the price of that comfort was to put up with tenants while Mr. Bagshaw located the major's niece, who would ultimately inherit Larchbanks, the price did not seem too high to pay.

Visits from prospective tenants had thus far been unproductive. We were, therefore, very interested in Mr. Bagshaw's present companion, and joined in hoping that he was a single, elderly gentleman of placid habit who would want little looking-after.

"My dear Mrs. Dodson." Mr. Bagshaw greeted me, beaming, and pumped my hand warmly. "I trust I see you in good health."

I was relieved that he had not brought Harold, his nephew and clerk. Though flattered by the deluge of badly written sonnets I had received over the course of the past few months since Harold had joined his uncle's office in Littlehampton, I found it embarrassing to encounter the postmistress's knowing expression at their frequent arrival. I was seized with the desire to rap Harold's knuckles sharply and order him to write a paper on Aristotle's *Poetics*.

"Certainly. I never ail." I freed my hand as soon as possible, drying it discreetly on the folds of my black stuff gown. Violet and Rose had but two days earlier offered to ask their mother to create something more modish and becoming, "because you look like a crow in that black, Mrs. D, truly you do." Touched by their offer, I had still refused. One of the prospective tenants, Mrs. Rutherford,

had certainly not thought my gown too dowdy; I had heard her mutter, "Flighty thing!" when she turned away after questioning the arrangement of my plaits. In this new century, it begins to be outmoded to speak of one's place in the world, but I had discovered that a lady in reduced circumstances who takes up a post as housekeeper becomes somewhat less than a lady in the eyes of others, and I will not claim a status in life that is no longer my own.

"This is Mr. Sigerson," Mr. Bagshaw said, introducing his companion. "Mrs. Charlotte Dodson, the late major's housekeeper. Shall we go in?"

In the hall, I relieved the gentlemen of their hats and gloves, and that engulfing scarf. Far from being elderly, Mr. Sigerson looked no more than five-and-forty. His black hair showed little grey, brushed straight back from a broad forehead. The short beard he wore rather marred, in my opinion, a face that could otherwise have been called handsome, though a physiognomist might have read arrogance and coldness in the high arch of the eyebrows and the set of the thin lips.

"Would you care for some refreshment after your journey?" I indicated the dining room, where decanters were set out on the sideboard.

"No, no," Mr. Bagshaw said. "The journey from Littlehampton is not onerous. I believe Mr. Sigerson would prefer to see over the house, and as you are the fittest to show it, Mrs. Dodson, would you lead the way?"

I ushered the two men into the drawing room. It was more of a parlour in size, with a beamed ceiling and diamond-paned casements that shone from Violet's vigorous application of vinegar-and-water. Although the furniture was not new, it was comfortable and well polished. I had filled a stone jar with larkspur and placed it on the window seat; the effect of morning sunshine on the petals was very pleasant.

Mr. Sigerson appeared bored. After a cursory glance around the room, he sniffed, "Charming," and turned on his heel.

Mr. Bagshaw bustled after him. Though he gave lip-service to

my knowledge of Larchbanks, Mr. Bagshaw had no intention of actually allowing me to do the honours. He was fond of the house himself, and dogged Mr. Sigerson's heels up the staircase. He burst into speech before we had arrived at the first floor.

"Observe the original oak wainscoting," he pointed out to Mr. Sigerson. "The house dates from the Queen Anne period, of course."

"Does it?" Mr. Sigerson's voice was languid, and I wondered if the scarf had indicated convalescence from some illness.

"Rumour has it," Mr. Bagshaw continued, with rather less enthusiasm in the face of such indifference, "that there are hidden compartments about Larchbanks—priests' holes and all that."

"Indeed?" Mr. Sigerson's languor vanished. He raised his head, his hooded eyes sharpening as he glanced up and down the corridor in which we stood, a panelled space running the length of the upstairs. "Let us see the bedrooms."

In rapid order he was through the bedchambers, paying little attention to the furnishings, though he gave a grunt of approval when Mr. Bagshaw pointed out the modern convenience Major Fallowes had been at such pains to install.

Back in the corridor, Mr. Sigerson sunk his head on his breast, paced quickly between two of the bedchamber doors, scrutinised the carved rosettes that surmounted the wainscoting, and walked away, giving as he went a seemingly negligent twist to one rosette.

A length of the wainscoting flapped open like an emaciated door.

Mr. Bagshaw gasped. "Why, I never knew that was there. Did you, Mrs. Dodson?"

I looked thoughtfully at Mr. Sigerson. "Yes, Mr. Bagshaw," I murmured. "My son discovered it on his last holiday."

"A child lives in the house?" Mr. Sigerson whipped around, his expression one of distinct foreboding that seemed out of proportion to the notion of being subjected to a child. His was an attitude that bespoke little experience with those of tender years—or perhaps, experience of a particularly horrid kind.

"My son is away at school most of the year," I said. "He spends little time here."

Mr. Sigerson turned to Mr. Bagshaw. "This will not do," he said sternly. "I specified the minimum of staff and no children. When will the lad next take up residence?" The last was to me, accompanied by a piercing stare.

"Not until August." My gaze sought Mr. Bagshaw's, puzzled as to this stipulation. It is true that Stubby—or Maxwell Sturges Dodson—was, at eleven, rather loud and awkward. But Larchbanks, placed in its own grounds, had abundance of occupation for an active lad, and young Max had never seemed to bother dear old Major Fallowes.

Mr. Sigerson's face relaxed somewhat. "Is this the only priest's hole?"

His conversation jumped, as Mrs. Clithoe would say, like a drop of water on a hot griddle. "There is another, smaller one downstairs, more like a kitchen cupboard," I answered, my outward demeanor not, I hoped, indicative of my inner thoughts. "Those are all Stubby—Max—could find."

"No way in from outside?"

"None that I know of."

He turned away. "Very well. Is there more to see up here?"

"I suppose not." Mr. Bagshaw sounded a bit crestfallen. I led the way down the stairs.

"The house is available on a six-month lease?" Mr. Sigerson put the question to Mr. Bagshaw as we entered the library.

"And very fortunate for you, Mr. Sigerson, since you do not require a permanent residence." Mr. Bagshaw clapped his captive on the back, a familiarity Mr. Sigerson endured without comment. "Yes, my late client's niece will inherit, and while we attempt to locate her in the mission field, the house is to be let, furnished, for the six-month term." He pulled a long face. "I advised Major Fallowes to simply sell up and present Mrs. Staines, when located, with the money, but he thought she'd prefer to make that decision herself."

"And have you found any signs of her?" Mr. Sigerson wandered into the room, browsing along one wall of books. He stopped in front of the carved oak Bible stand, fingering its extravagant design.

I stood in the doorway, subduing my emotions. Unlike the odious Mrs. Rutherford, Mr. Sigerson did not give the library a cursory glance and walk away. He went behind the desk to try out the major's chair. It was plain that he fancied the library as his future workroom.

I found I did not like to see a stranger pacing through the room, weighing it for possible occupation. I had spent so many hours there, working with the major on his memoirs. It was for that reason that he had left me the contents of the library in his will, to be disbursed within six months, or after his niece was found, whichever occurred first.

"I fear not." Mr. Bagshaw pursed his lips over the fate of Patience Staines, the major's niece. "She was in China just prior to the Boxer Rebellion. I am much afraid..." He paused delicately.

I gazed at the desk and the Bible stand Mr. Sigerson flicked carelessly with one long finger, at all the woodwork, and made a mental note. Although I knew Violet had dutifully cleaned everything, the wood did not glow with its usual soft patina. I would have to speak to her about it.

"Exactly." Mr. Sigerson swung around. "This room, I suppose, is adequate."

I had difficulty schooling my expression into the proper impassivity on hearing this slighting remark. Even Mr. Bagshaw's beaming smile faltered.

"It is small, to be sure," he said doubtfully. "The house itself is not particularly large, but as you are a single gentleman..."

Mr. Sigerson paid no attention to this implied question, but I answered it to myself. Such a man would not be married; his aloofness was all but palpable.

"I am more interested in the grounds at this moment," he announced. "How extensive is the orchard? Are the fences and walls in good repair?"

"We shall take a look," Mr. Bagshaw said, restored by this evidence that his potential tenant had not totally given up the notion of leasing Larchbanks. "Allow me to escort you." He led Mr. Sigerson into the hall, and out the front door. I watched them take the gravel path that led around the house. The grounds had been let go, but there was still a pleasant walk beneath the wistaria arbour and through the kitchen garden.

For a few moments I lingered at the door, enjoying the freshness of the spring morning, the new green of the trees that edged the lawn and screened the lane from sight. A gap at the foot of the lawn allowed a distant view of the soft green downs. The air was so clear, I fancied I caught a glint from the sea, and certainly its tang was detectable in the breeze that blew against my face.

I could not stop long, however. We had been up before the dawn to prepare for Mr. Bagshaw's visit. All the holland covers had been taken off the furniture in drawing room and library, the carpets swept with tea leaves, and the rooms thoroughly aired before his arrival. Even so, while showing Mr. Sigerson the house, I had noticed things that needed attention—an overlooked cobweb in the corridor, an undusted table in one of the bedchambers, a smell of damp in the bath-room. Board wages or no, my responsibility was to see that Larchbanks was maintained suitably.

I shut the front door and returned to my tasks.

*All these employments [of the
housekeeper] call for no
ordinary degree of care,
taste, and attention.*

Chapter Two

IN THE KITCHEN, the maids sat at the scrubbed deal table near
the range. Violet read the newspaper to her sister, Rose, who
polished the teapot industriously. Mrs. Clithoe could be heard
rooting around in the larder, her muffled grunts interspersed with
rustling noises.

"It will never do, Violet."

Violet looked up at me from her newspaper, startled and de-
fensive. "What do you mean, Mrs. Dodson?"

"I mean that you must stop seeing that young fellow who trav-
els in household goods. Or, if you must see him, please do not al-
low him to press his inferior products on you. The woodwork in
the library looks positively dull."

Violet had the grace to blush. "I never thought you'd notice,"
she said, tossing her head. "And he did say it would make the
grain of the wood come up beautiful."

"He was wrong."

Mrs. Clithoe came into the kitchen, hardly bowed at all by the fifty-pound bag of flour she carried on her shoulder. "Mouse droppings," she said darkly.

"Oh, dear. Where?"

"On the larder floor, bold as brass." Still balancing the flour, Mrs. Clithoe opened the bin beneath the pastry table and poured flour into it. The long ribbons on her cap waggled like agitated fingers, but Mrs. Clithoe was not even breathing hard; her massive frame was capable of greater exertion than hefting a mere fifty pounds. A vapourous white cloud rose around her, sending the maids to coughing. "Didn't get into the bread crock, but not for want of trying. Violet, do you go fetch the rat poison from the garden shed."

"Fair gives me the creeps, it does," Violet muttered, but she ran out the back door.

Mrs. Clithoe shut the bin and used a handkerchief to dust her floury face. "What sort of gentleman did that Mr. Bagshaw bring, then?" She turned to the range, giving a stir to a pot that sent out savoury aromas. "Someone with a stomach to him, I hope. That Mr. Bagshaw is no better than a heathen, with his nasty weak digestion."

"He cannot help being subject to dyspepsia," I said, trying to avoid a wrangle on this subject. "Rose, the teapot looks beautiful."

Rose smiled with pleasure. The Wilkins girls were very good workers in their way, but prone to distraction. Rose, for instance, read signs and portents in everything. Violet had a taste for masculine admiration.

"A weak stomach is the sign of the Evil One." Mrs. Clithoe's implacable tone left no room for argument. Rose and I exchanged glances, and she rushed into speech.

"Is he a married man? The new tenant?"

"He appears to be single." I had seen no ring on his finger, though not all married men wore them. "And it is by no means certain that he will take the house."

Violet came back in, carrying the tin of arsenic between

thumb and forefinger, her face screwed into an expression of distaste. "Nasty," she said, handing the tin to Mrs. Clithoe and making a production of wiping her fingers with her handkerchief.
"Mind you don't go putting that in the sugar bowl." She and Rose
dissolved into laughter.

"I'm not likely to make such a mistake," Mrs. Clithoe said,
withering them with a glance. "It's only the dratted vermin will be
eating this." She vanished into the larder again. I moved to the
door, watching as she filled the little china dish she kept for the
purpose and set it on the stone floor near the bread crock.
"They'll be in the pickle barrel next," she muttered, "and then I'd
have to throw out all my pickles, and that would go hard with
me."

"I saw Mr. Bagshaw in the orchard with another gentleman,"
Violet announced behind me. "He was very tall. The other gentleman, I mean. Mr. Bagshaw isn't so much of a muchness." She and
Rose laughed again.

"Girls, it is not seemly of you to make such remarks about Mr.
Bagshaw. He is in the place of master here, and should be respected accordingly."

"Yes, Mrs. Dodson," they chorused, grinning at each other.

Mrs. Clithoe came out of the larder and drew some water
from the stove's reservoir into one of the stoneware jugs. She filled
the washbasin on the stand beside the kitchen door, dug into the
crock of soft-soap, and worked up a lather, rinsing her hands and
throwing the contents of the basin out the back door. "Violet,
come wash your hands," she commanded. "We're perticular about
that at Larchbanks."

"Yes, indeed." I knew the Wilkins girls thought that both Mrs.
Clithoe and I were a bit too rigid in the matter of hand washing,
but Mrs. Clithoe had a good cook's aversion to dirt, and I had read
Lister's work on germs.

"Well," Violet said, flouncing up from the table, "I hope the
gentleman does take the house. At least we'll be shut of board
wages." She washed her hands and examined her pretty face

minutely in the small looking glass that hung above the wash-stand. "I should have gone to London when I wanted to, after the major left me my legacy."

"Mum did right by your money and mine," Rose said earnestly. "A girl never knows when she might need a nest egg."

It was Violet's artless desire to become a music hall star, using the small legacy left to her by Major Fallowes as capital. She had tried to persuade Rose to accompany her, but Rose, though younger, was far stodgier than her flighty sister.

"I'm glad we didn't go," she averred now. "Vicar says London's a kennel of iniquity. Do you bide here, Violet, and say your cate-chism like a good girl."

Mrs. Clithoe nodded approbation. "Save your money for your old age, dearie, same as I've been doing. You never know when you'll need it. There's my old dad, now, snug as can be in his little cottage—"

"If the major hadn't given it to him, he wouldn't have it, would he?" Violet demanded.

Mrs. Clithoe paid no heed. "Wants for nothing, does my old dad. What I say is, that's as much as a body can expect in this world."

Violet sniffed at such mild views. "It's like being buried alive, living in this place all your life." She picked up the newspaper again. "Things is happening in London," she said wistfully. "See here? 'Wild Beast Eludes Capture, Mauls Three!' 'Prominent MP Admits to Opium Habit!' 'Famous Sleuth Threatened by Escaped Arch-Criminal!' Think of that! Just outside your window, in London." She let the newspaper drop.

"It don't bear thinking on," Mrs. Clithoe protested. "Don't be daft, girl. Suppose that there Arch-Criminal was outside your window. You'd be wishing you were back here safe and sound, you would!"

Rose spelled out the words in the paper slowly. She had made less progress in her reading lessons than Violet. Mrs. Hodges, the schoolmistress, did not worry overmuch about instilling learning

in her scholars' heads, though she was quick enough at picking up nuggets of gossip herself. The Wilkins girls had been barely literate when I began keeping house at Larchbanks three years previously. I felt a definite sense of satisfaction as Rose read from the paper.

"'Colonel Sebastian Moran, missing since Friday last from the high-security prison at Dartmoor, has sent a comm-u-neek'—is that right, Mrs. Dodson?"

I moved to stand behind her so I could read over her shoulder. "Communiqué," I said, pronouncing it correctly. "You are reading quite well these days, Rose."

She smiled with pleasure and read on. "'...to this journal, declaring that he will not rest until he has recked—'"

"Wreaked."

"'—revenge on Mr. Sherlock Holmes, late of Baker Street in this city, now retired from the London scene.'" She rustled the paper triumphantly. "See there, Violet? Even that Mr. Sherlock Holmes didn't want to stay in London no more."

I read the rest of the article to myself while Rose laboured through it.

> The famous consulting detective, who has solved many of the pre-eminent puzzles of our times, was instrumental in obtaining the arrest and conviction of Col. Moran in conjunction with the Adair case, which was chronicled by his friend and associate, Dr. John Watson, as "The Adventure of the Empty House." For the past two years Mr. Holmes has made his home in Sussex. Scotland Yard has offered protection against the threat to his life.

Violet looked sulky. "Well, he's old," she argued. "He must be forty or fifty if he's a day. London is different when you're young."

Rose had wandered on through the paper. "There's goings-on in Sussex," she declared. "Right here in the London paper they talk about it. 'Vampire Stalks Quiet Village.'" She read on and

raised saucer-like eyes to me. "That be over in Cowfold, not twenty mile from here!"

"Nonsense, Rose." I took the newspaper and put it in the kindling basket. "Vampires do not exist. The presses merely wish to sell papers to credulous readers."

Mrs. Clithoe was unmoved by anything to be found in the newspaper. "What might be the gentleman's name who's taking the house?"

"Mr. Sigerson," I said. "He may not take up the lease. He has merely expressed interest to Mr. Bagshaw."

Violet turned dreamy. "I'd like to lease a big house like this for myself," she said, staring into the fire. "And you, too, Rosie."

"Then we could have servants. Fancy!" said Rose, giggling. "That would be something like." She lifted her little finger and poured imaginary tea from the silver pot. "Another lump, Miss Hanover?"

"That's just what you'd get from her," Violet agreed.

"It is hardly fitting of you to speak so of the vicar's sister," I said, trying to bite back a smile. Miss Hanover's strong but disagreeable character was impossible to escape in the village. "Let us have more work and less gossip, girls, if you please."

"Yes, Mrs. Dodson," they chorused again, winking at each other. As soon as I left, I knew they would be casting aspersions freely on the vicar's sister and her bosom friend, Mrs. Hodges.

Mrs. Clithoe did not gossip. But she made pronouncements. "Vicar," she pronounced now, "should do something about that Squire Rutledge. Young Mary Beedle is off to Parish Hospital in Portsmouth."

The girls stared at each other, and I frowned at Mrs. Clithoe. "This subject is not proper for our girls to hear."

"Nay," Mrs. Clithoe insisted stubbornly. "They should know the wickedness of the world, and of men like Squire. Mind you never be alone with him," she admonished.

"Not likely," Violet said. She glanced at me. "We know about it already, Mrs. D," she told me kindly. "Happens sooner or later to

all Squire's housemaids. That's why Mum never let us go out to work there. Said she didn't want no grandchildren born on the wrong side of the blanket."

The girls dissolved into laughter.

"I doubt if Mary Beedle finds it amusing," I said, unlocking the silver cupboard to put away the teapot.

"I can't abide the notion of it," Mrs. Clithoe muttered, thumping a pot of potatoes onto the range as if it were the squire's head she held. "It quite brings on me Spasm to think of the wickedness of menfolk."

This was ominous. Mrs. Clithoe, widowed so long ago that the unknown Mr. Clithoe had ceased to figure in her conversation, had a somewhat strange view of the male sex. Her Spasms swept over her periodically, when something occurred to upset her—usually brought on by the perfidies of men. She had not had a Spasm for some time, so Squire Rutledge's lecherous behavior might be enough to bring one on. She often amused herself while setting the bread, for instance, by a rhythmic proclamation of hellfire for Squire Rutledge and every other libertine she had ever known or heard of, including, until just lately, His Royal Highness the Prince of Wales. Now that he was King Edward VII, she had expunged him from her list—but nothing less than coronation served that purpose.

By good fortune, the drawing room bell rang. "Mr. Bagshaw has finished his tour of the grounds," I said, smoothing my hair. "I will go find out the result."

Balked of an audience, Mrs. Clithoe subsided. Her expression was pettish, however, and I did not wish to take chances with the quality of her cooking by leaving her riled. "Why don't you do one of your wonderful raised pies for dinner, Mrs. Clithoe?" I smiled, with as ingratiating an expression as I could muster. "That will help us forget the wickedness of men."

"So I shall, Mrs. Dodson." Mrs. Clithoe brightened up. "So soon as I find those dratted specs of mine." She looked around helplessly. "Now what did I do with them? I had 'em on when I did my tatties, as I recall."

Mrs. Clithoe's spectacles were lost at least four times a day. On this occasion, they perched on top of her cap, the first place I checked whenever she missed them. Thankful to have averted a Spasm, I fled.

The men stood in the drawing room, talking. I put the decanter of sherry and biscuit jar on a tray and carried it to them. Mr. Bagshaw gave himself a liberal handful of ginger biscuits and poured a brimming glass of sherry, but Mr. Sigerson declined refreshment with an impatient shake of his head. The gesture reminded me of my father, a country vicar who, when on the track of just the right text, would refuse sustenance until he found it, whether the search took hours or, sometimes, days.

Setting down the tray, I retreated to the door and folded my hands, ready to render any assistance. After some low-voiced conversation, Mr. Bagshaw turned to me, all smiles. "Mr. Sigerson would like to have a word with you," he said. "While he is doing so, I thought perhaps I should look over your accounts, as quarter-day is approaching."

I should have foreseen that Mr. Bagshaw would want to look over the accounts. He always does, quarter-day or no. The accounts book was up to date, but I had left it in my private parlour off the kitchen. "Certainly, Mr. Bagshaw," I said. "I shall bring it to you."

"No need, no need," he said jovially. "I can track it down, Mrs. Dodson. Right now Mr. Sigerson wishes to speak to you."

I told Mr. Bagshaw where in my sitting room to find the accounts book and he departed, cramming a last ginger biscuit into his mouth.

Left alone with Mr. Sigerson, I found him using those keen grey eyes on me. I knew well enough what he would see—a woman in her mid-thirties, no longer in the first blush of youth, whose cares and responsibilities sat gravely on her brow, from whose mouse-colored hair three silver threads had been ruthlessly plucked that very morning. I am accounted by some—Squire Rutledge is the most vociferous—to be well formed and of graceful carriage, but since the passing of my dearest Maxwell, I have had no interest in the opinions of others as to my person.

So I raised my chin a trifle and added to my observations of Mr. Sigerson. His face showed the pallor of indoor confinement, unusual for the warm and relatively dry stretch of weather we'd had. His beard was short, allowing me to ascertain that it was not worn to disguise weakness of the chin, which jutted out in the most uncompromising way. A moustache somewhat obscured his thin, mobile lips. His face, like the rest of him, was lean, with aquiline nose and broad forehead the most prominent features.

"Pray be seated, Mrs. Dodson," he said at last, lounging against the mantelpiece. "I see that you are a widow of some years' standing. You have many responsibilities here in the absence of owner or tenant. You have been used to write a great deal, but not so much in the immediate past. And your boy is, I think, aged eleven or twelve?"

I chose one of the Queen Anne side chairs and sat with composure. My widowhood was proclaimed to all by the black ribbons on my cap and the wedding ring on the third finger of my right hand (where a callus on the second finger, formed by the pen over the course of the years I had worked on the major's memoirs, could still be seen); the bunch of keys hanging from my belt was larger than is usual for a housekeeper, since I had added the major's keys to grounds and wine cellar.

The age of my child was a trickier matter. But, smoothing my skirt, I noticed that protruding from one pocket was a letter from Stubby, inscribed to me in his as yet unformed hand, and grubby, as was everything which he touched.

"You are correct," I replied, when it appeared Mr. Sigerson expected a reply.

He appeared a little put out. "Don't you wonder how I knew these things?"

"No, I do not," I said. "Such signs are easy enough for the observant to read. Or you could have received your information from Mr. Bagshaw, for you have uttered no secret. I might, of course," I pointed out, "have been a child bride, with a penchant for novel-writing and a grown son afflicted with poor penmanship."

Mr. Sigerson gazed at me for a moment longer. "You have

some talent for observation yourself, it seems," he said at last with a grim smile. "Pray, what do you make of me?"

"It is not my place—"

"Never mind that," he interrupted. "I have no turn for polite twaddle, and I daresay you feel the same. I'm interested in knowing what conclusions you draw about this stranger you see before you."

I hesitated a moment, but speaking frankly is not a treat I often get, circumscribed as I am, and after all, if he refused to lease the house, perhaps the next prospective tenant would be a more conformable person.

"You are obviously a man of keen intellect," I began slowly, "since you observe, and interpret so clearly what you see." My gaze travelled over him, and I noticed that betraying callus, plus several ink-blots, on the third finger of his right hand. "You are of a scholarly turn of mind, working on an important project," I conjectured, "one which perhaps keeps you from taking your usual constitutional. You forget to eat your meals—food is not very important to you." I endowed him with traits I had observed in my father, though I would have gone bail he had none of my father's benevolence. But it is my conjecture that certain outward signs can be counted on to predict behaviour; and so that lean build, that prominent forehead, that scholarly turn of mind, bespoke a man to whom food was important only as a necessary fuel.

Then I thought of the well-made and well-tended hat and gloves I had taken from him. "Financially you are quite comfortable, and your current housekeeper is very good. Why do you need another?"

He returned no answer. Recollection of his hat and gloves suggested another clue. "Your hat showed few traces of coal dust, so your train journey to Littlehampton must have been brief. I surmise your present residence is no great distance from here. Perhaps you are having repairs done, to need so short a lease." His countenance was impassive; I did not feel I had found the right note there. "Wearing a scarf on such a warm day means you are either an invalid or anxious to conceal your identity. If you are not

an invalid—" and given the palpable air of nervous energy he pro-
jected, I could hardly believe him in danger of taking a chill "—it
must be the latter." I lifted my palms. "That is all I can deduce
about you just now, Mr. Sigerson."

"Amazing," he muttered, fixing those keen eyes on me again.
"There is a risk here I had not anticipated." Turning away from
me, he paced rapidly through the room, deep in thought, his gaze
inward. I felt quite hopeful that I had given him a disgust of
Larchbanks and my prying ways.

Halting in front of me, Mr. Sigerson made as if to stroke his
chin. When his fingers encountered the beard, he jerked his hand
away from his face. Catching my eyes, he gave me an unwilling
smile. "Too true, Mrs. Dodson," he said, throwing himself down
into the chair across from me. "My whiskers, as you no doubt ob-
served, have been only recently grown. Let me be frank with you. I
wish to live retired, in seclusion, in fact, and this estate would be
adequate to supply my requirements. However, I must have no
gossip in the village, no questions about my past, no snooping into
my actions. Do you understand?"

I drew myself up. "I understand that you fear me to be incapa-
ble of discretion, Mr. Sigerson. If that is your judgement of my
character—"

He held out an imperious hand. "I have formed no judgement
of your character. Indeed, that takes more than a few minutes,
Mrs. Dodson! I merely state my requirements. You have men-
tioned my scholarly work. I am an apiarist and have undertaken a
study of bees. You have no objection to bees, I hope?"

"It would not be my place to object."

He raised one saturnine eyebrow at this meek remark. "I fan-
cy, Mrs. Dodson, that place or no place, you order things as you
wish at Larchbanks. I, on the other hand, do not care to be both-
ered with domestic details or hypothetical air-guns or meddling
busybodies who think I have nothing better to do with my time
than haul them out of their ridiculous scrapes!" He leapt to his
feet, glaring around the room. Finding it, as usual, calm and quiet,

he passed one hand over his face. "Forgive me. I have been under a nervous strain lately."

"You are, then, an invalid?" I thought perhaps he was recovering from a nerve storm, which might explain his jittery manner.

He raised the other eyebrow. "My research," he said, "is nearly at a successful conclusion. If my bees can be persuaded to settle in to the fine orchard I noticed out there, I shall be able to complete my monograph, and well ahead of those apiarian rivals who dispute my findings. That, madam, is all it will take to restore me to my usual perfect health." He turned to the window, which looked over the extensive though somewhat neglected parklands to the swell of the downs. "It is peaceful here. That is what I require, Mrs. Dodson. Peace and quiet—"

His words were interrupted by a bloodcurdling scream. It was loud enough to begin with, but it grew even louder and more imperative as it rapidly approached the chamber in which we sat.

"Good God, what is that?" Mr. Sigerson's eyes were fixed on the drawing room door. "What horrid apparition does Larchbanks hide, Mrs. Dodson?"

With foreboding I realised that I had sent Mr. Bagshaw to the vicinity of the kitchen on a day when its primary denizen was already keyed up about the menfolk who were setting us all about our ears.

"It is no apparition, Mr. Sigerson," I said, for the first time not altogether displeased to witness what promised to be a corker of a Spasm, as Stubby would say.

The door was flung open, and Mrs. Clithoe appeared, her head wound in her apron, one hand brandishing the rolling pin, the other propelling Mr. Bagshaw in front of her. His ineffectual attempts to escape were accompanied by panic-stricken bleats.

Mr. Sigerson sprang from his chair, but made no attempt to rescue Mr. Bagshaw. "If you assure me it is no apparition," he remarked, "no ghostly cook who walks the halls of Larchbanks, bludgeoning innocent solicitors—"

"This is no time for levity," I said, managing to wrest the

rolling pin from Mrs. Clithoe. Her eyes were wide and wild, and those bloodcurdling screams rent the air with a regularity which somewhat reduced their effect. I picked up the vase of larkspur, removed the flowers, and dashed the water into her face.

She gasped, gurgled, and finally reached for her apron to wipe her face. "This Man," she proclaimed, staring hard at Mr. Bagshaw, "do be rummaging and rampaging about your rooms, Mrs. Dodson! The Iniquity of it! The ravening Beasts of the Fields await for such as he! The Eternal Hellfire—"

"It's all right, Mrs. Clithoe," I said in a firm voice. "I have made Mr. Bagshaw free of my parlour."

"Free, ha!" Mrs. Clithoe smoothed some grey locks beneath her cap, and her eyes lost their glassy stare. "Free by name and free by nature! I know what awaits for them as makes free!"

"Quite right," I said soothingly, herding her into the hall. "I can take care of it now, Mrs. Clithoe, thank you. Hadn't you better finish your preparations for luncheon?"

Mrs. Clithoe gave the gentlemen in the drawing room a scowl that expressed eternal vigilance toward evildoers, and stumped down the hall and through the green baize door.

Mr. Bagshaw passed a snowy handkerchief over his face. "Good Gad, Mrs. Dodson," he said shakily. "Why do you not turn the woman off? I had no idea she was given to fits!"

"Spasms," I corrected. "She's an excellent plain cook, and it is seldom that the wickedness of mankind sets her off."

Mr. Sigerson clasped his hands behind his back and smiled thinly. "I see that the peaceful appearance of Larchbanks is deceptive," he told Mr. Bagshaw. "All is calm on the outside, but within—" he made a sweeping gesture "—chaos!"

"That's rather strong," I protested. "I think you would find, sir, that this is a particularly well-regulated dwelling."

Mr. Bagshaw found his voice. "Is there anything further you wish to ask of Mrs. Dodson?"

Mr. Sigerson shrugged and turned away.

"That will be all," Mr. Bagshaw said to me.

I went thankfully from the room, hoping that next time Mr. Bagshaw would produce a quiet, unobservant gentleman of regular habits, or a widowed gentlewoman of comfortable means with a fondness for country pursuits, who would never give Mrs. Clithoe a moment's unease.

*We are sometimes obliged to
change our residences. The rent
of a house, it is said, should not
exceed one-eighth of the total
income of its occupier.*

Chapter Three

To my surprise, Mr. Sigerson leased Larchbanks.
And to Mr. Bagshaw's surprise. He explained in a puzzled way
that Mr. Sigerson required a place ready for immediate occupancy, and despite the drawback of a cook who was liable to indulge
in Spasms, thought the advantages of Larchbanks outweighed the
disadvantages.

Within the week, I once again opened the door to Mr. Bagshaw and the new tenant of Larchbanks. Mr. Sigerson strode into
the hall in a businesslike way, declining my assistance with his
carpet-bag and violin case, all the luggage he carried. As Mr.
Bagshaw, overflowing with an excess of welcome, followed him up
to the first floor, Violet and Rose exchanged glances. We were
lined up in the hall to greet our new master, but he'd passed us by
with little more than a jerky nod of the head.

"Not too friendly," Mrs. Clithoe sniffed. "But at least he don't
oil all over a body, like that Mr. Bagshaw."

"Not near as handsome as the new curate," Violet said with a giggle.

"He doesn't have very much with him," Rose observed. "Why is that?"

Violet threw herself into the question with enthusiasm. "He's run off from his wife," she opined. "Or she booted him out. What do you think, Mrs. D?"

"I think such speculation is totally out of place." I led my staff back to the kitchen. "His luggage is our concern only if he wishes us to unpack it for him. At present, luncheon is a much more important topic. Let us get to work."

Not an hour later, carters began to arrive with mysterious boxes and bundles, some of which were established immediately in the small orchard beyond the kitchen garden. These, I presumed, pertained to bee-keeping.

For the rest of the week, intermittent deliveries ranged from crates of bees to boxes of books to full suits of clothing. It appeared that our new tenant was starting from scratch at Larchbanks; he even purchased new spirits for the decanters, instructing that they all be emptied and washed carefully. Though it seemed a waste, I obeyed his instructions, as was my habit, without comment or question.

Maintaining my usual calm demeanour was, however, a bit of a strain. The house felt very different with a man like Mr. Sigerson in residence. The major's masculine presence had been fatherly. Mr. Sigerson, in some way that I could not define, disturbed the very air of the house. At least, he disturbed me.

Perhaps it was my imagination; certainly Violet and Rose and Mrs. Clithoe settled into the new routine with little difficulty. I felt on my mettle to manage with the most unobtrusive smoothness; the episode with Mrs. Clithoe had, I feared, put me at a disadvantage. So forcible a personality as Mr. Sigerson's could be allowed no opportunity for domination. Though I had put my neck into the yoke of servitude, I would yield up my dignity to no employer. No matter how unexpected his behaviour was.

The morning after his arrival he had been up at dawn. An early riser myself, I had just come into the kitchen when Mr. Sigerson strolled through the back door, fresh air hovering about him. "Ah, Mrs. Dodson!" His voice was genial enough, though he darted a wary glance around the kitchen. "You rise with the birds, I see!"

"You are early yourself." In my experience, gentlemen do not penetrate to the kitchen unless they are very sharp-set, but Mr. Sigerson did not have the appearance of a man in need of a meal. Indeed, he was more than a little disheveled, with a couple of box leaves caught in his hair and damp stains on his trousers.

"I have spent the last half hour crouched in the orchard, watching my bees," he explained, brushing at his hair with a vigour that belied my initial perception of him as a victim of nerves. "They must be observed very carefully after having been uprooted from their previous location and transported."

A leaf was still caught in the dark strands of his hair. An impulsive wish to free it made my fingers twitch. "You should wait until the dew is off the grass," I said. "The damp is very unhealthy."

"Nonsense," Mr. Sigerson snorted. "You do not appear to be an old enough wife to believe that tale, Mrs. Dodson. Fresh air is the very elixir of health." He threw himself down at the deal table. "You are—what? Four-and-thirty?"

"More or less." I turned my back to stoke the range. The abrupt manner in which he spoke robbed his words of any personal imputation; he might have been gathering data for a monograph on the relative ages of housekeepers in the Sussex Downs. But personal or not, I was unwilling to regale him with my life story.

Mrs. Clithoe's heavy footsteps thumped down the back stairs; she pushed open the door and stopped there, transfixed. "Lawks-a-mercy!"

Mr. Sigerson nodded. "Good morning, Mrs. Clithoe." In contrast to the abrupt and distant man of the previous day, his tone was cordial.

Mrs. Clithoe looked at me. I shrugged. "Mr. Sigerson must be

feeling quite peckish, Mrs. Clithoe, or he wouldn't have stepped into the kitchen."

Mention of food turned Mrs. Clithoe's thoughts. "I can do you a rasher or two, and new-laid eggs, and a bit of kedgeree if you should fancy it, or a kipper." She was at the range, taking down pots, as she spoke.

"Bacon and egg will do me nicely." Mr. Sigerson lounged at the table while Mrs. Clithoe fried up and I sliced the day-old bread and toasted it. When I began to lay a tray, he insisted on consuming his breakfast right there, which he did with dispatch.

"Very tasty." He tossed his napkin on the table and rose to bow over Mrs. Clithoe's hand. "Madam, I congratulate you."

He strode from the room. Mrs. Clithoe and I stood, watching as if mesmerised while the green baize door swung closed. I wondered if Mrs. Clithoe would take a disgust of Mr. Sigerson's careless manner. Perhaps she would begin to mutter his name in the evenings as she set her bread.

At last she stirred and broke the silence. "I disremember when I've fed the master of a house right in my kitchen, save for the time I worked for Mr. Denham. Him and his friends would come back to the house after a hunt, mired as they was from the horses, and crowd into me kitchen, and frighten the maids, and use manners more fitting to a hedge-tavern than a gentleman's house." She picked up Mr. Sigerson's plate from the table. "At least new master has a very gentlemanly way to him."

This was a relief. I did not wish to endure another Spasm any time soon.

After making his toilette, Mr. Sigerson vanished into the library. Some hours later, when I tapped on the library door and entered with a fresh vase of flowers, I found him on the divan, deeply asleep. I stood in the doorway for a moment, staring without even realising that I did so. With those all-seeing eyes veiled, curled on his side, he revealed a surprising vulnerability. It crossed my mind that he slept with the concentration of someone totally exhausted. I set the flowers on the nearest table and withdrew.

Nothing more was heard from our new employer until the library bell rang just before tea-time. Mrs. Clithoe had the tray ready, so I took it with me to answer the bell.

Mr. Sigerson stood before the fireplace. He nodded silently as I set down the tray. "One moment," he said, when I would have glided from the room. "Where did that come from?" He pointed to the arrangement of narcissi and tulips.

"I brought them in earlier," I said, vaguely uncomfortable. "You were asleep," I added scrupulously, "and I tried not to wake you."

He did not speak for a moment. "Mr. Bagshaw said something about your assisting your late employer with readying his memoirs for publication."

I inclined my head, but did not speak. The major and I had spent many happy hours at work in the library; those memories were all the more poignant to me because, when we had begun the task shortly after my arrival at Larchbanks three years previously, I had been newly bereaved, suffering many sleepless hours that cried out for occupation.

Mr. Sigerson waited a moment, and when I did not speak, he went on. "I can readily understand, Mrs. Dodson, that during your editorial duties with your late employer, you came to consider the library as your workroom. I do not wish to give offense, but I must have an undertaking from you that you will henceforth knock, and refrain from entering unless expressly bid to by myself."

I managed, with some effort, to keep my face from showing my feelings. "Very good, sir."

"I do not care for cut flowers." He picked up the vase and handed it to me. "If you could limit them to the other rooms of the house?"

"Of course." I took the vase. "If you will excuse me?"

He smiled suddenly, but his eyes were fixed with cool speculation on my face. "You will soon be used to my quirks, Mrs. Dodson, and I expect we will rub on tolerably well."

"Certainly, sir." I allowed myself one quick survey of the

books. I had come to think of them as mine, and now they were barred from my perusal.

Already the room began to seem more my new employer's than the cozy retreat I had grown used to. Pamphlets and pipes were scattered everywhere. Mr. Sigerson had drawn the curtains for his nap and forgot to open them again.

I did not offer to open them for him. I took the vase of flowers to the drawing room, and conveyed instructions to Violet that she need no longer bother to tidy the library.

"New master be one of those finicky men," Violet said knowledgeably. "Can't abide to have his things touched. Ticked Rose off something proper for turning out his wardrobe."

"Rose, you did not tell me."

"I didn't mind," Rose said. She sat at the kitchen table deciphering the newspaper. Mr. Sigerson had somehow managed to arrange early delivery of the post, and Rose had been delighted to learn that no fewer than five newspapers, from various cities throughout the world, would arrive regularly. The one she read had gaping holes in it where Mr. Sigerson had clipped out some article or story; I hadn't supposed there was such a quantity of news relating to bees in *The Times*. "Old major needed a deal of picking up after, as you know, Mrs. D. This Mr. Sigerson told me he likes things untidy."

"Surely not." I poured myself a cup of tea and accepted a slice of cake from Mrs. Clithoe. Although I sometimes enjoyed having tea by myself in my private parlour, and invariably had it there with Stubby when he was on holiday from his school, as a general rule I took it in the kitchen with the rest of the staff. It would be a false kind of pride indeed that led me to keep distance between myself and my fellow servants. After my encounter with Mr. Sigerson, my sensibilities were smarting. I took a painful satisfaction in associating with those others who were at the beck and call of the gentry.

"Well," Rose defended herself, "he said as how he didn't want a parcel of womenfolk straightening all the order out of his things, and he could manage very well if I forgot about dusting."

"Mr. Sigerson is the master of Larchbanks now," I said, "but that does not mean that the dust will take orders from him. We will strive to leave his books and papers and personal items untouched, but there must be cleanliness and neatness in the house." I poured another cup of tea. "I am sure when we are used to his ways, everything will resolve itself."

Mr. Sigerson's ways took a deal of getting used to. His timetable, if it could be dignified by that name, defied order. He was up early, slept half the day, spent half of it out in the grounds, and stayed in the library until the wee hours, evidently tabulating his research.

For the first few days I kept away from the library, but while he was out one afternoon I peeped in, to find it stale, musty, and cluttered. I aired it briefly, restored what order I could to chairs and tables without disturbing the stacks of books and papers that littered every surface, and withdrew. I repeated the process the next day, and felt confident that I could at least maintain a more wholesome atmosphere in a room for which I had justifiably proprietary feelings.

I only wished that the unsettling effect Mr. Sigerson had on me could be tidied away as easily as I could sweep up his pipe dottles.

*Her spirit will be seen through the
whole establishment; and just in
proportion as she performs her duties
intelligently and thoroughly, so will
her domestics follow in her path.*

Chapter Four

THROUGH HEROIC EFFORT, everything went smoothly for the
first week. I was lulled into a sense of complacency. Thus it
would continue, I supposed. The house would run like clockwork;
Mr. Sigerson would have no cause for complaint.

In hindsight, this ambition of mine verged on hubris. The
events of the following weeks resembled clockwork only if the
clock were scattered in a hundred pieces, incapable of being fitted
together except by a master hand.

But I had as yet no inkling of that on the first Sunday after Mr.
Sigerson's arrival. He had not accompanied his household to wor-
ship; this did not surprise me, in light of what I had gleaned about
his routine.

According to what I knew of Mr. Sigerson, while the vicar
mounted into the pulpit my employer was no doubt snoozing
on the library sofa. I felt sure that he would observe no Sabbath
rest; after the cold collation which was all we had at luncheon on

Sunday, he would be out to commune with his bees, not knowing or caring that the staff would be off until after dinner-time. Perhaps I should have made sure he understood this; it could prove awkward for him at tea-time. I confess that the notion of Mr. Sigerson in discomfort—not much, just a little—was gratifying to me. I missed my library.

Violet and Rose sat with their mother, instead of in the Larchbanks pew; their half-day out started directly after church. Beside me, Mrs. Clithoe divided her attention between her prayer book and her father. Old Thurlow, who had been pensioned off from his position as gardener at Larchbanks after the major's death, sat with his cronies in a corner near the vestibule, where they could nod at will without attracting undue attention.

The vicar sat down and a stranger rose to read the lesson. Mrs. Clithoe gave me a sharp poke in the ribs.

"That's Mr. Simms, the new curate. He be powerful handsome," she whispered loudly. I had to agree with her assessment. The man occupying the pulpit had clear-cut features and fair hair that tumbled ingenuously about his broad, benevolent forehead, focusing attention away from his rather squinty-eyed gaze. He read well, though with a certain flatness of intonation that struck me as vaguely foreign. Glancing around the church, I could see that the young ladies of the parish were already his devoted slaves, Violet and Rose among them, with expressions as they gazed at him far more worshipful than any thought of God or Duty had ever called forth

This notion made me smile. I found the curate staring at me as he finished the lesson. There was something peculiarly magnetic in his gaze, no matter how squinty; I dropped my eyes to my prayer book, feeling that I had seen enough overbearing masculinity that week to last a lifetime.

"A ravager, a deceiver, a trifler of women," Mrs. Clithoe muttered beside me, glaring at the pulchritudinous Mr. Simms. "I've seen his like before...somewhere."

In my turn, I dug an elbow into her ribs, fearful that a Spasm

was brewing, and she subsided with a grumble. Although attending the Church of England like most of Stafford-on-Arun, Mrs. Clithoe always seemed more Methodist in her theology.

When the service ended, I stood and waited for Mrs. Clithoe to heave herself to her feet. I received a few cold nods from several ladies of the parish; since Major Fallowes's funeral, and the revelation that he had left me the substantial gift of his library, Miss Hanover and Mrs. Hodges, the village gossips, had put it about that there must have been more between my employer and myself than simply an old man's gratitude for help with editing his memoirs. Otherwise, they whispered, he would not have left me so personal a bequest.

I paid no attention to the Scandal Sisters, which was one of the nicknames the major had made up for Miss Hanover and Mrs. Hodges. The major's bequest, when realised, would fund my son's education, and might even provide a small income to make me less dependent upon my labours for my bread. No amount of whispering could taint it for me; I knew it had come straight from the major's generous heart, not, as implied, from an elderly infatuation.

The gossip, however, was still fresh. Not even Mary Beedle's fall from grace had sufficed to eclipse my newfound notoriety. As a result, the last three Sundays had been rather tiresome for me, with murmured speculation from those whose salacious thoughts had afforded them much pleasure.

Only Mrs. Rutledge paused to speak to me.

"My dear Mrs. Dodson." She squeezed my hand. "I must thank you again for helping me to find my crystal brooch." She glanced around. Almost everyone had left the church by this time; Mrs. Clithoe had reached her father's side and they were among the last clustered at the door.

Mrs. Rutledge lowered her voice, nevertheless. "It has been in Squire's family for so long," she whispered. "I don't know what he might have done if I'd lost it."

"My pleasure, Mrs. Rutledge. It was really nothing."

She smiled at me timorously. She was a wispy woman, blessed

by Squire's robust appetites with three sons and two daughters, all as loud and boisterous as their father. Her downstairs maid had mentioned to Violet that her mistress had lost a valuable brooch and was afraid to tell Master, who always cut up something stiff with her. Violet had retailed it in her daily dish of gossip to Rose. When I had overheard, I sent a note to Mrs. Rutledge offering my assistance in finding the brooch. I have a knack for finding things. It requires only a logical approach and a willingness to search carefully; a surprising number of people lack either or both of those commodities. After listening to Mrs. Rutledge describe the day on which she last recalled wearing the brooch, I had advised her to look amongst the woolens she'd directed to be packed away until the next winter. The brooch had turned up entangled in the folds of a cashmere shawl.

"Mama! There you are. We are waiting for you in the carriage." The eldest Rutledge girl came bustling up. "Whatever can you be doing?" She gave me a stare. I returned a bland smile. Mrs. Rutledge went meekly after her daughter, and I followed in their wake.

Reverend Hanover and Mr. Simms were still on the church steps, chatting with parishioners. The vicar gave me a cordial smile and shook my hand. At least he was not party to his sister's mischief-making. He pulled his new curate over.

"Mrs. Dodson, here is my new assistant, Mr. Peregrine Simms, who tells me he's not yet met you."

I offered my hand politely, withdrawing it when Mr. Simms showed an impulse to retain it. "I was unable to attend the last meeting of the Ladies' Aid Society," I said. "How do you do, Mr. Simms?"

At close quarters, the impression of good looks faded somewhat. The new curate's face was marked from a bad case of youthful spots, and his peculiarly light brown eyes were indeed small. However, his smile, which Violet and Rose had described in raptured terms, did display beautiful teeth. The intensity of his gaze did not abate.

"I am all the better for meeting you, Mrs. Dodson," Mr. Simms said. "May I escort you to your carriage?"

"That is not necessary, thank you." I turned back to the vicar. "Pray tell your sister that I shall make every effort to attend the next meeting."

"Ah yes," the vicar said. "I suppose you have been settling in with the new tenant of Larchbanks." He glanced around expectantly.

"Mr. Sigerson did not accompany us this morning." I offered no explanation, and, Miss Hanover coming up at that moment, the vicar forbore to inquire further.

Like her brother, Miss Hanover was tall and thin. She had none of his benevolence of spirit, however; she was as sour as curdled milk. She customarily wore black or grey, "because," as I heard her say on the previous Easter, sneering at one matron's primrose-colored ensemble, "it would not do for the vicar's sister to appear frivolous." After one look at her pursed, bloodless lips and scowling brow, no one could have thought her frivolous even if she'd been decked head to toe in Worth's airiest creation.

"Mrs. Dodson," she said, with a precisely calibrated chill in her voice. Her Sunday black silk was pinned at the high, boned collar with an etched gold brooch, her only concession to ornament. Her black silk bonnet was in a style popular over a decade before. Although her own garments were neatly brushed and pressed, I noticed that the vicar, for whom she supposedly kept house, wore a rumpled cassock and boots which had not been polished recently.

"Miss Hanover." My voice lacked warmth. In truth, I despised her as much as she did me. If she spent more time tending her brother and the vicarage, and less time scouring the village for scandal to retell, I would have respected her even if I could not like her.

Miss Hanover turned to Mr. Simms. "My dear Perry," she said, at once patronising and syrupy, "would you mind seeing to these?" She handed him a stack of prayer books

"Certainly, Miss Hanover." He bowed over my hand, accepted the prayer books, and turned away.

Miss Hanover's smile was triumphant, as if she had saved the curate from converse with a Jezebel.

"I must be off, too." I smiled at the vicar and inclined my head towards Miss Hanover.

"Oh, Mrs. Dodson." Miss Hanover was not yet finished with me. "I did not hear from you about serving in the tea marquee during the village fête. I have put you down for three o'clock to five o'clock. It is a good time to see gentlemen; I know that will be an attraction to you."

Sensing hostility, the vicar blinked. I stared at Miss Hanover until her gaze slid away, then smiled.

"Naughty Miss Hanover, to know so well when the gentlemen come for their tea. Of course I am only too glad to help." Miss Hanover flushed from neck to forehead. The vicar ventured an uncertain laugh. "Good day, Vicar. Good day, Miss Hanover."

Mrs. Clithoe always accompanied old Thurlow home on Sundays to give him dinner, so I had the lane to myself on the way back to Larchbanks. It was pleasant to walk through the warm, scented sunshine. Orchards on either side of the lane were bursting into bloom, and primroses starred the banks.

I did not hurry. Consequently it was nearly one o'clock when I reached the house. I went around to the kitchen entrance to tidy myself and arrange the cold collation in the dining room—not that Mr. Sigerson would notice, for he was, as I had foretold, indifferent to meals, occasionally eating voraciously, but more often than not taking little more than bread and cheese.

Mrs. Clithoe had prepared a tempting spread, and I carried the tray to the dining room to set it out. Hearing movement in the library, I tapped on the door. "Luncheon, Mr. Sigerson."

The movement ceased abruptly. Considering my instructions, I ought to have walked away, back to my own luncheon. But there was something about the hush behind the library door, something that raised prickles of alarm on the back of my neck.

I turned the knob and threw the door open. Standing behind the kneehole desk, confusion written all over his face, was young Harold Bagshaw. Mr. Sigerson was nowhere in evidence.

"Harold!" I shut the door behind me. "Whatever are you doing here?"

Harold blushed scarlet, wearing an expression of guilt that would not have been amiss on Stubby's countenance when caught with one hand in the comfit box.

He glanced at the welter of papers that cascaded off the desk. "I didn't do this, I swear it," he cried. "Please, Charlotte—Mrs. Dodson! You must believe me!"

He rushed around the desk towards me, hands held out in supplication. I stopped him with a gesture.

"Simply tell me what you are doing here, Harold."

He gulped air. "Why, Uncle asked me to bring down some papers for Mr. Sigerson to sign. No one answered the door when I arrived, but it was open, so I walked in." He looked at me like a puppy caught in a misdeed. "I thought you might be in here, so I took the liberty…" Glancing around, he appeared genuinely bewildered. "It was like this when I entered. I couldn't think— I was afraid something had happened! At any rate, I didn't mean to snoop! But what fiendish thing has caused this massive upheaval?"

"Nothing," I replied. "This is how Mr. Sigerson likes it. Isn't that so, Mr. Sigerson?"

Harold gaped at me as if I'd lost my mind, but with a slight disarrangement of the long curtains at the French window, Mr. Sigerson stepped out, a heavily weighted walking stick in his hand.

"Nothing escapes your eagle eye, Mrs. Dodson," he said with some exasperation, glancing down at his boots, the toes of which I had seen protruding from the curtains. "I was waiting to see what my uninvited visitor would do next when you accosted him." He gave me a grudging smile. "You appear to have more than a woman's portion of bravery."

"Nonsense," I said in as colourless a voice as I could manage. For some reason, his very moderate remark had made me momentarily breathless. "Mr. Harold Bagshaw is hardly a frightening sight."

"Well, be that as it may." Mr. Sigerson propped the walking stick in a corner and advanced on the hapless Harold. "May I suggest you give me the papers you came to deliver, and then share my luncheon?"

Harold, confused, looked at me.

"I shall lay another cover at once, sir," I said, and left the room, a prey to conflicting emotions.

Although I did not doubt Harold's story of events, I wondered about the papers he'd had in his hand, and which he had so hurriedly concealed in his coat-pocket when I opened the door. I had not mentioned it at the time, because it seemed a breach of hospitality to demand that a guest, no matter how uninvited, turn out his pockets.

Still, the papers had looked familiar. Several sheets, folded together, the topmost one with a large splash of red sealing wax. That was all I had seen before Harold had stuffed them into his coat, but it was enough. I realised that what he had taken was a document of my own.

It was my final communication from Major Fallowes, a letter which Mr. Bagshaw had handed me after my late employer's funeral.

*The housekeeper...should be
above suspicion, and her honesty
and sobriety unquestionable, for
there are many temptations to
which she is exposed.*

Chapter Five

Dear Max,

How is the term going? Has Worsley Minor escaped
from his chicken-pox quarantine yet? We are settling in
with the new tenant here, a Mr. Sigerson, who keeps
bees. He has a talent for finding the hidden passages in
the house. Perhaps he will uncover one you missed.

I PUT DOWN MY PEN and sipped the water that had accompa-
nied my solitary lunch. Usually I enjoyed the ritual of writing to
Stubby (or Max, as I tried to remember to call him) on Sunday af-
ternoons, and every so often I received the reward of a reply. This
afternoon, the mention of Mr. Sigerson diverted my thoughts from
the letter I penned to the scene in the library.

It would upset Max to hear of Harold Bagshaw's furtive be-
haviour, so I would not mention it. Despite my distaste for his
maudlin infatuation with me, Harold had been very kind to my

son during the Easter holiday, engaging him in impromptu rugby practices on the lawn and volunteering his assistance with a particularly difficult holiday task, thereby occupying the role of hero in his adoring young friend's eyes. Max was of an age to see proficiency at sport as the ultimate pinnacle of mankind.

No, I would not tell my son of Harold's unaccountable abstraction of my letter. It was, however, certainly worth speculating about. I minded very much sharing the contents of personal letters with another, even if that other was associated with my late employer's solicitor.

And perhaps a sinister motive was behind Harold's behaviour.

It had been Harold, in fact, who had prompted Mr. Bagshaw to give me the letter after the will had been read. He had evinced an interest in its contents from the beginning. But his interest had been unfulfilled. I had not opened the letter then.

It had been a trying morning; the funeral was a sad occasion for those who had loved and respected the major. The presence of such cyphers as Squire Rutledge and the village gossips had been unpleasant, but the vicar's heartfelt remarks were uplifting. It was only fitting that when the will was read, the parish fund was found to have been generously remembered. Violet, Rose, and Mrs. Clithoe had received legacies; old Thurlow had been granted the freehold of his cottage; frail Mr. Bartlett, the major's valet, had been handsomely pensioned.

I had expected a modest gift of money, having been in the major's service for only three years. Instead, I had received the contents of the library, books and furniture, to keep or sell at my discretion.

Given the value of the books the major had lovingly collected during his well-travelled army career, I expected to profit quite handsomely from the sale. By the provisions of the will, that action would be delayed until the major's niece, Patience Staines, was found and her wishes made known; at that point I would be free to complete the disposal of the books. It would mean several hundred pounds, not the twenty-five or thirty I had expected.

Enough to ensure young Max's schooling for a number of years, independent of my wages, which had barely covered the costs. Enough to enable me to be selective about my future employment.

The village had found this bequest peculiar (hence Mrs. Hodges's scandal broth), but they didn't know the half of it. After the will had been read and the neighbours had finally gone, after Harold's prompting, Mr. Bagshaw had handed me a letter Major Fallowes had left with a keepsake for my son in it. Curious, the Bagshaw uncle and nephew had lingered for a few minutes, but I had not been able to open and read so personal a communication while anyone watched, and soon they, too, took their leave.

With everyone gone, I had tidied the library, returning chairs to their proper spots. Then I took my accustomed place in front of the big kneehole desk. I could not bring myself to sit behind the desk in the major's chair. I pulled the packet Mr. Bagshaw had given me from my pocket. It was wrapped in brown paper, lavishly sealed with bright red wax—the major had a weakness for sealing wax—and inscribed with my name. Inside was a sealed letter addressed to me, and another, smaller packet.

"Dear Mrs. Dodson," the major had written. His handwriting, barely legible at the best of times, had degenerated over the course of his final weeks.

I have taken the liberty of putting aside for young Master Dodson the tie-pin made from the spent cartridge that nearly did for me in the Crimea. He has so often teased me for the story that I wanted him to have a keepsake to remember the old major by, and the gallant action of our brave men at Balaclava.

You must allow an old man to tell you, my dear Mrs. Dodson, how much your assistance has meant to me these past three years. I know very well that it was your skill with words that made my memoirs acceptable to Messrs. Smith and Elder. You may find my bequest to you

a little unusual, and I know your modest soul will believe it excessive, but I feel it is barely adequate to reward the best editor an old soldier could have had, and not incidentally, the finest housekeeper I ever had.

That is why I have left another keepsake for you, in the secret drawer I once showed you. I didn't mention it in my will, for such things are likely to stir up envy and opprobrious talk. However, it is entirely yours, to keep or sell, though I don't advise you to sell it except in case of direst need. Such a thing would be likely to cause a bit of excitement if it came to light, don't you know. At any rate, I have put in a paper declaring it to be your property, in case anyone ever doubts it. You remember the Orb of Kezir? It sparkles no more than your bonny eyes, my dear. Bless you for your excellent care of an old man, and believe me to be,

Cordially,

Major Sir Arthur Fallowes

As may be imagined, this document had filled me with surprise. The praise it contained was welcome, though overblown. And perhaps, by marshalling his facts and finishing his memoir, I did the major no favour. The occupation of puttering around with his journals had kept him alive and in good spirits into his ninth decade; and only after the book was finished and accepted for publication had he succumbed to the lung affliction that eventually carried him off.

Though his grasp on Balaclava had been impeccable, the major's memory for recent events was not so good. He had sometimes confused me with his former housekeeper, his sister, Maud Saunderson. Mrs. Saunderson, I gathered from things Mrs. Clithoe had let fall, was sweet, good-tempered, and incompetent. No doubt she had known the hiding place of the Orb of Kezir, if it indeed existed, and was not just the legend I had thought it to be when the major had first mentioned it. But I did not.

I remembered vividly the night he'd told me of the Orb. We had been sitting together in the library after dinner, as was our custom.

"Did you really save a raja's life?" I looked up from the journal pages I pored over, deciphering my employer's handwriting as best I could.

Major Fallowes pushed his chair a little away from the desk and clasped his hands over his ample stomach, a sign that he had a story to tell. "I did indeed, Mrs. Dodson. I did indeed. My, yes, that was rather exciting."

I held my pen poised over the paper on which I was making notes. I had started out merely copying the journals into manuscript form, but it soon became clear that they held only the barest outline of Major Fallowes's army career. The real stories emerged when the major recounted them, full of wonderful details which he had not bothered to write down at the time, or had sketched too briefly to do them justice.

I had begun jotting notes whilst he recounted the events in his life, and adding these richer seasonings into his manuscript.

The major was not wholly convinced that, in this new century, anyone would be interested in an old soldier's memoir of long-ago engagements in India and the Crimea. I, too, was not sure what kind of readership a memoir of such matters could garner. But I was determined that it should be as appealing to a publisher as possible. My skill (and it is but a skill, no matter what Miss Hanover says about arcane powers) in finding things that others lose was put to work on the major's memoirs. He had lost the colour out of his life in the act of writing it down. I intended to find it, and give it back to him.

I sat opposite him at the front side of the kneehole desk; we had formed the habit of working thus most evenings, the major because, at eighty-one, he could keep what hours he chose, and I because the bereavement that had forced me to seek employment would not let me rest at night. The major's memoir had been a godsend to me, giving me agreeable work to fill the empty hours

after my duties as housekeeper were done and the other servants had gone to bed.

"It was in 1865—or was it '66? I forget exactly which, but it is written down there," he began, gesturing towards the leather-bound journal that lay between us on the desk. "There was a monsoon that year. Wiped out the crops. Bad for the elephants, too; there had been a couple of nasty stampedes in several villages.

"I was stationed in Punwalli then. The raja was an old fellow, generally in accord with his people. But after the elephants trampled one village, a faction arose led by this wild-eyed young fellow, blaming the raja for not properly making offerings to Ganesh. As I said, the crops were bad, people were hungry. There was a riot, and the raja was trapped in his palace, with several hundred angry villagers demanding his blood outside.

"As it happened, I had been to a polo match at the raja's compound just the week before. He'd taken a fancy to me, and I to him."

"Were you a dashing polo player?" I had to interrupt. The major had several fading daguerreotypes of himself taken in his dress uniform at various times of his military career. He had been a handsome fellow once, and the pictures projected an air of gaiety and zest, qualities he still possessed, though in muted form. I had not heard until now, however, that he played polo.

"I was a decent player," he said modestly. "Didn't fall off the horse. Better at cricket, don't you know, and the Punwallis were mad for cricket. Anyway, I'd been asked for tea and was actually in the compound when the riot started. There we were, surrounded by all this opulence, shaking in our boots because the villagers were beating down the gates."

"What was it like to have tea with the raja?"

"It was astounding, Mrs. Dodson." Major Fallowes stared into the past. "Everything was inlaid with gold or silver or precious jewels. The raja's sceptre, or whatever he called it, was a solid gold rod bearing a huge blue topaz surmounted by a gold replica, not more than two inches high, of an elaborate temple in his

compound." He shook his head. "I tell you, Mrs. Dodson, the wealth in India was astounding. And right next door to the most alarming poverty."

"So what did you do? Just keep on sipping your Darjeeling?"

"It was Darjeeling, as a matter of fact." He smiled at me. "With little honey cakes and rosewater-scented sweetmeats. No, we were all rather worried, and the raja became distraught. So I offered to go talk to them."

"Talk to the rioters?" I stared at him. "You knew Hindustani?"

"Used to be a dab hand at it." The major shook his head. "Mostly gone now, don't you know. Well, I settled with the raja what I would say and went out to the terrace. I could see that the mob were nearly through the gate. Thing is, I'd coached a lot of these fellers on the Punwalli cricket team. We'd got up a good eleven against the sides from the neighbouring areas. I just let out the yell—"

"The yell?"

He put his hands up to his mouth and emitted an indescribable sound, a hybrid between the shriek that seeing a mouse produces in a woman, and the yowling of amorous cats. "Each side had its own yell," he explained to me. "We had worked hard to make ours as fearsome as possible."

"I believe you succeeded."

"At least it got their attention. They stopped pulling the gates down and started calling my nickname."

"What was that?"

"Er, roughly translated, it meant Big Bat." Major Fallowes seemed abashed.

"I suppose it was a term of respect on their part."

"Not really, but it was all in good fun." The major leaned back in his chair once more. "I asked them to give me a chance to speak, and they consented after some rather noisy discussion. Told them that the raja knew of their suffering and would like to offer them gold with which to honour their dead and feed the living. That he planned to build a cricket pavilion and wanted

workers to muster the following day, as long as they couldn't get into the fields to plough."

He fell silent. After a few minutes, I prodded his recollection. "Then what? Did that solve the problem?"

"Hmm? Oh, yes. Yes, that took care of it. I passed out the gold the raja had given me to disburse for him, and the villagers went away. Don't know why it didn't occur to him before to aid them. Right thing to do in any case. But the upper castes there were so insulated from those lower down. I persuaded him to build a cricket pitch in the village, too. Those Punwallis loved their cricket."

"So that was how you saved the raja."

"Not a bad fellow, all in all." The major yawned. "He was grateful. Gave me the Orb of Kezir, don't you know."

"No, I don't know. You don't mention that in your journal." I flipped through the pages, trying to discern in the chicken scratches that made up the major's handwriting any mention of an Orb.

"Didn't I? Guess I thought it might be dangerous. Thing like that is pretty valuable, you know. Great hulking diamond with jewels all around it." He yawned again. "I showed it to you, didn't I?"

"No, you did not." I put my pen down. "And I should very much like to see it."

"Ladies have a fondness for gems, I know." Putting his gnarled hands on the arms of his chair, he began the slow process of standing.

I had known better than to offer assistance, though I wished he would accept my help. It was obvious that it pained him to stand, but he was too much of an old soldier to make any concession.

"It is more because of its curiosity than to admire it as a gem." I spoke at random, to take his mind off the pain. "One cannot, after all, adorn oneself with great hulking diamonds. But perhaps it would make an attractive paperweight."

That provoked his rich chuckle. "Well, you shall see it then, and tell me if you think it would be suitable for that. But it will have to wait for morning. I'm done for tonight. Exhausting thing, going back in the past."

His shoulders were still erect, but he moved slowly as he left the library. He'd been a vigourous eighty when I'd come to Larchbanks; and his mind had been as sharp and lucid as ever in what pertained to the past, right up until his demise. He had not been so clear about events of our daily lives, and he grew less active, substituting a stroll around the garden for his brisk constitutional through the park, until that final, fatal illness brought about his death in late March, less than two months previously.

I had mentioned the Orb in the major's memoir, because glittering treasure is always interesting. I had, however, been reluctant to press for a sight of the legendary jewel, and indeed had assumed that his failure to show it to me indicated it was not only legendary, but mythical. He had not divulged any secret compartments to me, and I doubted very much whether one actually existed, and if in existence, held a sparkling gem, no matter how alluring that picture was.

I had tucked away Max's packet, to await his visit at Easter, and filed my letter neatly in the drawer the major had allowed me to use for my own infrequent correspondence.

Now it was gone.

Perhaps Harold had read the major's memoir after its recent publication and noted the mention of the Orb of Kezir. He had transcribed the inventory which Mr. Bagshaw and I had made for Patience Staines. He would know that no such jewel had been listed amongst the house contents.

Major Fallowes's letter would avail Harold little if, incredible as it seemed, he wished to find the Orb for himself. It had not helped me to it, and I knew more of Larchbanks than Harold did.

I looked back down at the letter I was writing to my son. Of everyone, Max probably knew the most about the house and its hiding places. All I had had to do when he had been home at

Easter was to mention that Mr. Bagshaw thought there were more priests' holes in the house. Max had greatly enjoyed being permitted to nose around the house without hindrance. Such a hunt was much to his taste. I felt quite confident that he had found every hidey-hole the house possessed, but no great jewel had come to light.

I put down my pen and capped the inkwell. I could not concentrate on writing a letter to Stubby, when the thought of Harold with my letter from Major Fallowes filled my head. Why in the world had Harold taken my letter? Before this, I would have said that he was the soul of probity. It grieved me to be under the necessity of re-evaluating his character.

And I had also to decide what action to take, for Harold could not be allowed to retain my letter. Should I approach him before he left and demand that he return it? Or should I speak to his uncle? Neither of these alternatives appealed to me.

As I rose to my feet, determined to confront Harold before he returned to Littlehampton, a tap came at the door. I wondered if it was Harold, seeking me out in order to restore my letter and explain the reason for his having taken it.

When I opened the door, Mr. Sigerson walked in without waiting to be invited. "Mr. Harold Bagshaw has taken his leave," he said abruptly, glancing around with bright-eyed interest. "What do you make of his unexpected advent, Dodson?" He shot a look at me. "If it was unexpected?"

"I, at least, did not anticipate it." My reply was phrased a trifle tartly. I did not like his inference that I had, perhaps, invited Harold to a *rendezvous*. "And I can make nothing of it, Mr. Sigerson."

"I thought you might have decided that he was after this." Mr. Sigerson reached into his waistcoat pocket and produced—my letter. He tossed it negligently on the table, and was gone before I was capable of speech.

I must have stood there, bereft of sense, for several seconds. Finally I picked up the letter, opening it with unsteady hands. It

was indeed my final communication from Major Fallowes, written in his spiky, uncertain characters.

Seeing that hand brought a flood of memories from before the major had been taken ill, when we were absorbed in readying his memoirs for publication, when each day had brought agreeable duties and his fatherly companionship. Those days now seemed so simple, so tranquil, though at the beginning of my employment I had felt the utmost terror that my labours would be insufficient to provide for my son. That terror had been nearly as strong as the grief that pierced me over my husband's death.

I still could not think of my beloved husband's death without pain. We had been so happy. Maxwell had enjoyed vigourous good health his entire thirty-five years; our son had attained the interesting age of eight; and the small preparatory school into which we had sunk all our financial resources was thriving. Maxwell had attended to our young charges' minds, and I had overseen their comfort; the work had been hard but satisfying, and my husband's companionship everything a woman could want. Perhaps I had not realised that with enough force at the time. If I had known it would all be snatched away, leaving my son without his father and me without the love and support of my heart's companion, I would have relished every minute.

One day, Maxwell complained of a headache. The next day, he was dead.

In my stupefied misery, I was hard-put to understand that everything would have to be sold to pay our debts, leaving a residue of the most meagre income, too small to support us; that my son and I would be without home, without occupation. My parents had preceded Maxwell in death but a year previous, and his family, though a proud one, was too much straitened by bad investments to assist me; indeed, I asked for no assistance, for I, too, had my share of pride.

By the greatest good fortune, the solicitor who had handled the sale of our home knew of Major Fallowes's need for a housekeeper after the death of his elderly sister, who had performed

that function for him. The major was willing to overlook my lack
of formal experience in the post, and had no objection to receiving
my son into his home as well. My wages were enough to pay for
my son's school, a matter of no small import. Thus, at the age of
thirty-two, I came to Larchbanks, and found a refuge from grief in
work, especially after my son went away to school, returning only
at holidays. Despite the physical demands of my position (and it
was no easy task, as the major's sister had let things slide for the
past few years), I had been unable to work hard enough to compel
sleep to visit my lonely bed.

How soon the major had set me at ease. With what congenial
work had he occupied my grieving heart. I had recourse to my
handkerchief before scanning once more the last lines he had
penned. Folding the letter, after a moment's thought, I locked it
into Maxwell's old dispatch-case. Then I went in search of Mr.
Sigerson.

Cleanliness, punctuality, order,
and method, are essential in
the character of a good
housekeeper.

Chapter Six

M R. SIGERSON WAS NOT IN THE LIBRARY, so I sought him
in the orchard. From the kitchen, we had often glimpsed
him there, beyond the hedges that enclosed the kitchen garden,
engaged in some kind of concentrated activity beneath the old ap-
ple trees.

I stood in the archway that separated the kitchen garden from
the overgrown knot garden beyond, which gave in turn on the or-
chard. Mr. Sigerson was not immediately visible. I wandered
through the knot garden, wishing we had a gardener to prune the
knee-high avenues of box and lavender back to their former glory,
and came to another vine-covered arch opening into the orchard.

The scene was one of tranquil beauty. New green grass car-
peted the ground, enlivened by sweeps of bluebells and freesias.
The trees' bright green leaves rustled in the breeze. Scent drifted
from creamy pink apple blossoms; the gnarled trees held up their
lacy boughs like rows of cotillion partners, and petals danced in
the breeze.

Under the trees, boxy white structures had been installed by Mr. Sigerson. They looked nothing like the domed straw skeps the local farmers used as hives. I wondered how close to them I could get before inviting unwelcome attention from bees.

Before I could step away from the hedge, my ankle was seized most ungently, accompanied by an angry hissing sound. I froze, a vision of poisonous adders filling my mind. Then I saw that it was Mr. Sigerson, peering through a crack in the hedge, glaring back at me.

"Do not make a sound," he said in a fierce whisper, when I opened my mouth. "You may destroy all my efforts."

I closed my mouth.

"Come back here." He made an imperious gesture, mouthing the words. I thought of retreating to the house, but that would delay my opportunity to question him about Major Fallowes's letter.

So I pushed through a weak spot in the hedge, and at Mr. Sigerson's behest, knelt behind its shelter.

He peered between the bushes through powerful field glasses slung around his neck, ignoring me as he made minute jottings in a small notebook. Being long-sighted, I managed to oversee what he wrote. It appeared to be compass directions.

Puzzled, I looked where he was looking, at the nearest of the tall white boxes. By squinting, I could make out the tiny black dots of bees moving between the hive and the snowy, blossom-laden apple trees.

Mr. Sigerson lowered his field glasses and approached his mouth to my ear, speaking in a mere breath of sound. "It is vital to maintain absolute quiet for the next twenty or so minutes," he murmured into my ear. "If distracted by human noises, the bees may alter their behaviour upon returning to the hive. I cannot take that chance."

I nodded to show my understanding, and debated my choices. I could crawl back to the house to await Mr. Sigerson, or I could pass the time here, certain of gaining my employer's attention when his observations were finished. I decided to wait, crouched

behind the hedge that separated the knot garden from the orchard. There were worse places to be on a May afternoon.

At first I watched the hives, which looked like white-painted hand-trunks set on end with flat, almost Mediterranean roofs, and small, square bee doors a few inches from the ground. Gradually the sounds of the orchard penetrated my consciousness. Bees hummed all around us, like the bellows of a great organ, a contented bass note to the treble rustling of new leaves. A thrush sang from the nearby hedgerow, his music punctuated by the sweet, commonplace trill of a wren.

My lunch had been substantial, and in the blossom-scented sunshine my urgency to speak to Mr. Sigerson began to dissipate. I confess that I was about to succumb to torpor when muffled words escaped my companion.

"At last!" Even in his excitement, he didn't forget to whisper. "Look, Dodson!"

He passed the glasses to me, although the cord still remained around his neck. Through the lenses I could see bees thronging about the hive opening. At first I could not tell what he would find remarkable in the aimless comings and goings of these insects. Then I noticed clusters of bees gathered around one of their fellows.

"Do you see that dance they do?" Mr. Sigerson's whisper resounded in my ear. "That is what I am studying. I have marked certain bees to differentiate them, and now at last I can prove—"

He broke off, snatching the glasses away from me, and turned to examine part of the distant hedgerow that separated the parklands from the lane.

After a moment I whispered, "What is it?"

Slowly he lowered the glasses. "Nothing at all. Pray remain here, Mrs. Dodson. I will return soon."

With that, he snaked away behind the box hedge, and was soon out of sight around the house. Such was the force of his personality that I did not dare to simply stand up and walk back to my rooms. Instead I emulated his fashion of creeping along behind

the shelter of the hedge, and thus gained the gate leading into the walled kitchen garden.

I had waited inside the gate only minutes before Mr. Sigerson came striding back, as coolly as if he had not just been the cause of my undignified exit from the orchard.

"Ah, Mrs. Dodson." He spoke carelessly, without undue caution. "Did you wish to consult me?"

"What was it you saw in the hedgerow?" I demanded.

He shrugged. "Why, nothing at all. Merely, I wished to check that there was no one lurking around." He gestured vaguely at the bees. "My research, you understand, is very confidential. I do not doubt I am onto something, and I have no wish to be scooped once again by Henry Alley!" He caught my look of inquiry. "A greedy American apiarist, who sees nothing but shekels in his hives! No doubt he will take my discovery and manage to turn a profit on it, but at least I shall have the satisfaction of first publication."

I cleared my throat. "And you suspect other bee-keepers of spying on you here?"

Mr. Sigerson had no difficulty discerning my thoughts.

"Indeed, Mrs. Dodson, it sounds unlikely." He threw back his head in the queer soundless laugh I had noticed before. "But I have known it to happen, and I won't have my research interrupted at such a critical point. In a month, perhaps less, I shall have everything pulled together and then—" He broke off, looking at me keenly.

"Then what?"

"Why, then I shall publish my results, and perhaps put some of your editorial talents to work, ma'am."

I did not feel that this was what he had intended to say. And though I wanted to scoff at his imagining spying interlopers everywhere, a shiver of unease took me instead.

Mere irritation of the nerves, I told myself. "Mr. Sigerson, I wish to speak to you."

He had turned towards the house, but at this he stopped. "You are speaking to me," he observed.

"About my letter—the letter from Major Fallowes," I persisted. "How did you manage to obtain it from Harold?"

"It wasn't difficult," he said, waving a hand in dismissal. "I picked his pocket."

I took a deep breath. "You picked his pocket."

His thin, mobile lips quirked in a brief smile. "Yes, when I helped him on with his overcoat after luncheon. And then, of course, I read the letter, to find out to whom it belonged."

"You—read my letter." I didn't manage to keep my tone as even as I wished.

"It was interesting, and answered some questions I had been harbouring," he said obscurely. "Have you found this Orb of Kezir?"

"It is none of your business," I said, striving to contain my temper, "whether I have found it or not!"

"You haven't, I see." His smile appeared again. "Pray don't let me hinder you in your search. Quite amusing, I'm sure."

"Your feelings on the subject do not interest me in the least," I snapped.

"Very proper." He nodded. "What interests me chiefly at this moment is tea. Is there the prospect of any? I noticed the kitchen seemed deserted earlier."

With an effort, I mastered myself, slipping into the demands of my position. "It is the staff's day off, sir. However, I would be glad to prepare a light repast for you." And season it heavily with the best cayenne pepper, I added bitterly to myself.

"I would not dream of putting you to the trouble." Mr. Sigerson made a creditable bow. "I shall seek sustenance elsewhere, Mrs. Dodson. Good afternoon."

He strode along to the library doors, stepped through, and was lost to sight. The snick of the French doors' lock was clearly audible in the Sunday quiet.

I took my own way in through the kitchen, locking my parlour door behind me with a defiant sniff, and sat down to finish my letter to Stubby. It was no easier than it had been earlier. Now Mr.

Sigerson's annoying ways were jumbled up with Harold's strange behaviour, making it impossible to concentrate.

Sighing, I gave up on my correspondence. Mr. Sigerson's remarks about the Orb of Kezir amounted almost to a challenge, and I could not resist the notion of casually producing the Orb some day, to wipe that knowing smirk right off his face!

But if it was not hidden in any of the secret panels and hidey-holes Stubby had uncovered, where could it be?

I ran the facts through my brain once more. In thinking that he had shown me the hiding place of the putative Orb, Major Fallowes had undoubtedly confused me with his sister, who had kept house for him for nearly thirty years, and might have been supposed to be privy to all his secrets. She had come to him after he'd sold out of the army at age fifty and bought Larchbanks for his retirement.

After all, Larchbanks was not an ancestral home. Major Fallowes himself had perhaps not been aware of all the hidey-holes the house possessed.

There was one place, though, with which he would have been familiar.

I had no sooner formulated the nebulous notion of a possible hiding place than I was out of my parlour, determined to search it without loss of time. The case clock tolled the half hour as I passed through the hall—half past four. Mr. Sigerson's hat and gloves were missing from the hall table. There was, then, no danger of being surprised by him. No doubt he was still commandeering the attention of the local public house.

My slippers made a whispering sound on the hall's marble floor. Approaching the library gave me the strange sensation of *déjà vu*, as if I would find Harold Bagshaw there again when I opened the door.

The library was empty. Nothing appeared changed; heaps of journals and extracts still spilled over desk and table; a line of pipes still littered the mantelpiece; the curtains were still tightly closed against the sun.

But something about the room was not quite right. I paused before approaching the desk, trying to decide wherein the difference lay.

As my eye wandered over the row of pipes, I realised that the atmosphere of the room was uncommonly fresh, holding the moistness of the spring budding just outside the door.

The door! The curtains billowed, and I rushed to pull them open. Both leaves of the French door were set wide. And I distinctly remembered hearing the bolt driven home after Mr. Sigerson vanished into the library that afternoon.

It took but a moment to check that no one lurked, this time, behind the folds of fabric. Whoever had opened the windows had escaped. However, the miscreant had not been gone long. I could hear noises in the shrubbery bordering the side lawn, as though someone forced a passage through the bushes. Without a thought for my thin slippers, I was in pursuit.

I had little doubt whom I chased. "Harold!" I yelled, while I had breath to utter. In a few more strides I was gasping for that precious commodity. My quarry still forced his way through the overgrown yews around us. Years ago this had been a pleasant, sheltered walk for the ladies of Larchbanks. Now the path that twisted through the center of the bushes was barely discernable— and stony; my feet were soon bruised.

The shrubbery made it difficult to see more than a few feet ahead. I caught only fleeting glimpses of the person I had taken to be Harold, and it occurred to me that I might be chasing, not harmless Harold Bagshaw, but some more sinister minion of the criminal classes. Whoever it was seemed disinclined to meet me, and that made me the more determined to force such a meeting.

I could not catch him up. Years of trailing after Stubby had made me fleet, but with him away at school, my endurance was not as good as formerly. I was winded, pursuing mostly from sheer stubbornness. Also, I knew the path we followed ended abruptly at the old stables, deserted now that Larchbanks kept no horses. I

expected to corner the malefactor there, and have the satisfaction of finding out if Harold was behind this latest offence.

Near the old stables, a portion of the wall had fallen down, and I suddenly realised that this was where the unknown intruder intended to quit the grounds. I put on a turn of speed that brought me out of the yews in time to glimpse someone scrambling over the wall.

This person seemed taller and more loose-jointed than Harold, although that was perhaps the result of his all-black clothing. I realised that Harold would have no need to creep into the grounds over a broken wall; he could saunter up the drive at any time without seeming out of place. Perhaps this was the rival apiarist Mr. Sigerson had thought he glimpsed earlier.

I paused for breath at the foot of the wall. My lungs felt totally deprived of oxygen. The blood thundered through my ears, and I contemplated giving up the chase. It seemed clear I could not catch the fleeing form which had scaled the wall so nimbly.

However, I could not abandon the chase once engaged in it. Tucking up my skirts, I clawed at the pile of fallen rock until I straddled the top of the wall, and slithered down the other side.

The wall bordered Stafford Lane, a quiet country road which stretched away, deserted, in both directions.

I let down my skirts, giving a moment's brief thanks that no one was about to witness my undignified descent from the wall. In the muddy verge of the road were the fresh, clear marks of bicycle tyres. The housebreaker had made a swift escape.

I set off down the lane with the best speed I could manage, following the track, noting that it did not branch off. A Sunday afternoon calm garbed the scene, the sunlight slanting in thick slabs through the fresh green leaves of the larches. To the left, the distant, rounded shapes of the Sussex Downs were thrown into relief against the westering sky, their flanks wearing the creeping green kiss of spring. In such a placid landscape, it seemed unbelievable that villainy could occur.

Rounding the bend, I noted without surprise that there was

no fleeing form on the sun-moted road before me. I limped too much to set the kind of pace it would take to catch someone on a bicycle. And if the truth be told, I was growing reluctant to force a confrontation on a person who was so very averse to facing me.

A little further along was old Thurlow's cottage. I would ask if he'd seen anyone pass, and rest my abused feet while deciding what to do next.

Thurlow's door stood open to the mild spring weather. I paused to knock for form's sake on the ancient planks, but my knock never fell. Seated comfortably in front of the fire was Mr. Sigerson, deep in conversation with Thurlow, while the remains of bread and cheese and beer attested to the old gardener's hospitality.

A housekeeper should be healthy and strong, and be particularly clean in her person, and her hands, although they may show a degree of roughness, from the nature of some of her employments, yet should have a nice inviting appearance.

Chapter Seven

M R. SIGERSON'S PRESENCE astonished me. But my arrival appeared to affect him even more. He leaped to his feet. "For God's sake, Dodson! What has happened to you?"

His concern seemed overdone until I looked down at myself. My skirt was ripped, probably from a rough place on the wall. My hair hung around my face in tangled hanks; my stockings were in shreds, and one of my toes throbbed where I had stubbed it painfully on a rock.

"Nothing ails me," I said, resisting when he tried to lead me to the bench in front of the fire. "Has a bicycle passed by in the last few minutes?"

Old Thurlow blinked at me in amazement. "Lordy, Missus Dodson, if nothing ails you now, I'd hate to be by when summat does! What's come of you?"

"Nothing, really," I said impatiently, turning to Mr. Sigerson. "There has been another—disturbance at Larchbanks."

He applied his handkerchief to my face. It came away smeared with blood. I put my fingers up and felt a graze across my cheek. "Don't bother with that. The miscreant is even now escaping!"

"Has escaped." Mr. Sigerson handed me the bloodstained hanky and I pressed it once more to my face. I eased my slipper off, noticing that somehow I'd worn a hole right through its thin sole, and wiggled my throbbing toe. It would mend. "It has been almost ten minutes since a cycle passed here," Mr. Sigerson continued. "I heard its tyres through the gravel, though I did not see it go." He surveyed me with more detachment than sympathy. "What exactly happened?"

"Having occasion to enter the library," I said, wincing as I shoved my slipper back on, "I noticed the French window was open. I heard noises in the shrubbery and followed the sounds, hoping to discover who it was. I did not get a clear sight of the person involved, though my impression is of a tall, lanky, black-clad individual."

"Not Harold Bagshaw, then," Mr. Sigerson muttered.

Old Thurlow pricked up his ears at this. "Nay, then, young Master Bagshaw do be away on the up train."

"You are sure of that?" Mr. Sigerson's brusque way of speaking did not appear to discompose the gardener.

"Daughter and me took our noon bite with old Wilfred Debbins, him what does for the Curtis sisters," he said thoughtfully, rubbing the stubble on his hoary chin. "He lives along of the station. Us went out to see the up train off, and there be young Master Bagshaw, a-leaping on her just before she starts."

"The train leaves at quarter to three." I tried to tuck my straggling hair back into its plait, a singularly unsuccessful task without a glass. My fingers, oddly enough, were shaking.

"Yes, yes, I know," Mr. Sigerson said impatiently. "And there is no other train today, up or down." He strode around the small room, at great danger to my already injured toes, which I prudently tucked under the tattered remains of my flounce.

"I don't like the look of this, not at all." He whirled towards me. "You did, I presume, lock up before plunging into precipitate pursuit?"

My heart sank. He read the answer on my upturned face.

"My thanks for your refreshment," he cried to Thurlow. "Madam, I will send a conveyance for you shortly." Then he was gone.

I stood up on my abused feet, hissing at the pain it caused. But I could still hobble. Send a conveyance, indeed! If it had been unwise of me to try to catch the intruder, it was certainly my duty to resume my station as soon as possible.

Besides, the chase had been exciting; and that excitement had just followed Mr. Sigerson out the door. Like any child of Hamelin, I must follow, too. Leaving Thurlow in loud protests, I set off once more down the lane.

Mr. Sigerson could move with great rapidity. I caught him up, however, at the fallen-down wall, where he quested over the muddy verge like a terrier that smells a rat. Seeing me, he frowned. "You should not attempt this in your condition."

"If I have been remiss in my duty—" I began.

"Fiddle-faddle." He had the grace to look slightly shamefaced. "Ten to one there is no reason to gallop back." He looked at the wall, then back at me. "You came over this way?"

"Following the trail," I said. The wall seemed much taller now than it had when I had passed over it before. I did not like the notion of trying to clamber up with my skirts tucked into my waistband while Mr. Sigerson watched.

"No need for me to do so as well, then," my employer said briskly. "We shall go through the wicket gate."

The gate, old and shabby, had not interested the criminal because it was locked. Mr. Sigerson calmly waited for me to produce my key from the bunch that hung from my belt. I did so, feeling quite foolish, and wondered why it had not occurred to me to use it before.

Mr. Sigerson stopped to study the ground around the pile of stones that marked the ruined bit of wall. "We must see to having this repaired," he said. "I presume the path through the shrubbery is the quickest one back to the house?"

"Yes. But why—"

"There is probably no cause to hasten back," Mr. Sigerson put the lie to his words by striding off through the yews. "But for the truly ingenious criminal, the deserted house presents unlimited opportunity. He draws you off, he circles back, and burgles at his leisure."

"I have never considered Stafford-on-Arun a likely place to find an ingenious criminal," I panted, dodging a branch that whipped back into my face. I had spoken rather loudly to his back; he turned and placed a peremptory hand across my mouth.

"Neither did I when I removed here," he muttered. "Now, silence if you please!"

I followed him through the shrubbery on feet that were mercifully losing all sensation. Mr. Sigerson moved from bush to bush like a Red Indian, making no more noise than the breeze that stirred the unpruned branches of yew. My sleeve brushed the dark leaves, releasing their dusty, spicy scent on the evening air. The lowering sun caught the stone façade of Larchbanks, glittering off its windows, enshrouding the rest of the building in blue shadows. Smoke rose lazily from the kitchen chimney, and I pulled Mr. Sigerson's sleeve, pointing to it.

He nodded. "Mrs. Clithoe has undoubtedly returned from her afternoon out," he whispered, his mouth close to my ear. "If our malefactor did come back, he will be gone by now."

"Then why are we still whispering?"

He put one hand under my elbow and guided me toward the still-gaping library window. "Because," he said in his normal voice, "Mrs. Clithoe might go into another Spasm if she sees you before you have managed to smooth away the effects of your chase. You look as though you'd met the Devil himself."

I preceded him inside the French windows. "Don't be ridiculous." I did not remember my housekeeperly voice; the words came out sharply, as if I spoke to Stubby.

He turned me to face the looking glass over the mantelpiece. "Perhaps you should tidy up a bit before you chance meeting her," he suggested.

I did not, of course, appear blasted by Satan, but my hair had escaped almost totally from its plait, to snarl wildly around my face. My face was scratched, grimy, and streaked with dirt and blood, and my feet throbbed with painful intensity. Suddenly exhausted, I sank into a chair.

"I don't suppose you have such a thing as a comb about you?" Masking my fatigue as much as possible, I straightened my back. I wanted no compassion from Mr. Sigerson, even supposing such a commodity could be had.

"I do occasionally use one," he admitted, "but it is in my dressing room." He treated me to a brief, comprehensive survey. "Wait here."

I doubt I could have done other than wait. The flood of spirits which had kept me on my feet until then had vanished. I nestled more closely into the deep leather of the chair and closed my eyes.

It seemed only seconds before Mr. Sigerson was back with a damp face-flannel, which he handed to me. "Are you capable of using this, do you think?" He retained one corner of the cloth, looking at me doubtfully.

"Of course." He relinquished the flannel, tossing me the hand towel as well, and went to lean against the mantel, watching me with bright-eyed interest.

I suppose it was too much to expect him to give me privacy. I turned my back and washed my face and hands, and felt immeasurably better. I picked up the comb he had put on the table beside me, and eased the pins out of my hair.

There were disquieting overtones of the boudoir in taking down my hair in front of Mr. Sigerson, but my feet felt unequal to

the task of carrying me to my own room until I rested them, even supposing my disheveled state escaped Mrs. Clithoe's attention. And soon, wrestling with the snarls the yews had wrought in my hair, I forgot everything but the struggle to subdue the tangled locks. The process brought tears to my eyes more than once.

The comb was taken impatiently from my hand. "Let me," Mr. Sigerson said behind me. "You are making a mull of it."

"Don't be absurd." I put my hands over my hair and twisted around to glare at him. "I wish you would go away!"

He ignored me. Pulling my hands away, he began to work the snarls out himself. "I cannot stand to see things done badly, Mrs. Dodson, a sentiment I feel sure you share."

His touch was as impersonal as any hairdresser's. By degrees I began to relax.

"This is...totally unsuitable," I murmured drowsily.

"You should not bind your hair away so tightly," was his impertinent reply. "That causes a constriction of the blood vessels that feed the scalp."

"Nonsense." I twisted away before he had finished with the last snarl and did the rest of it myself, though conscious of my employer standing nearby. My hair fought more than usual against being confined. Each individual strand felt separately alive, like some breathing, sentient creature with its own wishes.

Mr. Sigerson, I saw from the corner of my eye, had an irritating, superior smile on his face. I thrust in the pins and put the comb down.

"Thank you," I said stiffly, not looking at him again, "for your assistance. Pray believe I will not be so foolish again—as to leave the doors open."

I glanced at him when he did not reply, surprising a light in his eyes that I knew not how to interpret, though I chose, after a moment's reflection, to call it grudging respect.

I was expecting some brief speech of absolution for my momentary lapse of good sense, some acknowledgement of the pains I had (literally) gone through to pursue the intruder. Instead he

said, reflectively, "I liked your hair better down than up, you know."

"Mr. Sigerson—"

"I am not sure why, though," he went on, and I realised that he had ceased to be aware of me as anything but an audience to receive his conclusions on a subject that had seized his interest. In this respect, he was as bad as Mrs. Clithoe, although not as noisy.

"The whole topic of female adornment," he propounded, beginning to pace around the library, "is difficult to understand. Why, for instance, is one style of hairdressing more acceptable than others at any particular time? What does fashion consist of? Is it not one more manifestation—"

I was not in the mood to listen to this sort of drivel. "If you will excuse me, Mr. Sigerson?"

Unheeding, he looked at me without really seeing. "It would be interesting," he mused, walking around me, "to conduct an experiment—say, leaving the hair down one week, and putting it up the next week. I could make note of my reactions."

I retreated to the door, with him following every foot of the way. "I should have the most strenuous objection to any such experiment," I said, feeling the doorknob behind me.

Mr. Sigerson stared for a moment longer, then seemed to come to his senses. "Naturally," he said, with a shout of laughter. "Don't worry, Mrs. Dodson. I wouldn't scandalise you by such a request, although I have known employers to ask young ladies to do far stranger things with their hair than wear it down."

I began to think the new master of Larchbanks was either deranged or debauched, perhaps both. He must have read my thoughts in my expression.

"Now, now, Mrs. Dodson, I can act the gentleman with the best of them." He bowed with an elegant flourish. "You will find no fault with my behaviour."

"Thank you, sir." I inclined my head and limped out the door with all the dignity I could muster.

Choosing a moment when Mrs. Clithoe's back was bent intently over her pastry, I slipped into my sitting room. It took some time to bathe my feet in the tepid water from the washstand and eliminate all traces of the afternoon from my appearance. I had an unquiet feeling that there were repercussions ahead, not so easily washed away.

Mrs. Clithoe had moved on from pastry to bread when I returned to the kitchen. "That for Squire Rutledge," she muttered, slamming the dough onto the breadboard. "And that for Mr. Bad-tummy Bagshaw." The dough thumped down again. "And that for old Thomas Beddoes."

"Why, what has Mr. Beddoes done?" I turned from filling the kettle with water. "Surely he hasn't tried to chase you around the taproom at the Rose and Crown."

"Not me, Mrs. D," Mrs. Clithoe sniffed, pausing in her punishment of the bread dough. "But that Nancy that waits on the public bar—why, I saw with my own eyes last time I was in to arrange for the ale to be delivered. She come skittering out of the bar, giggling like she was daft, and he right behind her!"

"I cannot believe it of old Thomas," I declared, suppressing a smile at her description. The landlord of the Rose and Crown was a bit too inclined to *embonpoint* to pursue anyone, even supposing Mrs. Beddoes, who kept a sharp eye on everything, would let him.

"Nay, it's true," Mrs. Clithoe said gloomily. "Wickedness, folly, everywhere the men go. Aye, and the boys," she added. "Old in sin, if not old in years."

A little of Mrs. Clithoe in this mood went a long way. I endeavored to give her thoughts another direction, one that might help me find the Orb of Kezir. It had become necessary for me to prove something to Mr. Sigerson. Finding the Orb seemed the best way to prove it.

"You have certainly seen some changes since you first came here. Would that have been near the time Major Fallowes bought the property?"

She gave the dough one last thump and covered it with a cloth. "That's right," she agreed, looking around the kitchen. "I was the second cook they had. First one was some foreign fellow, left an awful mess in the kitchen. He up and left, and Mrs. Saunderson, as was the major's sister, hired me. Nearly twenty-five years gone, it was." She dug a lump of butter from the crock and smeared it around the inside of her bread bowl. "Proper feckless one she was. Good with her needle, mind you, but she couldn't keep order like you can, Mrs. D."

"Thank you," I said absently, turning over this information. "And the house—did Mrs. Saunderson happen to mention if it was furnished when the major took it or did he bring his own things?"

Mrs. Clithoe went into the brief trance that indicated she was searching her memory. "Some of both," she decided at last. "Were you a-wondering about what will be yours in the liberry, ma'am? Seems to me the old major furnished that room from the ground up, as it were. Brought the pieces with him from his travels. All the rooms downstairs had been emptied, Mrs. Saunderson told me, but some of the bedrooms have the same lumber as was here when we came. Original, she called it, and them beds up there are old enough for that."

I nodded. That jibed with my own thoughts about a possible hiding place for the Orb. "Just idle curiosity on my part," I assured Mrs. Clithoe. "When Mrs. Saunderson's daughter is found, she may welcome any history of the house that we can give. She never lived here, I believe Mr. Bagshaw said."

"Nay, that she didn't." Mrs. Clithoe smoothed butter over the top of the dough and tucked it into the bowl, its travails over for the time being. "Grown and gone, she were, by the time the major sold out and retired, so Mrs. Saunderson told us. Gone off to them heathen parts." Mrs. Clithoe sniffed again, making clear her opinion of heathens. "She came back to visit now and again, Miss Patience did—Mrs. Staines, I should say." Her face darkened. "Bringing that—that wicked creature here. The

Devouring Worm, Mrs. Dodson—that's what waits for such as he!"

"Her husband?" I was lost now. "Mr. Staines?"

"Husband!" Mrs. Clithoe set the bread bowl on the shelf above the range forcibly enough that I was amazed it didn't break. "Her husband died soon enough after she married him. Only what you'd expect, and her old enough to know better." Pouring herself a cup of tea, Mrs. Clithoe sat down opposite me at the table, ready to unburden herself of the only family history that counted in her book—the history of iniquity.

"I really don't think—" I began, hoping to escape. It was no good.

"Yes, some sickly old man she married," Mrs. Clithoe went on, magnificently ignoring my feeble interruption. "He was a widower with a spotty lad in tow, and poor Miss Patience—Mrs. Staines, that is—was saddled with the boy after her husband died." She shook her head with gloomy satisfaction. "Only once she brought him along on a visit. Once was enough."

"I should be getting on with laying the table for dinner." I glanced at the watch that hung from its chain around my neck, but Mrs. Clithoe rolled, juggernaut-like, over my words.

"That Percy Staines was a jackal in sheep's clothes! Poor little Mary Judson as was the parlourmaid then—it's a matter of ten or fifteen years ago I'm speaking of, you understand—comes to me in tears, she did. 'Mr. Percy has been behaving that warm to me,' she sobs, 'and I daren't speak to Mrs. Staines, for fear she'll have me turned off.'"

Mrs. Clithoe took a draught of tea and went on before I could interrupt again. "Well," she said with great relish, "I spoke to Mrs. Staines. 'Your step-son,' I told her, 'is poking and prying all over the house, putting the maids in hysterics. Why, I wouldn't be surprised if we found that there pearl necklace of your mother's, that's gone missing, in his valise!' Well, she ferreted around and the next thing I know Mr. Percy Staines is on his way to school and the pearl necklace is back where it belongs."

"Very interesting," I said hastily. "And was there a secret hiding place—something Mrs. Saunderson might have known about—maybe where she kept her necklace?"

Mrs. Clithoe stared at me as if I'd ceased speaking English. "She kept it in her trinket box, o'course. Where else would a body keep a necklace?"

"Where indeed." I rose from the table, wincing only momentarily as my feet took my weight. "You certainly have a good memory for the old days, Mrs. Clithoe."

"And how much longer will it be wanted, I ask you," Mrs. Clithoe demanded. "When Miss Patience—Mrs. Staines—arrives, she'll be selling up Larchbanks, you can be sure of that, and giving the money to those nasty heathens of hers. Devoted to them, she is." She finished her tea and got ponderously to her feet. "Well, mayhap they've done for her, or we'd have her here now." She brightened momentarily before her face fell again. "But then everything will be sold up anyway. I'll have to go live along of Father, and he can be a powerful crotchety old man."

I judged it best to make no reply to this, merely assembling the china and plate to lay for the staff's supper. I laid a tray for Mr. Sigerson, but as the maids were back from their half-day out, I sent Violet to deliver it to the library. When Violet came back after locking up for the night she reported, "Master is still shut up in the library, and you can smell that pipe of his all over the hall."

MY DREAMS THAT NIGHT were turbulent, ending finally in one of those dreary nightmares where I pursued something terribly important, only to have it draw farther and farther away. When I woke, my pillow was damp with tears.

The grey light told of dawn. I arose, stirred up the fire to make a pot of tea, and took it back into my room. I did not wish to see Mr. Sigerson. The very stiffness and soreness of my feet reminded me of the previous day's unsettling events. I stayed sequestered until I heard Mrs. Clithoe rattling the range's lids.

When Violet brought out the breakfast tray she informed me that the master wished to see me. "And a proper taking he's in," she said, tossing her head. "Threw the newspaper on the tray and started to lolloping around the dining room, like he does, you know. 'Tell Mrs. Dodson to step in here,' he barks, not even looking at me. Sometimes I think he's addled in the brain, so I do!"

"That will do, Violet," I said, rising and smoothing my skirt. "I shall attend Mr. Sigerson immediately."

The conjectures that seethed through me left no traces on my face. I limped into the dining room and offered Mr. Sigerson an impassive "Good morning."

"Mrs. Dodson." His voice was brisk and cold, very different from the one in which he had complimented my hair. For a few moments I wondered if I had imagined the whole improbable scene. "Please send my valise up to my room. I shall require a hack from the village to take me to the train which leaves, I believe—" he pulled out a handsome watch on a gold fob "—in three quarters of an hour. I may be gone for a night or two."

I inclined my head, trying not to show by so much as a blink of the eye how odd I found this development. "Do you wish assistance in packing?"

His eyebrows drew together in the quick frown that was characteristic of him. "I prefer to pack for myself."

"As you wish, sir. Will there be anything else?"

He turned away to mount the stairs. "That will be all."

In the kitchen, Rose spelled out stories from the newspaper off Mr. Sigerson's breakfast tray, while Mrs. Clithoe trussed a chicken. Violet was at the back door, receiving the laundry from the village laundress's son. Before young Billy White could whip up his pony, I hailed him and asked him to request Mr. Fenster to bring his hack around in twenty minutes.

"Hack!" exclaimed Violet. "Now what's ado?"

"Mr. Sigerson will be away, perhaps for a day or two," I told her, looking around at Mrs. Clithoe and Rose, who soaked up the news. "Business," I added firmly, to stop the speculation I could

see building in their eyes. "Violet, please take up the clean laundry. Mr. Sigerson may need it."

"Rose is supposed to do upstairs," Violet sniffed, but she picked up the basket anyway.

"Rose can fetch Mr. Sigerson's valise from the box room."

"I will," Rose said reluctantly, tearing herself away from the newspaper. "Sorry, Vi. There's ever so fascinating a story in here."

"What is it?" Mrs. Clithoe came to peer over Rose's shoulder, squinting doubtfully at the words. "My dratted spectacles—" She groped on top of her cap, found them, and perched them on her nose.

"Here 'tis. 'Great Detective Feared Dead,'" Rose said. "'Dreadful Holocaust Destroys Home.' Remember that Mr. Sherlock Holmes we read about last week?"

"Go on, Rosie," Violet said, lingering with the basket. "What does it say?"

"'Mr. Sherlock Holmes, credited with solving untold crimes, is feared to be himself a victim of a cata—'" She glanced at me for help.

I stood beside Mrs. Clithoe. "Catastrophic."

"'—catastrophic explosion that completely destroyed his Sussex home. Mr. Holmes, for some time retired from actively pursuing criminals, may have perished in the blast late Saturday evening. According to Dr. John Watson, his friend and chronicler, Mr. Holmes was threatened recently by the infamous Col. Sebastian Moran, an associate of the late Dr. Moriarty and now a fugitive from Dartmoor Prison.'"

"Very good, Rose," I said absently, ignoring the stumbles she'd made. "Your skills improve daily." I remembered that it was only after looking at the paper that Mr. Sigerson determined to go away. Perhaps something he'd read was behind his precipitous departure, not, as I had assumed, a desire to put distance between himself and his housekeeper. Obviously I gave the previous evening's episode more weight than it carried with him. I resolved, somewhat peevishly, to put it out of my mind forthwith.

The girls went off to do their tasks. The hack appeared, and Mr. Sigerson duly departed to catch the train. It was a relief to have his overbearing personality removed, but it also made the house seem almost too quiet. After he left I took the newspaper to my room for a careful reading, but could find nothing which would make a scholarly bee-keeping enthusiast want to bolt to Littlehampton. It was a puzzle, certainly. And I was determined to solve it.

*If a benevolent desire is shown to
promote [the servants'] comfort, at the
same time that a steady performance of
their duty is exacted, then their respect
will not be unmingled with affection.*

Chapter Eight

JUST BEFORE LUNCH we heard a tap on the kitchen door. Violet
ran to answer it, and lingered on the step, giggling. "Bring the
young man in, Violet," I called.

"How did you know—" Rose began.

"That particular laugh from Violet, and her slowness in con-
ducting the visitor to me, indicate that she is talking to a man,
young and most likely handsome." This prediction was borne out
when Tim White followed Violet in, his cap between his enor-
mous hands, his fair skin suffused with colour. I surmised he'd
overheard my remark. Violet certainly had; she tossed her head
and flounced back to her task of assembling the crockery to lay for
luncheon.

"If you please, Mrs. Dodson," Tim began, staring down at his
worn work-boots. "Mr. Sigerson asked me brother to tell me to
step along of here and see about mending that wall that's fallen
down. Said you could show me where 'twas."

I was pleased at Mr. Sigerson's prompt action, though I could have taken care of the matter myself. I had meant to call Mr. Jackling, the stone mason, for an estimate. Tim White was not the person I would have chosen to mend the wall. "You probably know where it is, Tim," I said. "You showed your friends over it often enough two summers ago, when the damsons were ripe."

He couldn't suppress a grin. "So that's the bit wants mending," he said, relaxing when it was plain I didn't mean to hold a grudge. "Surely be easy getting in there."

"Mr. Sigerson wishes it to be repaired immediately. Can you start right away?"

"Right away?" He couldn't resist a glance at Mrs. Clithoe, who stirred a pot of her gypsy soup, famous throughout the village for its tantalising blend of spices. She had learned the receipt, she confided once to me, from the major himself, who had picked it up during his Indian travels.

"Yes," I said firmly. "Directly after luncheon."

He grinned again, and Violet, beaming, set an extra place.

"I will have mine on a tray in the library," I added. "There are some accounts to go over there."

That was fine with Violet, who would feel an unrestrained license to flirt with me out of the room. She prepared the tray and I carried it out of the kitchen just as they were sitting down to their meal. Tim had confided that Mr. Sigerson wished him to sleep in the groom's quarters over the stable until the work was finished, and I realised that our employer distrusted my ability to hold Larchbanks secure against intruders. That was rather galling.

However, the master's absence gave me another opportunity to search for the hiding place of the Orb of Kezir. My brainwave of the day before had involved the kneehole desk, which I remembered the major telling me had been purchased in Spain shortly before his retirement.

Where better to hide a treasure than the desk one uses daily? I had been through every drawer in the course of my duties, but

now I wondered if there was not another, hidden drawer. Given time, I would find it.

I put my tray down on the table and went to sit in the wing chair behind the desk. Mr. Sigerson's considerable debris, I saw with irritation, had not been cleared away before he left. It is to my mind the height of untidiness to fail to put personal effects in order before going on a journey.

My mission, however, was not to straighten the desk. Indeed, I had an uneasy feeling that no matter how I preserved the appearance of disorganisation, Mr. Sigerson would somehow know instantly upon his return that an alien hand had been among his papers.

It could not be helped. For the moment I ignored the desk top, a polished slab of inlaid oak nearly four inches thick. Down the right-hand side of the desk were five rather shallow drawers; down the left were three deeper ones. The centre drawer was wide, and when I pulled it open, cluttered with pipe cleaners, tobacco pouches, stamps and telegraph forms, and many bits of paper with cryptic words or sentences on them. My sense of honour demanded that I avoid reading these last, even inadvertently. Instead I felt around the sides of the drawer, measured its dimensions with the tape from the housewife on my belt, and compared the measurements with those of the exterior of the drawer. There were no discrepancies.

I subjected each drawer in the desk to the same treatment without success. Frustrated, I gave up for the moment and removed to the table to eat my cooling soup, staring at the desk front as I did so. It was elaborately carved with panels depicting the life of Don Quixote, set into borders of Spanish roses. I realised that I could spend the whole afternoon poking and prodding each carving, without any better success than I had enjoyed so far.

Finishing my soup, I figuratively rolled up my sleeves and got started. I was on my knees in front of the desk, having just finished vetting Sancho Panza's mule, when I heard voices in the hall, and the library door opened.

There was barely time to whisk my handkerchief out of my sleeve and rub industriously at the wood. "I declare, Violet," I said, not turning around, "we may have to find a way to remove the polish you used. This wood is still very dull."

"Excuse me, Mrs. Dodson." It was Rose, not Violet. I got to my feet to find her, looking faintly scandalised, with the new curate in tow.

"Mr. Simms has called," she said.

"How do you do, Mr. Simms." He advanced to clasp my hand. His palm felt clammy. "Mr. Sigerson is from home right now. Is there anything I can help you with?"

"As a matter of fact," he said in his flat, uninflected voice, "my errand is to you, Mrs. Dodson. Miss Hanover wishes to know if she can depend on your assistance in the tea marquee during the church fête." He beamed at me. Rose heaved a lovelorn sigh.

"Yes, of course." I looked at him, puzzled. "I assured her so after church yesterday."

He struck his forehead. "So you did. I have a list, you see, and I forgot to tick you off." He took out a handkerchief and wiped his face. "Quite a hot walk, and for nothing." His small brown eyes peered at me around the handkerchief.

I knew my duty, and I did it, though reluctantly. "Would you care for some refreshment? Lemonade, tea?"

"That would be welcome," he admitted.

"Let us go into the drawing room, then," I suggested, moving towards the door.

Mr. Simms stopped me. "No, no," he cried, "this is so delightful, so reminiscent of one's university days. May we stay right here?" He lowered his black-clad form into one of the leather chairs, still with that broad smile pinned onto his countenance. I handed Rose the tray that had contained my lunch, and asked her to bring lemonade to the library. Her eyes fixed worshipfully on the curate, she backed from the room.

"So Mr. Sigerson must be a man of scholarship," Mr. Simms ventured after Rose had gone.

"The books belonged to my late employer, Major Fallowes," I said, standing with my hands folded over my apron.

"Do, please, Mrs. Dodson, sit down, or I will feel dreadfully ill-mannered," he implored, fixing his eyes on me with an expression that strongly reminded me of Harold Bagshaw. Resigned, I sat, and when it came, dispensed lemonade with as much grace as I could muster, being all impatience to have him out of the room so I could resume my search.

And I was beginning to wonder what dreadful quality of mine prompted the attentions of callow young men. It was difficult to ignore Mr. Simms's determined compliments. After a few of them, I changed my mind and demoted him from resemblance to Harold. There was a knowing look in Mr. Simms's eyes that sat ill with his clerical collar, and the tone of voice in which he uttered his charmless remarks insinuated deeper meanings.

After fifteen minutes I rose. "I am sorry that Mr. Sigerson was out when you called. Unfortunately my duties preclude me from prolonging our chat."

Reluctantly Mr. Simms got to his feet. "Your duties?" He glanced at the desk. "It is too bad that a woman of such elegance and education is reduced to dusting furniture." He strolled over to the desk, eyeing its carvings. "What a hideous piece, to be sure. What in the world is it meant to represent?"

I bit my tongue to keep from ordering him away from the desk. "It is Don Quixote tilting at a windmill," I said repressively. "Spanish work."

"Ugly, none the less," he opined, leaning over to peer closely at the don's mournful eyes. The carving occupied the final panel on the desk front, which I had not yet been able to scrutinise.

"You appear to find it fascinating," I pointed out, shifting from one foot to the other.

"The workmanship is rather good," he admitted, and ran his thumb over the carving. Before I could blink, a little drawer popped out of the edge of the desk's top. It rammed against Mr. Simms's head hard enough to bring a most unclerical oath to his lips.

"Great heavens," I said weakly.

"How clever," he said, straightening and rubbing his head. "You did not tell me the desk had a secret drawer, Mrs. Dodson."

"I did not know." I started forward, but his lanky form was bent over the drawer, effectively screening it from my view. "And besides, it would be none of your concern," I added, goaded. "Pray move aside, Mr. Simms!"

"There's nothing much in there anyway," he said airily, at last stepping out of my way. "Just a letter." I fancied I heard disappointment in his voice, and gave him a sharp look before my gaze was drawn to the folded sheet of paper in the bottom of the drawer. It was not addressed to anyone, so I ventured to take it out and unfold it, expecting a final message from Major Fallowes.

Instead, in an abominable scrawl, were the words: "It wasn't here. Disappointed? S."

I stared at the paper for a few fulminating moments before I realised that Mr. Simms was peering over my shoulder.

"What is it? A *billet-doux* from Don What's-it?"

I folded the paper hastily and thrust it in my pocket. "Nothing so interesting."

The sound of throat-clearing came from the doorway. We turned to see Miss Hanover standing there.

Something about the vicar's sister reminded me of one of the beetles Stubby was forever bringing to my notice. Not that she was fat, glossy, and hard-shelled. On the contrary, she was thin. But like the beetle, she was well-armoured in her high, boned jet collar and sensible, stout leather boots. It was a surprise to see a frivolous pink ribbon adorning her austere black bonnet.

"Excuse me if I venture to announce myself," she said in arctic tones, staring at me, and then at the pocket into which I had thrust the note. "The front door was open, so I walked in. I wonder you are still here, Perry."

"Why are you here?" He looked askance at her. "I thought we were to meet the rest of the fête committee at Mrs. Hodges's for tea."

"It is nearly time. I thought I would step along and make sure you were not detained." Miss Hanover turned her steely gaze from Mr. Simms to me. "But if you wanted to chat longer, Perry, I have no objection. Indeed, I can think of a most excellent topic of conversation."

Mr. Simms showed the whites of his eyes. "Is it tea-time already?" He bounded over to the door. "As my errand here is completed, shall we be off?"

"Certainly." Miss Hanover watched him through the door. "You will excuse me if I snatch your guest away," she said to me. "It surprises me a little that you did not choose to speak to my brother about whatever is troubling you—much more suitable than unburdening yourself to Mr. Simms."

"Having no burdens, I have no need to unburden myself," I murmured in my gentlest voice. Although normally I can ignore Miss Hanover's insinuations, my mood at the moment was less than amiable.

Before she could regroup, Mr. Simms poked his head back through the door. "Coming, Miss Hanover? Your servant, Mrs. Dodson." Suddenly he was all eagerness to leave.

I watched them out the front door, an ill-assorted couple. Miss Hanover obviously thought that I was chasing after her pet curate, whereas I had somehow got the notion he was chasing after me. No doubt we were both deluded.

All thoughts of Miss Hanover fled as I looked at the desk and pulled Mr. Sigerson's note out of my pocket. I poked Don Quixote in the eye, watched the little drawer pop out, and wondered: Had Mr. Sigerson discovered the Orb of Kezir in the drawer? He implied not, in his note, but I found I did not really trust him.

And how mortifying to be cheated of finding the drawer, to have even Mr. Simms put his finger on the right spot through luck, when all my searching had been insufficient to locate it. I pulled on the drawer to see if anything was behind it, but it moved no further than its mechanism had already allowed. There were no discrepancies to indicate a false bottom or side. And indeed, if the

Orb of Kezir existed, it would by the major's description complete-
ly fill—if not overfill—the little space.

I was more convinced than ever that the Orb was a fiction,
created by the major to add spice to his book. If it had at one time
existed, he might have disposed of it elsewhere, and forgot that he
had. Such incidents were not unknown.

All the same, it was too bad of Mr. Sigerson to horn in on the
hunt for my Orb, mythical or not. I fingered the note in my pock-
et, staring down at the drawer.

Then, sitting in the wing chair behind the desk, I took a piece
of the major's cream laid notepaper and scratched out a quick
reply.

"If it exists, I will find it first. C.D."

I folded my note and put it in the drawer, replacing everything
as it had been. Then I went out to see what progress Tim had
made on repairing the wall.

Where a man is the only
male servant, then, whatever his
ostensible position, he is required
to make himself generally useful.

Chapter Nine

B ECAUSE MR. SIGERSON was not in residence, we combined
tea and dinner into one substantial meal. Tim White ate with
great gusto, charming Mrs. Clithoe, who hitherto had lumped him
with the Godless Scamps in her mind.

"Have some more, do," she urged, cutting him a second
wedge of veal-and-ham pie. "It's surely a pleasure to see a young
fellow enjoy his food like you do."

Violet pressed a tray of sandwiches on him as well. "You
worked so hard today," she said, with a reproachful glance at me.
"That wall doesn't have to be finished right away."

Tim bolted another bite of pie. "Mr. Sigerson did say as how
he wanted it done in jig time," he mumbled when he could speak.
"Fact, I think I'll get in another hour before sunset, Mrs. Dodson."

"Must you?" Violet was crushed, but I nodded approval.

"That's a good idea, Tim. Violet will be out before dark to
bring you some blankets for the night."

Violet's eyes gleamed, and mentally I revised that plan.

When twilight fell, I carried the armload of blankets out myself. Tim White stood on a ladder on the road side of the wall. He had made great strides towards finishing his work; already it would be impossible for any but an acrobat to get over the wall unaided.

I put the blankets in the groom's quarters in the old barn, noting with approval that Violet had swept and dusted the little chamber, and went through the unlocked wicket gate to speak to Tim. He had more skill in fitting the stones together than I had credited him with.

"Where did you learn stonework, Tim?"

He came down the ladder, wiping his face with an enormous spotted handkerchief. "Learned in reverse, you might say, Mrs. Dodson." His smile was certainly engaging. "I took down enough walls for me dad to get the hang of how they went together."

I remembered his father's untimely death shortly after I'd come to Larchbanks, ascribed to being caught in a poacher's trap at Arundel Castle.

For a few moments, I watched him work, admiring his easy grace while handling the heavy stones. The evening was sweet with the fragrance of blossoming pear trees, the sky tinted with soft sunset colors.

A stranger hobbled into view around the curve of the road, an ancient who carried a dusty valise. He returned a surly grunt to my cheerful "Good evening."

Something about him kept my eye fixed on him in absentminded scrutiny. Whether he felt my glance or not, he stopped in front of me, changing his scowl into a wheedle.

"Is there a chance you could spare an old man a drop of something wet? I'm fair parched with walking." His voice was a cracked whine. I stared down at him, for he was bent with age.

"Certainly," I said. "Come with me to the kitchen. I suppose you could do with some food as well?"

"Aye," he said querulously, following me in at the gate.

"Let me know when you are finished for the night," I told Tim, "and I'll return to lock the gate." He nodded, and I set off to the house, the old man following.

When we were screened from both wall and house by the shrubbery, I stopped. "I assume you do not actually wish to chance the kitchen," I said, turning to confront the old man. "I cannot guarantee that Mrs. Clithoe would not take a dislike to your present costume."

The old man said nothing for a moment, then laughed silently, his head thrown back. "Well done, Mrs. Dodson!" As he spoke, he straightened until he towered over me. "I did not think even your sharp eyes could penetrate my disguise."

"You will pardon me for asking why you are disguised?"

"No, I will not," he snapped, setting off towards the house. "You women are all alike, always wanting explanations. I wished to be disguised, so I was. That is sufficient."

My employer was, I thought again, a singularly odd man. Somehow, though, I did not resent his sharp speeches as I had Miss Hanover's snide insinuations.

He strode to the library's French doors. I pursued the path that led to the kitchen, knowing that the library was locked, and he would have to wait for me to let him in.

Violet, aggrieved because I had not let her carry Tim his blankets, had left shortly after dinner to take a parcel of mending to her mother, who was to darn some sheets for me. Rose was busy in the scullery. Mrs. Clithoe was setting her bread for the morrow while telling over her litany of sinners. I did not stop, but went quietly through the room and opened the library door.

Mr. Sigerson was already there, sitting at the desk and peeling away the bushy white eyebrows that formed part of his disguise.

"You did not need assistance in entering the house, I see." I should have simply left him alone, but Mr. Sigerson is right—we women always do want answers. I wanted to know what my employer had been up to, and I lingered near the doorway, hoping that he would drop some hint or clew.

"The person who understands locks is rarely kept waiting at

the door." Mr. Sigerson flicked open the valise he'd set before him on the desk. A vigorous rummage produced a small case full of little pots and sticks of greasepaint, spirit-gum, and other components of make-up that heretofore I had associated with amateur theatrics.

He took out a wad of cotton-wool, and with the aid of a small glass in the lid of the case, began removing the appearance of age from his saturnine countenance. "Do you mind fetching a pot of cold cream from my chamber, Mrs. Dodson? This one appears to be empty, and I daren't risk getting it myself for fear of meeting Pansy, or whatever her name is, in the corridor."

"Certainly," I said, making no move to leave the doorway. "I see that you came back on the omnibus instead of the train."

He glanced irritably at the reddish-brown road dust that streaked his left shoulder. "How do you know I didn't come in a waggon or open carriage?"

"Because you were walking from the village," I explained kindly. "A carriage would have brought you to the house."

"Unless," he shot back, "I had desired to approach the house in a less obtrusive fashion."

"So you didn't take the omnibus?"

"I took the omnibus," he snarled, making futile dabs at his face. "The cold cream," he added pointedly, "is in the third drawer of the highboy."

The hall was deserted when I slipped out of the library. I pushed the green baize door open a mere crack. The sounds of clinking cutlery came from the scullery, where Rose finished the washing-up. Mrs. Clithoe, spectacles atop her head, still tolled the list of men for whom hellfire was to be the most pleasant part of their afterlife.

All was secure in the kitchen. I sped up the stairs as soundlessly as possible. It is lowering to reflect that the clandestine nature of my assignment was enormously stimulating. After all, I could with perfect impunity enter Mr. Sigerson's room in his supposed absence.

But in fact, I had rarely done more than glance around the

room to make sure Rose was adequately performing her duties. Closing the door behind me, I stood still for a moment to allow my eyes to become accustomed to the dimness, lit only by fading twilight outside.

This was the same room Major Fallowes had occupied, but how different now was the atmosphere! The major's bedside table had been piled with books and papers, his washstand set out with the various draughts and boluses recommended by Dr. Mason.

Now it was Mr. Sigerson's chamber. And in contrast to the library's overflowing clutter, the room was austere. The dressing-table was bare of anything but a solitary bottle of Macassar oil. When I opened the third drawer of the highboy, I noticed that his linen was in impeccable order. Beside the crisp, folded shirts was another case like the one he had downstairs. In it was a new pot of cold cream.

On an impulse, I glanced in the wardrobe as I passed. Neatly hung suits gave out a faint fragrance of cedar. The top shelf held a row of hats: a bowler, a soft tweed cap, and—incongruously in the country—an opera hat. I had a brief vision of Mr. Sigerson, cloaked and hatted, striding towards Royal Albert Hall through the glittering throng of music-lovers. Maxwell had taken me to the opera on our one visit to the metropolis. I had felt dowdy and provincial amid the well-dressed city folk.

On the floor of the wardrobe I could make out the dark shape of a violin case, and wondered when Mr. Sigerson would play it.

Suddenly feeling that I intruded, I shut the wardrobe. I took a hand towel from the washstand and hurried to the library.

Mr. Sigerson had brushed the powder from his beard and pulled off the wisps of grey hair that completed his disguise. With a few swift movements he wiped off the rest of the greasepaint and accepted the proffered towel.

"Thank you, Mrs. Dodson. That feels much better. Pulling the wool over people's eyes is a damned exhausting endeavor."

Indeed, with the make-up removed he looked tired. "You are back sooner than you expected, at least." I hesitated, but could

not resist a question. "Did you conclude your business so quickly?"

He cocked an eyebrow at me. "Can't you tell by looking, Mrs. Dodson?"

"If I were to guess," I began, speaking over his rather disrespectful snort, "I would suppose your trip to have been an unsatisfactory one."

"You are too damnably acute with your observations," he grunted. "Pray obtain some supper for me, and leave me in peace."

"Certainly," I said, retreating to the door. "As soon as you have returned."

He snapped the case shut. "Mrs. Dodson," he began, and then shook his head. "Of course. I am slow this evening. If you will lock the French doors after me, I will officially arrive."

After locking the doors I retired to the kitchen to wait for my employer's "arrival." Mrs. Clithoe, finished with her dough, occupied the rush-bottomed rocker beside the kitchen fire while she read her Bible, her lips moving as she formed the words. Rose sat near the lamp. In its mellow light, her embroidery needle flashed in and out of the flounce she worked. Violet had not yet returned.

"Well," said Mrs. Clithoe, looking at me over her spectacles. "Could you fancy a bite of supper, Mrs. D?"

"I certainly could." I smiled at her, flooded with the sense of peace and well-being that I generally only felt when my son was with me. No matter for how short a time, the cozy kitchen was my home, and these women, however tenuously, were my kin.

The front door bell jangled.

"There, now," Rose said, putting down her embroidery. "Who ever could that be so late and all? Shall I go, Mrs. D?"

I nodded permission. Mrs. Clithoe, supper forgotten for the moment, went to stand by the baize door, her ear to the crack. "Sounds like a man," she said dubiously.

"Perhaps it is the vicar," I suggested.

"Vicar never comes calling this time of night." Mrs. Clithoe's eyes began to glitter. "Shall I slip around to the stable and rouse up that Tim White?"

"I don't believe that will be necessary."

Rose came through the door, nearly catching Mrs. Clithoe's nose. "It's the master," she said excitedly. "Back so soon, and us with nothing ready for him!"

"Nonsense," I said. "Everything is in order, as always."

"He wants some supper, he said."

I turned to Mrs. Clithoe, to whom the mention of food acted as a tonic. "Why, I can get him as tasty a supper as you'd ask for— some of that veal-and-ham pie, and a morsel of the plum-cake he's fond of." She was already bustling around the range.

I had begun to prepare the tray myself, despite Rose's offer to do it, when the back door burst open and Violet rushed in. Her face was flushed and her eyes were wild.

"Oh, Mrs. Clithoe! Oh, Mrs. Dodson!" She collapsed, breathless, into a chair. "I ran all the way from the village! Oh, I was never so scared!"

"What is it, Vi?" Rose knelt by her sister, rubbing her hands. "Why, you're trembling like anything!"

I unlocked the cabinet containing spirits, and poured a medicinal dose of brandy. Violet's teeth chattered on the glass, but after a few sips she was able to speak coherently.

"It's all over the village," she gasped. "Miss Hanover, the vicar's sister—she's dead! They found her in the church, just after Vespers!"

I clutched the edge of the table. "She was here this afternoon," I said stupidly. "She was fine then."

"What was it? Food poisoning?" Mrs. Clithoe plopped down and fanned herself with her apron.

"She were murdered, they do say!" Violet's eyes were round with fright and another emotion, which I realised was enjoyment. "And—" she paused for maximum dramatic effect "—they found two little puncture marks." She pointed to her neck. "Right here!"

Rose broke into hysterical sobs. "Vampires! Just like in the paper!"

I persuaded Rose into a chair. She was rigid with panic, and

reiterated over and over, "Vampires! No, no!" Her hands made hard fists, which she pounded into the chair arms.

"Rosie!" Violet knelt by her sister, seized with remorse. "Oh, Mrs. D, I'm sorry for coming out with it like that. Poor Rosie always gets so upset!" She took the damp cloth I handed her and bathed her sister's face.

I pushed Mr. Sigerson's forgotten dinner tray aside and set out more glasses. Mrs. Clithoe was ominously silent; a glance at her showed that we would be fortunate indeed to be spared another Spasm.

We were starting the second round of brandy, with no visible calming effects, when Mr. Sigerson strode into the room. "I've been ringing the library bell," he began, then surveyed the carnage with his sharp gaze.

Rose still sat, or rather lay, rigid in her chair, as if hypnotised into a board, her sobs coming with frightful regularity. Mrs. Clithoe muttered darkly, caressing her rolling pin. Violet was distracted between her own excitement and worry over her sister.

"What has happened?"

Turning, I regarded him thoughtfully. "Miss Hanover, the vicar's sister, has died suddenly. While you were away today."

Our eyes met and held, but I could not read his expression.

Method, too, is necessary, for when
the work is properly contrived, and
each part arranged in regular
succession, it will be done more
quickly and more efficiently.

Chapter Ten

THE BRANDY WAS NOT EFFECTIVE in procuring repose at Larch-
banks. Inspired by Miss Hanover's demise, Mrs. Clithoe deliv-
ered a Spasm to end all Spasms. Rose did not relinquish her
hysterics; periodically through the night she broke into uncon-
trollable sobs and screams. Mrs. Clithoe finished off her Spasm
with a final cathartic outburst, and then settled placidly to sleep.
But Rose obtained no such relief. At dawn I sent Tim for Dr.
Mason.

It was breakfast-time before the doctor arrived. After examin-
ing Rose he sank into a chair in the kitchen.

"I'm getting too old to work the night through." He rubbed his
unshaven jowls and placed his bag upon the floor. "I've given Rose
a mild sedative to calm her down, and I suggest you let her go
home for a few days. Mildred Wilkins is a good nurse and will take
excellent care of her girl."

I had already decided that home was the best place for Rose.

"Violet, if you will pack for her? I can send Tim to ask Mr. Fenster to bring around his hack."

"No need," the doctor said, nodding to Tim, who stood near the baize door with one arm protectively around Violet. "I can take her up in my gig."

Violet's tears overflowed again. "Rosie's always bin delicate," she sobbed into an already sodden handkerchief. "She do worry so about what she reads in the paper. Is it the Cowfold vampire, Dr. Mason? Is that what killed Miss Hanover?"

The doctor sighed. "You are speaking great nonsense, young lady. The Cowfold vampire is nothing but journalistic hyperbole. The woman in question was fatally overcome by a spider bite. These things sometimes happen."

"But Mrs. Hodges told me mum—" Violet said shrilly.

"No doubt something of the same kind happened to Miss Hanover." Doctor Mason was firm. "I have not had time as yet to do a full examination. But you can assure your sister that there is no such thing as a vampire. The idea is ridiculous."

Unconvinced, Violet frowned as she went upstairs to pack her sister's things. Tim squared his shoulders and charged off to finish the wall. "And then, Missus Dodson, I'll be mending the lock on the front drive gates. No vampire's going to get in here!"

"I'll just be off to the village," Mrs. Clithoe put in, jamming her hat onto her head and picking up her big basket. "Best get the marketing out of the way early. The bread should come out in a bit, Mrs. D. If you'd see to it?"

There was no use protesting, though I knew she was going more for gossip than the fresh plaice we had planned to serve for dinner. When she had bustled off, the kitchen seemed calm and quiet. I opened the oven to peek at the bread; the golden loaves gave off a homely aroma at odds with violence and death.

I offered Dr. Mason a cup of coffee while he waited for Rose to be ready to leave, and he accepted, settling down at the kitchen table with a grateful smile. "I don't mind telling you, Mrs. Dodson, that this whole thing has me flummoxed."

After filling his cup, I sat down opposite. "Just how did Miss Hanover die?"

Dr. Mason stirred his coffee meditatively. A degree of confidence had arisen between us during Major Fallowes's illness. Despite his bald head and shabby appearance, he was as sharp and up-to-date as any Harley Street man, and a shrewd judge of character besides. He knew I would treat anything he told me as confidential.

"I don't know," he said finally. "Of course, the idea of a vampire is nonsense. She wasn't drained of blood or anything of that nature. However..." His voice trailed off momentarily. "There were the puncture marks."

"You mean—"

"Just here in her neck." He raised one pudgy hand and touched his jugular vein. "Two very neat little holes. And without the stigmata of a poisonous spider. No swelling, no discoloration." He sipped his coffee and put the cup back down. "Of course, she might have had a seizure or some such thing, and the puncture marks mean nothing. I'll find out when I open her up later."

I couldn't repress a shiver. "It's very odd, all the same. Two little marks on her neck..." Something about that bothered me. I pictured Miss Hanover as I had last seen her. "Had she changed her dress?"

Dr. Mason gave me a testy look. "How would I know that?"

"When I saw her yesterday afternoon around three, she had on a high boned collar, black net embroidered with jet beads," I said slowly. "No vampire could have got near her neck."

Dr. Mason was interested. "Her collar was unfastened when I saw her. I never thought to inquire if she was found that way."

"It would take something stronger even than a supernatural influence to cause Miss Hanover to bare her neck."

He pushed away his empty cup. "I think I shall have a word with Constable Ritter." He grimaced. "Better than bringing it up with the squire."

"What has Squire Rutledge to do with this?" The bread

smelled done. I tapped one loaf, found it hollow, and began lifting them from the oven.

"He's Justice of the Peace for the district, you know. Bound to be in charge of the investigation."

"Too bad," I muttered. Squire Rutledge wouldn't begin to know how to conduct a criminal investigation. Not that I did, either.

"Yes, well, perhaps they'll call in Scotland Yard." Dr. Mason eyed the hot loaves covetously. "Beautiful," he murmured. "Mrs. Frawley doesn't bake—she says the village bakeshop does it just as well as she could." He picked up his case and cleared his throat, returning to his previous subject. "I know I can count on your discretion, Mrs. Dodson."

"Of course." I have heard Mrs. Frawley, the doctor's housekeeper, discoursing on her methods in the churchyard after service. It is difficult to feel that a woman who drives her employer to take most of his meals at the Rose and Crown is really doing her job. I wrapped one of the loaves in a clean kitchen cloth and presented it to the doctor.

"Why, thank you," he said, beaming. "I wasn't really hinting, you know."

"Mrs. Clithoe loves to have her bread appreciated," I said, although she had never told me so. "And she always makes enough for a regiment." That at least was true.

"I will certainly appreciate it." Dr. Mason sniffed at the loaf with an ecstatic smile and tucked it under his arm. "It takes me back almost twenty years, before my wife's death. Home-baked bread! This will set me up wonderfully for the postmortem. And as soon as I finish that I can get a few hours of kip. I hope no one decides to break a leg or have a baby today."

Violet supported her sister into the kitchen. Rose was very pale and clutched anxiously at her sister's arm. Perhaps I had been grossly negligent in teaching her to read, since the result had been to throw her into hysterics.

"Doctor Mason wishes you to go to your mama for a spell," I

said, wrapping another loaf and giving it to her. "Please take her
this, if you would like." She held it in her arms like a baby. The
warmth of it, I hoped, would do her good. "You will feel better at
home, I am sure."

"Indeed, Mrs. Dodson," Rose quavered. "I'm sorry to be so
feckless. It—it just seems to come over me, sudden-like."

"Don't worry," I said briskly. "You'll be back at work in no time.
Have a nice rest with your mother, and I'll stop in to see how
you're doing in a few days."

Rose was stowed tenderly in the doctor's gig; Violet squeezed
in to accompany her. The kitchen was suddenly very empty. Ordi-
narily I would have enjoyed a rare moment of peaceful reflection
over my coffee, but the quiet was somehow unnerving. I filled it
by clattering through the plate drawer to prepare a tray for our
tenant, whom we all had come near to forgetting during the long
night's ordeal.

There was no sign of Mr. Sigerson when I mounted the stairs
to his room. The bed was smooth and pristine, as Rose had left it
the previous day.

For a moment I wondered if he had left the house the night
before and never returned. However, his wardrobe was un-
touched. The valise from his journey stood by the door, awaiting
unpacking. I made a mental note to attend to that as soon as pos-
sible, and took the tray back downstairs.

Crossing the hall, I paused outside the library door. Faintly
from within came the regular rhythm of pacing feet.

I tapped. "Your breakfast, Mr. Sigerson."

For a moment there was no reply, although the footsteps
ceased. Then I heard a muffled oath, and the door opened.

"I did not ring for anything. However, you may put it down."

Mr. Sigerson stood aside, and I entered. The room was thick
with tobacco smoke; I nearly choked carrying the tray to the cen-
tre table. Mr. Sigerson strode to the desk, trailing miasma from his
pipe. It was evident from the atmosphere that he had been smok-
ing for some time. I resolved to breathe very shallowly, if at all.

"Pray excuse the fumes of my tobacco," Mr. Sigerson said,

noticing my distress. He flung open the French doors. Fresh morning air came in a blessed flow. "I had recourse to my pipe instead of my bed last night, and as a result the room is rather close."

"I'm sorry that Rose kept you up all night." I set out the coffee-pot, the covered dish, the cup and silver and linen. "She will recuperate from her shock at home in the village. I trust there will be no further trouble."

He waved my words away impatiently. "I have no patience with hysterical females, but it was not the disturbance that kept me awake. There was too much to think about." He passed a hand over his forehead. "I have made little progress, however."

He rested his arm on the mantelpiece, knocking the dottle out of his pipe into the fire—or at least, nearly into the fire. Shreds of half-burnt tobacco drifted to the hearth-rug, joining a considerable dusting of ash and more tobacco already there.

Giving him a wide berth, I pulled open the curtains. Outside was a bright May morning, the breeze seeming straight from the sea. My fingers itched to get the hearth brush and tidy the fire, but that would have to wait until Mr. Sigerson left the room—if, indeed, he ever planned to. With a shabby dressing gown slung around his shoulders, his dark hair rumpled, he had that dug-in look that men get in their contemplative periods.

There are ways, however, of coping with this tendency. "You had no time for your bees yesterday morning." I gazed for a moment out the window toward the orchard. "I wonder if they are missing you."

He scoffed at the notion of bees possessing the higher emotions, but it lacked conviction. Even the most rational creatures will endow their hobby horses with the power to return the love they bestow on them. "It is not that the bees would miss me, Mrs. Dodson. It is my research, which would be invalidated without regular observation and notation. Rest assured that I shall perform that without fail." He packed more tobacco into his pipe. I edged toward the door. "A moment," he said, observing my attempt at departure. "I have need of you, Mrs. Dodson."

"I—beg your pardon?"

He applied a match to the tobacco. "The doctor has just left the house?"

"Quite true." The library's casement window faced the drive. He had observed Dr. Mason's gig pass that way.

"It was the same doctor who has examined the woman—Miss Whoever who has been found dead?"

"He's the only doctor for miles around." I took the cover off the plate. The dish was barely warm. Mr. Sigerson would no doubt forget to eat it, anyway. I put the cover back on. "Shall I remove this for you?"

Mr. Sigerson blew out another cloud of smoke. "Certainly not. I have not yet had any."

"It is no longer hot," I explained. "I will bring you a fresh plate."

"Not right now," Mr. Sigerson said irritably. "I wish you will stop fussing around!" He summoned one quick, chilly smile. "Sit here." He patted one of the leather chairs. "Tell me what the doctor told you. About this Miss Whoever."

I stared at Mr. Sigerson. He was paying more attention to his pipe than to me, but at last he shot a look at me. Brief though it was, it contained all the enormous force of his personality, bent on me like a searchlight. It took a great deal of will to stand up to such scrutiny.

"What makes you think he told me anything at all?"

"The only doctor for miles around is bound to have attended your late master during his illness. He has no doubt come to respect your native but rather limited ability to observe and deduce. It would surprise me greatly if he had not confided to you any puzzling aspects of the affair. I imagine you are used to receiving people's confidences." There was a note of resentment in this last, of which he himself seemed unaware.

He scarcely needed the ability to extract secrets from people, given his compelling methods of directing their behaviour. Was I not here, in the library, instead of starting the day's work? "If, as you say, people tell me things, it is because they can be sure their

confidence will go no further. I do not gossip, Mr. Sigerson." I
picked up the tray. "I will bring you something more appetising
presently."

Not choosing to accept this dismissal, he followed me out of
the library through the green baize door to the kitchen. "I am not
asking you to gossip," he declared, pacing impatiently while I
dumped his breakfast into the scrap bucket and shook the damp-
ers in the range. "I am simply asking you to provide me with infor-
mation—vital information that I must have in order to get to the
bottom of things."

I sliced the day-old bread and put it on the gridiron. "It is cer-
tainly a mystery why you should think yourself required to get to
the bottom of things." Dodging his striding form, I took eggs from
the basket. "But if you will accept advice from your housekeeper,
you would do well to wait for the constabulary to ask your assis-
tance before you offer it."

"It will be too late by then," he muttered, casting himself into
the same chair Dr. Mason had earlier occupied. "There are deep
waters here, Dodson. Very deep." He steepled his fingers together
and did not move, even when I thrust a hot plate in front of him.

"Eat your breakfast now," I snapped, "before it grows cold
again, *Mister* Sigerson." I could not like his calling me "Dodson,"
relegating me to the status of kitchenmaid. And yet I felt that
in his case such usage arose from informality, even from a feeling
of comradeship, rather than a desire to put me in my place as
servant.

A lifted eyebrow was all the acknowledgement I got. Absently
he stabbed an egg. "You have the quality of perception," he said,
leaning over the table. "Tell me, is this death likely to have been
accidental? Is there a chance of its being explained away, like the
Cowfold spider bite?"

"You know of that?" I stood with the kettle poised over the tea-
pot, and looked again at Mr. Sigerson. When in his presence, cer-
tain suspicions I had harboured to myself seemed absurd. And his
insistence on getting to the bottom of things had sounded sincere,

not like a smokescreen for someone who had been murdering a woman whose name he didn't even know.

But how had he known about the spider bite? It certainly wasn't common knowledge.

The kitchen door, one possible escape route, stood ajar. The table where Mr. Sigerson sat, eating eggs with a methodical lack of interest, was between me and it.

"It was an obvious inference," he said, dabbling a toast point in egg yolk. "There was a full account in yesterday evening's *Sussex Journal*. Evidently the woman had been whitewashing the barn loft that day—a common place to find spiders. The venomous grey-hackle spider has been found before in Sussex, as witness your Rangtry's *Fauna of the Downs*. There was characteristic discoloration around the puncture marks. Ergo, a spider bite or bites that, piercing the jugular vein, succeeded in rushing the venom through the circulatory system. If the bitten individual is susceptible to the venom, death in such circumstances is not uncommon."

His explanation sounded cogent. I decided not to dash for the door.

"You can have no pressing duties at this time of day," Mr. Sigerson said, making in this instance an incorrect statement. With Rose gone, Violet no doubt away for the morning, and Mrs. Clithoe gossiping in the village, I had more work than usual to accomplish. There was no use in detailing this for my employer, however. Household work is supposed to happen invisibly.

Mr. Sigerson's brief smile appeared again. "Pray do me the honour to join me in a cup of coffee, Mrs. Dodson."

Though normally the most decisive of women, at this point I found myself uncertain. "I have had my coffee already," I said at last.

"With the doctor, I presume," he said, allowing his glance to dart to the scullery, where two cups from the good service reposed on the drainboard.

Smiling reluctantly, I carried my teapot to the table. "I will take a cup of tea."

As soon as my compliance became clear, Mr. Sigerson retreated into his thoughts again. I stirred the teapot's contents, fetched a clean cup, and sat across the table from Mr. Sigerson. I took care to sit at the side nearest the door.

"No, indeed," he said finally, speaking with decision. "Madam—Mrs. Dodson—I have come to admire your reasoning abilities, primitive as they are, and your intuitive though rather slipshod grasp of the principle of induction. You have no concept of Method, but that would be expecting too much from a female. You observe and often draw the correct conclusion from your observation. Not one woman in a thousand—a million—could have penetrated my disguise yesterday!"

I bit back a retort and poured my tea with composure. It was amusing that he assumed his skill in disguise equal to the scrutiny of a thousand women. I felt he severely underestimated the ability of my sex to notice and classify detail.

"It is for that reason," he went on after a short pause (no doubt waiting for me to commend his talent for deceit!), "that I feel certain that if we put our heads together, we can arrive at a solution for this crime."

"That is surely a matter for the police." I discounted his flattering remarks, but even so they sent a momentary flush of enthusiasm through me. I had no objection to distinguishing myself if it were possible, but it was a far step from finding Millicent Rutledge's rock-crystal brooch, or noticing that an old vagabond's ears were the same shape as Mr. Sigerson's, to apprehending a murderer. "I fear my small gifts, despite your kind praise, are not equal to the task."

"I would not dream of putting you in charge of our investigation," Mr. Sigerson assured me. "But you will certainly make an adequate gatherer of facts to which I can then apply Method. Method, Dodson, is the key to success in these matters. The police, in my experience, totally lack Method."

"You have much experience of murder?" I found Mr. Sigerson's words disquieting, reanimating the suspicions I had

dismissed moments before as absurd. Remembering his mysterious absence the previous day, during which Miss Hanover had been murdered, I pushed my chair a little away from the table, glancing from the corner of my eye to the door, and wondering which kitchen implements would make the best defensive weapons.

Mr. Sigerson did not appear to notice my disquiet. He lifted one hand to his beard and turned a satiric smile on me. "Do you imagine scholarly researchers to be above crime? A stolen thesis, purloined apparatus—it is seldom indeed that the constabulary can unravel such easily deciphered events. Do you find the police particularly effective here?"

I thought of Squire Rutledge, with his bulging piggy eyes and constant attempts to corner female servants. The squire, as far as I knew, did a good enough job with the usual matters of quarrels over land and livestock. But murder had never before come his way in his term as Justice of the Peace.

I said as much to Mr. Sigerson. "I prefer to let those who have some notion of how to carry on go about their business without interference," I added.

He sipped his coffee, one eyebrow raised disdainfully. "I assure you," he said at last, "if three or four pipes of shag have not sufficed for me to see the bottom of this affair, your local squire is unlikely to come at it unaided."

"It remains to be seen," I said. "But at any rate, I have no desire to meddle."

Mr. Sigerson rose and bowed, his expression ironic. "Then you are indeed a most unusual woman, Mrs. Dodson."

He strode out the back door, not knowing or caring that his dressing gown was still draped across his shoulders. I watched him make for the orchard, taking as he went a notepad and pencil from his pocket. Despite the unexplained nature of his excursion the previous day, I felt sure somehow that Mr. Sigerson had not assumed his disguise for the purpose of killing Miss Hanover.

But someone had killed her. When Mrs. Clithoe and Violet

returned, replete with what they were saying in the village, I would know more. Unlike Mr. Sigerson, I had no need to ask for gossip. It would come to me.

For now there was no time to dwell on the possible murderer of the vicar's sister. The housework demanded my attention.

I started by unpacking Mr. Sigerson's valise, refraining virtuously from snooping, not that there was much to be learned from the anonymous piles of his body-linen. I took the empty valise along to the box room, dusted and swept his bedchamber and dressing-room, and gave a sketchy once-over to the rest of the first floor.

From the window above the upper landing I saw Mr. Sigerson inching away from his observation post behind the hedge. The weather had become overcast, with clouds moving in rapidly from the southwest. Evidently the bees would not perform under such circumstances. I had counted on him spending his usual two or three hours, to allow me time to get into the library before he came back. Now there would be no opportunity to sweep up the hearth and clean out the ashes. He headed straight for the French doors, and a few moments later they banged shut behind him.

I decided not to wait for Violet's return before starting to work in the drawing room. I had just picked up a vase to freshen when the doorbell rang.

It was Police Constable Ritter, with Squire Rutledge leering behind him.

A gossiping acquaintance, who
indulges in the scandal and
ridicule of neighbours, should
be avoided as a pestilence.

Chapter Eleven

I TOOK THE SQUIRE AND Constable Ritter into the drawing room, where Ritter came right to the point.

"Miss Hanover's death," he said, consulting his notebook. "Information has been received that she came here yesterday afternoon."

"Yes." I stood with my hands folded. "Mr. Simms called about the church fête, and Miss Hanover came in a little later."

Squire Rutledge interrupted, bouncing on his toes in his excitement. "Think carefully before you answer, Mrs. Dodson. This is a serious matter, you know. Murder's a capital offence."

"And do you suspect me of having murdered Miss Hanover?"

The squire looked away, his red face growing even redder. "Not exactly," he muttered. "But it's well known there was bad blood between you. You want to be very careful, Mrs. Dodson. Might be wise for you to have a friend at court, hey?"

I deflected his lecherous gaze as best I could by shifting my

attention to P.C. Ritter. "Did you see Doctor Mason this morning?"

"Not yet," Ritter smiled at me sympathetically. I had always thought him a cut above the usual village policeman, both sharp-witted and compassionate in executing his duties. He had worked for a time in the metropolitan force, returning to Sussex a few years earlier so his wife could tend her aging mother, who had since died. "I mean to stop in later for the autopsy report."

"Who discovered Miss Hanover's body?"

"The verger," Ritter said amiably.

"We'll ask the questions," the squire roared at the same time.

"If you have questions I can answer, you're assured of my assistance." I ignored the squire and spoke to Ritter.

He managed, with a shrug and pursing up of the lips, to indicate his opinion of the squire's interference. "Thank you, ma'am. Really we have nothing to go on. I'm just checking into the victim's movements." He sniffed dolefully and reached inside his tunic for a peppermint, speaking rather indistinctly around it. Mrs. Ritter had, I had heard, forbidden him to smoke any more after nursing him through a hacking cough the previous winter, and now he was rarely without his bull's-eye.

"Best call in Scotland Yard at once, I'm thinking," he said. "I've worked up in London, you know, and that's what we would have done. Request the Yard to take a hand before all the clews get mucked over."

"Nonsense," Squire Rutledge said testily. "Those Yard people would just get in the way. You listen to me, Ritter, and we'll capture the culprit all right." He made a peremptory gesture towards the door. "Why don't you let me question Mrs. Dodson? I feel sure she'll be more comfortable unburdening herself with me."

After a few more skirmishes of this nature, he allowed P.C. Ritter to get on with his questions. Ritter wanted to know how Miss Hanover had seemed the day before, and I replied truthfully that she'd only stopped in for a minute, to collect Mr. Simms for a meeting, and I hadn't exchanged more than a few words with her.

"But," I concluded, "perhaps you've already spoken to Mr. Simms, and to Mrs. Hodges. The meeting, I believe, was at her house."

"I haven't spoken to them yet," P.C. Ritter said, snapping his notebook closed. "Squire insisted on coming here first."

"Highly suspicious, if you ask me," Squire Rutledge said importantly. "Woman comes to see someone she doesn't half dislike, and a matter of hours later she's dead."

I directed a look of disgust at the squire. "Your constable is correct, Squire. Scotland Yard is better equipped to deal with this sort of thing than you are." I turned back to Ritter. "Miss Hanover was wearing a high boned collar, black net embroidered with jet beads. Doctor Mason and I wondered whether the—injury had occurred through the collar, or whether it had been unfastened. And if so, when."

Constable Ritter was interested. "Have to check with the verger," he said, crunching away at a peppermint. He glanced around the room. "I suppose I should speak to the master of the house."

"I don't believe he ever met Miss Hanover. He was out yesterday when she called." Why did I bother to shield Mr. Sigerson? I could not say. The words had spilled out without my volition.

"Just the same," Constable Ritter said stubbornly. "I'll need to hear that from him, if you please, ma'am."

As I had surmised, Mr. Sigerson was in no mood to talk to the police.

"I do not wish to be disturbed," he growled, after I had tapped at the door.

"Police Constable Ritter and Squire Rutledge have called," I said through it, "and wish to speak to you about Miss Hanover."

Mr. Sigerson threw the door open. Once more tobacco smoke blanketed the air. "Good God, I never even met the woman." I continued to stand there, and at last he shrugged. "Very well. Lead me to them. But wait—" He rummaged along the mantelpiece and came up with a pair of spectacles. "I can at least enliven the

proceedings a bit." He turned away to don the spectacles, and turned back to me with a smile. "How do I look?"

He appeared to be a different person, a shambling, stooped figure with untidy hair, whose short-sighted peerings had all the abstraction of the lifelong scholar. He flung off his dressing gown, draping it over a chair, and replaced it with a shabby smoking jacket that he unearthed from beneath a pile of newspaper.

"You do not look at all the same," I replied truthfully.

"Good," he said, waving his pipe. "A penchant for disguise, Dodson, gives even the dullest event a more pleasing aspect."

I led the way from the room, wondering what the newly developed science of psychology would have to say about Mr. Sigerson's compulsion to assume false identities.

Throwing open the drawing room door, I ushered Mr. Sigerson in. I should have left the room, but no consideration of my station could have dragged me away from the pending encounter between Mr. Sigerson and the squire. I stood in the doorway, head meekly bent, as if awaiting further orders.

Squire Rutledge thrust his hand toward Mr. Sigerson. "Don't believe I've had the pleasure," he grunted, taking in the ash-flecked smoking jacket, the flashing eyeglasses and air of bemusement. "Sigerson, eh? Any kin to the Norfolk family?"

"Hey?" Mr. Sigerson thrust his pipe into his pocket and cupped one hand behind his ear. "Pardon me, sir, I am rather deaf. You are the police constable?"

"No, no." The squire drew himself up importantly. "I am Squire Rutledge, Justice of the Peace. This is P.C. Ritter." He looked Mr. Sigerson up and down once more, and his lip curled scornfully. "Haven't seen you about in the village."

"No, no," Mr. Sigerson said, staring vaguely at the constable, and then around the drawing room, as if unsure where he was. "I don't go about much, that's true. I have my books—books, you know, and bees." He pulled the pipe out of his pocket and gazed at it as if he'd never seen it before. "You wished to ask me something?"

Constable Ritter cleared his throat and spoke with the lack of expression that denoted his official voice. "Questions concerning the demise of Miss Evaline Hanover, who visited this house yesterday shortly before dying in suspicious circumstances."

"Dear me, dear me." Mr. Sigerson turned to me, lifting helpless shoulders. "Did I know Miss—Miss Whoever, Mrs. Dodson?"

"No sir, you did not."

"Yes, of course," he said with relief, putting the pipe between his teeth and speaking around it. "I didn't think so."

"Were you here when she called yesterday?" Constable Ritter plowed doggedly through his questions, pencil at the ready, another peppermint tucked into his cheek.

"Yesterday." Again Mr. Sigerson turned to me. "Really, I don't... Was I here yesterday, Mrs. Dodson?"

"No sir, you were away for the afternoon." It was an effort to hold my voice steady.

"Of course, of course." He took the pipe out of his mouth and smiled at Squire Rutledge. "Wonderful woman, Mrs. Dodson. Knows everything, you know."

"Where were you, Mr.—Sigerson, if you don't mind my asking?"

Mr. Sigerson cupped his hand around his ear, and Constable Ritter repeated his question, watching Mr. Sigerson closely. His scrutiny should have reanimated the doubts with which I had previously regarded Mr. Sigerson. I did not, I now discovered, want to believe that my employer merited police suspicion.

"Where was I? Let me see..." Mr. Sigerson was evidently not willing to let me answer this question for him. "Books—that's it. A sale of books in Suffolk—I hoped to find that edition of *Religio Medici* I've been looking for." He turned to me, as if for confirmation. I thought I saw the ghost of a wink behind those abominable eyeglasses. "Yes, of course. And I missed the train back...had to take the omnibus...it was rather late when I returned."

"Did they have the book?" Constable Ritter appeared fascinated by this tale. He stared in a dazed sort of way at Mr. Sigerson.

"No, alas. After all that trouble…" Mr. Sigerson looked into his pipe, found it empty, and put it back in his pocket. "Is that all, gentlemen? Because I am engaged on a tricky bit of translation just now—"

"Yes, yes, that's all." Squire Rutledge was obviously bored. "Damned fellow doesn't know anything except books," he whispered loudly to Constable Ritter, secure in his victim's supposed deafness.

"Books, that's right. Books and bees, I'm afraid, are my hobby horses. I'm fortunate to find such a lovely place to pursue my little recreations." Now that Squire Rutledge was routed, Mr. Sigerson seemed determined to pepper his rearguard with words. "Have you any knowledge of bees, Mr.—Er? Fascinating, aren't they? I could tell you—"

"Some other time, perhaps." The squire made for the door as fast as he could. "Right now, we must get about our investigation. Come along, Ritter. I told you it would be a waste of time coming here. We should have spoken to Mrs. Hodges first!"

Constable Ritter, behind the squire's pudgy back, allowed himself a grimace of resigned patience. I followed Squire Rutledge out the door. To my surprise, Constable Ritter didn't come along. I heard him address an urgent query in an undervoice to Mr. Sigerson. I did not hear my employer's reply.

The squire lingered at the front door. "If we call in Scotland Yard, madam," he hissed at me, red-faced, "I know who'll be at the top of their suspect list. You'd better be nice to me if you don't want a lot of detectives poking around here."

As he spoke, he seized my hand, trying to pull me closer. I shook off his grip rather easily, thanks to a skill learned when Stubby was taking a correspondence course in Jujitsu.

"You make yourself ridiculous, sir."

He bridled for a moment, then changed his tactics, pinning a wheedling smile onto his jowls. "Why you want to work for that moss-backed scholar when you could be having some fun whipping my place into shape, I don't know," he said with ponderous

playfulness. "I could certainly do with your—talents—at the Hall."

I dropped him a sarcastic curtsey. "I don't feel up to the struggle," I said sweetly.

Constable Ritter came out of the drawing room, followed by Mr. Sigerson, who directed one of his searching looks between myself and the squire. It was out of his character as a doddering bookworm, but Squire Rutledge didn't notice it.

"Come along, Ritter," he said importantly, and led the way out the door. With a last, meaningful look at Mr. Sigerson, Constable Ritter followed him.

I shut the door and turned to face Mr. Sigerson. His head thrown back, he was enjoying a silent laugh.

"I doubt if your Squire Rutledge will bother me again," he remarked at last, taking off the spectacles and beginning to fill his pipe from the pouch in his pocket.

"I wish I could say the same," I muttered.

He glanced at me from under his brows, one of the lightning-like flashes that seemed to comprehend everything. "He appeared to be trying to hire you away from Larchbanks, Mrs. Dodson."

I did not deign to reply to this. Only a fool would have left the relative security of Larchbanks to work for such as Squire Rutledge. I am far from a fool.

However, I did resent, even fear, being dependent on the puny rewards of my labour to take care of my son. Public schools of the sort that young Max should attend do not come cheap. Most of my salary went to keep him there, and what was left, no matter how frugally I saved it, did not yet amount to enough to purchase my independence. I coveted the money I could receive from selling the contents of the library, but the sensible side of me recognised that continued long-term employment with Patience Saunderson Staines, the major's niece, provided more security than any inheritance. If she could not be found, the future was not clear. Such as Squire Rutledge might lurk ahead of me, whether I willed it or no.

"Will you go?" There was an intentness in Mr. Sigerson's voice that brought me out of my musings.

"Go?"

"To work for Squire Rutledge."

I stared at him. "Because of Major Fallowes's kindness, I am entitled to retain my post, at a generous salary, for at least six-months' term. Did you wish to install someone else as housekeeper, Mr. Sigerson?"

"Don't be absurd," he snapped. "I meant—oh, never mind. I merely wished to be assured that I should not need to find another housekeeper during my tenancy here."

"There was never any danger of that," I said.

"That's all right then." We gazed at one another for a moment or two, and then he went into the library and closed the door. I went into the drawing room to continue my interrupted tasks, but I must confess that I stood with a vase of flowers in my hands for untold minutes before I remembered what I was supposed to be doing.

Friendships should not be
hastily formed, nor the heart
given, at once, to every
new-comer.

Chapter Twelve

A ND SALLY WHITE DID SAY as how she saw a Black Shadow creeping out of the church, soon after Vespers!"

Violet flapped her duster for emphasis. She had returned from escorting her sister home, big with news that she'd managed to gather on the walk back.

"Probably the vicar," I said prosaically. "Please use the duster on the mantelpiece and not in the air, Violet. Those ornaments appear untouched."

Violet scarcely heard me. "And Clarice Barlow said Mrs. Hodges said that Miss Hanover was going all queer in her head the past few days. Mrs. Hodges said she stepped up to the vicarage yesterday morning and found Miss Hanover in the parlour with one of the lace curtains wrapped around her head, rolling up her eyes in the mirror as if she was in a fit!"

I might have reproved her for such an orgy of gossip; but despite my avowed lack of interest, I was storing up nuggets of

information as a mouse stores seeds for winter. Not, I assured myself, that I intended to gratify Mr. Sigerson by passing along my accumulated hoard—at least, I did not think so.

But despite the sketchy nature of Violet's work, my heart was not in my reproofs. What were dust and withered flowers compared to sensational death? And some small part of me still wondered about Mr. Sigerson. The intent scrutiny Constable Ritter had given our tenant, not to mention his still-unexplained absence at the crucial time, provided food for thought. I did not for one moment believe his tale about a book sale. I wondered if Constable Ritter did.

"A lace curtain," I said absently, noticing Violet's expectant gaze. "That does sound strange."

"Bride of the Devil—that's what Mrs. Hodges thinks," Violet said, shuddering with shocked delight. "Who would think we'd ever have such a one in Stafford-on-Arun!"

"Who, indeed!" I smothered a laugh. "Mrs. Hodges is talking more nonsense than the newspapers."

"She were talking *to* the newspapers," Violet explained. "The Rose and Crown is just packed with newspapermen. Even some from London, there are!"

"How upsetting."

Violet did not look upset in the least. In fact, her eyes held a familiar gleam.

I hastened to give her thoughts another direction. "Just as well we will all keep close to home. I know a good, upright girl like yourself doesn't want to be accosted by a pack of vulgar journalists." Her face fell, and I added craftily, "Tim can keep them out, if they venture here."

The thought of Tim, nearby and handy, as it were, gave Violet the strength to totter out to the ashheap with the cleanings from the drawing room fire. I left her to it, while I braved the library. Mr. Sigerson was upstairs enjoying the convenience of the bathroom Major Fallowes had installed. I hoped for twenty minutes or so to put things to rights.

I had no sooner set the French doors wide to drive off the last traces of the strong shag tobacco Mr. Sigerson smoked, than I perceived Mr. Simms hurrying down the drive to the house. Spying me at the same time, he changed his course towards the library windows.

"Mrs. Dodson! I called to see how you are bearing up under this—this unbelievable thing!" He came into the room, taking my hand for an obligatory squeeze, and casting himself into a chair. "It has really quite overset me! I'm not at all myself. Poor Miss Hanover. Such a shock!"

Indeed, he looked pale, and drops of sweat stood on his brow. "You have walked too quickly from the village, Mr. Simms," I said, stooping to pick up one of the newspapers that littered the floor. The Sussex Vampire, I saw at a glance, had been given excellent play, thanks to that modern invention, the telephone. Some enterprising journalist must have discovered the instrument at Arundel Castle. One of the newspapers had even included a map, with Stafford-on-Arun indicated by a small black arrow.

"It's the shock," Mr. Simms said in a failing voice. "The Evil One…here among us—"

"I'm sure there's no more scope for the Evil One here than in other parts of England."

Mr. Simms glanced away. "But surely you don't imagine that some human agency is at work here. After all, the vicar's sister!"

"I have no patience with such nonsense, Mr. Simms."

He blinked several times. "You must be right," he said at last. "Of course it was some kind of unfortunate accident. I do not know why I feel so overcome." He groped in his pocket and pulled out a small flask in a movement so automatic I supposed he often had recourse to its contents.

But not today. Finding the flask in his hand, he started and looked at me. "Ha ha," he said nervously. "Not the best thing for a clergyman." He put the flask away, and I saw that his hand shook. "Perhaps, if I might have a glass of water—"

I rang the bell, but no one answered. Mrs. Clithoe had not yet

returned from the village, and Violet was probably lingering over her task, hoping to sight her cavalier in the grounds. "One moment," I told Mr. Simms. "I will procure you a drink."

I hastened to the kitchen, wishing that I had kept up the major's custom of having a jug of water placed with the brandy decanter daily. After the previous day, I did not really trust the curate alone in the library. His discovery of the hidden drawer had come very pat.

And indeed, as I paused at the library door with a glass of water on a tray, a dramatic tableau was enacted before me. Mr. Simms knelt at the side of the desk, staring up in paralysed wonder at Mr. Sigerson, who stood, his hair still wet from his bath, with a weighted walking stick pointed menacingly at the curate. From the tip of the stick, a slender, glittering blade protruded.

"Gracious, Mr. Sigerson!" I put down the tray, not knowing whether to laugh at the comical expression of terror on Mr. Simms's face, or to sternly order my employer to behave.

"How comes it that this fellow is left to make himself at home in my library?" Mr. Sigerson's voice was sharp.

"He said he was faint."

Crouched by the desk, as if interposing its bulk between himself and my employer, the curate quaked visibly.

"He might have been after my notes! Did you not think of that?" Mr. Sigerson pressed a button on the walking stick, and the blade whispered out of sight. "I have told you, Mrs. Dodson, of the importance of my research. And yet, you let any Tom, Dick, or Harry into the library the moment my back is turned."

"Mr. Simms is not after apiarian glory," I said slowly. Enlightenment began to break. If what I thought was true, I had been embarrassingly slow to see it. "Are you, Mr. Simms?" Advancing, I fixed the curate's shifty gaze with mine. "You are looking for the Orb of Kezir, are you not?"

He burst into fevered denials. "I don't know what you're—the Orb of what? Really, Mrs. Dodson, you are imagining—"

Mr. Sigerson thrust himself forward like a hound that scents

the quarry. He pulled Perry Simms to his feet and deposited him in a chair. The man's face was pasty with fear and chagrin; his hands clutched and writhed together in his lap. For a moment I was afraid he would lose consciousness, and wondered at his reaction.

"Now then," Mr. Sigerson said, almost genially. "Make yourself comfortable for the inquisition." He turned to me. "What are your reasons for the accusation you have leveled, Dodson? Knowing you, I would assume them to be cogent."

"I should have seen it much sooner." I felt mortified by my lack of perception. "When he found the secret drawer like that, right away. It was far too easy to be coincidental."

"So he found it, did he?" Mr. Sigerson regarded the curate with interest. "To what do you ascribe that, Mr. Simms? A flash of precognition?"

Perry Simms's lip curled. "You are making up fairy tales, both of you," he spat. "I wish to leave now."

Mr. Sigerson's walking stick restrained him when he tried to arise from the chair. "Not just yet," he said softly. The thin smile and the hooded gaze that accompanied his words were enough to make Mr. Simms settle back into the tufted leather, shifting uneasily. "Mrs. Dodson has not finished drawing her conclusions."

"There is little to draw," I said unhappily. "Mr. Simms paid a totally unnecessary call on me yesterday. He put his hand on the catch for the secret drawer while pretending to admire the carving. I suppose, since it was empty—"

"Relatively empty," Mr. Sigerson said. Only the faint twitch of his lips showed his amusement.

"Relatively empty," I agreed. "At any rate, he seems to have decided to attempt further searches. But how did he know where to find the catch of the drawer? No one else in the house did." I fell silent.

"What is it? What have you remembered?" Mr. Sigerson watched me with the same intent gaze he bent on his bees, as if I, too, were an experiment, a human grappling clumsily to put two and two together.

"Mrs. Clithoe," I said slowly, still feeling my way. "She was telling me about Patience Staines, the major's niece. Patience had a step-son, she said, a spotty boy named Percy who'd caused trouble with a housemaid when he'd visited here ten years ago." I could tell by the trembling in the curate's hands that I was on the right track. "You are Percy Staines, not Perry Simms." My eye fell on the three volumes of Major Fallowes's autobiography, nicely bound in calfskin and displayed in a place of honour on the library shelves. "You saw the publication announcement of your step-mama's uncle's memoirs and obtained the volumes, hoping to gain some advantage. The mention of the Orb of Kezir brought you here, did it not? Are you in fact a curate, or did you hoodwink the vicar?" Reverend Hanover was rather credulous.

"None of your business," Percy Staines said, an uneasy sneer on his face.

"Forged papers, I suspect," Mr. Sigerson said. "The easiest thing in the world, Dodson, to graduate from any number of distinguished institutions without actually bothering to attend." He swung around to his captive, forestalling Percy's attempt to rise. "Did Mrs. Staines tell you of the secret drawer in the desk?"

"I saw the old major use it when I was visiting," Percy muttered. "I never saw the Orb, but my step-mama told my father about it once, and I overheard."

"An expert snooper and eavesdropper, it seems," Mr. Sigerson murmured.

Percy glared at him. "The Orb should be mine, since I'm the closest to an heir my dear step-mama has."

"In fact, it was the major's to dispose of, and he disposed of it otherwise." Mr. Sigerson's voice was brisk. "Good work, Mrs. Dodson. A nicely reasoned piece of deduction."

"Sheer guesswork," I protested. "And it gets us no nearer to—"

I had not meant to say so much, at least not in front of our miscreant. "So you have not found it either," the false curate said. "It should be mine!"

"It would not be yours in any case," Mr. Sigerson pointed out, "since your step-mother is not yet known to be dead."

Percy sprang from the chair and this time Mr. Sigerson made no move to stop him. He strode to the door and turned, his mouth twisting unpleasantly.

"She is dead, you know," he said. "She must be. It is more than two years now since the Boxer Uprising, and nothing's been heard of her. When this place is sold up and you—" he directed a venomous glare at me "—are out on the street, I'll be sitting pretty. She's dead, and it's all mine!"

With that, he left.

There was silence for a moment. Mr. Sigerson selected a pipe from the mantel and filled it with tobacco.

"Should you have let him leave?" I watched from the window as Percy hastened down the front drive. "He is perpetrating a fraud, after all."

"You will inform the vicar of your deductions, and Mr. Staines will receive his due." Mr. Sigerson's words were muffled around the stem of his pipe. The odour of tobacco drifted through the room.

"If he remains here to receive it." I dropped the curtain and turned to face Mr. Sigerson. "In his place, I would be planning to take the next train."

"He will not get away," Mr. Sigerson said calmly. "You have only to drop a hint to that excellent fellow, Constable Ritter. He'll take care of it."

"You seem to have a higher opinion of the police than you did earlier," I snapped. "Why don't you find your constable? I have work to do."

"I do not leave the grounds." Mr. Sigerson was suddenly, quietly implacable. He flung up a hand when I would have spoken. "Suffice it to say, Dodson, that I have my reasons. If you will not go to the village, Tim White must carry a message." He paced over to the mantelpiece, taking up his usual position against it. "It's unfortunate that the telephone has not yet found its way to Stafford-on-Arun."

"Since we have not the new-fangled luxuries to which you are accustomed, we shall have to make do as we always have," I returned. There was no excuse for my peevishness except that the incidents of the past few days had been quite upsetting.

To soothe myself I went mechanically around the room, picking up all the newspapers and piling them on the divan to remove to the kitchen.

"Is your false curate right about being Mrs. Staines's heir?" Mr. Sigerson removed his pipe and gazed directly at me.

"I have no idea." I straightened a mass of books on the round table. "It makes no difference, anyway. In default of Patience Staines turning up, or heirs of her body only, the estate will be sold and the proceeds divided among several charities."

"And where does that leave you, Mrs. Dodson?"

I turned away to reshelve books that were stacked on the floor. "I cannot conceive of it being any concern of yours, sir."

I heard his impatient exclamation. Rapid footsteps paced across the floor. His hands on my shoulders whirled me away from the bookshelves. His eyes looked into mine. "Where does that leave you, Dodson?"

"Thanks to your tenancy, it is academic for the next six months." I shrugged away from his grasp and that piercing stare, picking up the stack of newspapers. Something in the way he stood, rigidly puffing his pipe, made me add, "I am sure I shall find a new position rapidly when it becomes necessary."

"And perhaps if you had the Orb of Kezir, it would be unnecessary," he growled around the pipestem. "Oh, put those things away and sit down." He wrested the newspapers from my grip and seated me in the same chair as Percy Staines had occupied.

"Are you going to interrogate me next?"

"Don't be ridiculous." *The Times* on top of the pile caught his eye. "Ah, the Agony Column. I have not yet read it." He scanned the paper intently. "There is more communication among the criminal classes this way than any other," he muttered, before tossing the whole pile of newspapers behind him, creating a veritable sea of newsprint on the carpet.

"Really, Mr. Sigerson—" I started to get out of the chair he'd put me in, but he held up a peremptory hand.

"A gentleman never interrogates a lady, but I do ask you to grant me the courtesy of a few minutes of your time." Once again his lips twitched in the gesture that passed, with him, for polite amusement. "The fact is, this whole business has greatly discomposed me."

"You mean Miss Hanover's murder?"

"Of course. What else should I mean?" He gave me a puzzled look, and I dropped my eyes. "I suppose the village is crawling with the minions of Fleet Street and other sensation-seeking ghouls."

"According to Violet, the newspapermen are in full force. She did not mention ghouls."

He stood for a moment, his head bowed, fingers steepled. "Nothing could be more inconvenient," he muttered.

"You are thinking, perhaps, that some of your apiarist rivals may get wind of your presence here. Is that why you do not leave the grounds?" I concealed my own amusement. "They would only know of your presence if they were interested in vampires as well as bees. Or perchance they are vampires."

He looked up, his rare smile flashing out. "You would be surprised, my dear Mrs. Dodson, at the accuracy of that characterisation. But no, I was thinking of something else." His gaze withdrew again, becoming grave and inward. "I fear—I very much fear—that danger, evil, is approaching Larchbanks."

"But—" I shook my head. "This must be a product of your nervous condition," I ventured soothingly. "There is no danger."

"A woman has died," he said, his voice level. "Can you be so sure that a second death will not follow?" He stepped closer, and I could feel the intensity of his gaze. "I want you to promise me that if I so indicate to you, you will take the servants and go."

"Go?" A strange weakness invaded my lower limbs. The mesmeric force of his gaze held me motionless, nearly incapable of thought. "Go where? And why?"

"Where? That is the question." He turned away, releasing me from that brief bondage, and refilled his pipe. "What place is safe, if the very sanctuary of the church has been invaded?"

"Perhaps you should lie down for a little while," I suggested. The melodramatic words, uttered in that calm, reflective voice, made the hairs rise on the back of my neck.

"Nonsense." He swung back to me, puffing away at his pipe, a strange smile on his lips. "I see you fear for my reason, Dodson. It is no such thing. I assure you, I am wide awake to all the implications of the past few days. You will take the other women and go to Thurlow's cottage. That will be the best place. No one would think to look for you there."

"This conversation is pointless." I dashed a lock of hair out of my face. "The only way I could be persuaded to leave my post and my duties would be if…"

"If what?" He was watching me closely, puffing all the while on his noxious pipe. I longed to yank it away from him and cast it into the fire.

"If, for instance, your rather cryptic utterance just now indicates your fear of your own actions, Mr. Sigerson." I drew myself up, one hand clutching the carved oak Bible stand for support. "You have reason to believe, perhaps, that in a moment of mania you have caused Miss Hanover's demise. Fearing that your mania will overcome you here and endanger the servants, you have concocted this scheme to try and avoid another tragedy."

After a moment of stunned silence, Mr. Sigerson's shoulders began to shake. He was laughing! Tears streamed from his eyes; he had recourse to a large handkerchief to wipe them away.

"Capital, Mrs. Dodson!" he cried when he could speak. "That is certainly one theory to account for my actions. It is not, fortunately, the correct one, but very imaginative, indeed!"

I bent to gather up the newspapers once more, feeling humiliated and foolish but, for all that, relieved as well. If my words had come anywhere near the facts, Mr. Sigerson would not be wiping traces of hilarity from his face.

"I am happy to provide you with so much entertainment, sir," I said, moving to the door.

"Stay!" he commanded. "We have not yet determined how to find the Orb of Kezir."

I turned at the doorway, my impassive mask once more in place. "I beg you will not trouble yourself with my small concerns." I left, shutting the door behind me.

Hospitality is a most excellent virtue,
but care must be taken that the love of
company, for its own sake, does not
become a prevailing passion; for then
the habit is no longer hospitality,
but dissipation.

Chapter Thirteen

I HAD JUST PUT ON THE KETTLE for elevenses when the front bell rang again. It seemed that the turmoil of the village was to be echoed at Larchbanks. I shoved the kettle to the back of the range and went to answer the bell.

Mr. Bagshaw stood on the step. Harold, a hangdog expression on his face, stood behind him.

"My dear Mrs. Dodson," Mr. Bagshaw cried, advancing into the hall. "So terrible to drop in on you this way, but really, I could not believe my eyes this morning when I saw the newspaper!"

"Are you all right, Charlotte—Mrs. Dodson?" Harold could not quite look me in the face after the incident of stealing my letter, but he sounded anxious. "No one has dared to threaten you, have they?"

"No indeed." I shut the door after them, wishing that I need not be bothered by a gaggle of house-guests when the upstairs maid was out of commission. "We are entirely unconnected with the problem."

"Of course." Mr. Bagshaw frowned at Harold. "Whatever or whoever is causing the disturbance down here, it can have nothing to do with Larchbanks." Despite these top-lofty words, it seemed to me that Mr. Bagshaw's glance around the hall held less than his usual complacent delight. "However, it has probably upset poor Mr. Sigerson, who was so in hopes of peace and quiet." He shook his head mournfully. "One thing after another! I am quite put out about it."

"I am sure Miss Hanover would not have inconvenienced you for the world," I murmured. Mr. Bagshaw was not listening, but Harold turned away to hide a smile.

"We must make it up to him," Mr. Bagshaw was continuing. "I am managing another little property, not so desirable, but certainly remote enough, in Cornwall. I shall advise him immediately to remove himself from all the fuss." He sighed heavily. "To think that such a thing could happen within a mile of the park gates! It is too bad, indeed it is. I have always had such a fondness for this estate. So peaceful, so entirely suitable for a gentleman."

This was certainly true. Mr. Bagshaw had enjoyed staying over when called down on business before the major's death; indeed, he still had a way of turning up to stay every so often.

"I believe you exaggerate," I said. "It is still quite peaceful here. Mr. Sigerson does not seem at all upset. His bees have settled in nicely. I do not think he will care to move them again, so far as Cornwall." Certainly, the thought of losing our tenant so soon after his advent caused me an unwelcome twinge of—something. I put it down to the previous night's brandy.

"Be that as it may, I allowed Harold to persuade me down here, to ascertain for myself how matters stood." Mr. Bagshaw unfurled a snowy handkerchief and gave an agitated rub to his forehead. "I cannot believe poor Miss Hanover is dead. It seems like only yesterday she attended the major's funeral."

"The funerals have been rather thick lately." I spoke my thought, not really attempting levity, though Mr. Bagshaw's severe expression told me I had achieved it.

"At any rate," he went on, "I have some matters of business to go over with you, Mrs. Dodson, and papers concerning the lease, if Mr. Sigerson decides to stay on." The primming of his mouth told his opinion of that. "So I thought it as well to come along." He smoothed what remained of his hair. "I should have sent notice, I know, but you always have everything so well in hand anyway—"

"Of course you must put up here," I said, knowing it was my duty to oblige. "I doubt you could find rooms in the village if you tried. It is, I understand, overrun with the minions of Fleet Street." Violet peeked around the green baize door, and I hastened to get some work out of her before she should vanish again. "Violet, help Harold with the bags. The same rooms as before."

Simpering, Violet took the smaller of the two cases Harold carried. Their voices receded up the stairs, Violet's containing a note of playful badinage.

I turned to Mr. Bagshaw. "I am sure you would like to go up and tidy for luncheon," I said. "It will be served at one o'clock, as usual, if that is convenient."

"It is eleven now," he said, taking out his watch. "Certainly a rest will be welcome. We were on our way first thing this morning." He picked up his scarf and in his turn ascended the stairs.

I conveyed the news of our two visitors to Mrs. Clithoe, who was just setting down her market basket in the kitchen. Having been well wrung-out by her Spasm of the night before, she heard Mr. Bagshaw's name with a mere grunt of disapproval.

"And how is a body to stretch chops?" she demanded. "Just enough I ordered from the butcher, and he's sending them round, ever so nicely trimmed."

"It is a pity," I agreed cravenly. "But I depend on your genius, Mrs. Clithoe. Do not worry about saving one back for me. Some soup is all I require."

"And the sole for dinner," she went on, scowling even more ferociously. "Two more at table is simply too much, Mrs. Dodson. And drawing-room tea! I shall need a bit of smoked salmon to make sandwiches."

"Very well. I must go into the village on other business, so I shall stop at the butcher's for you, Mrs. Clithoe, and at the fishmonger's."

Mrs. Clithoe was not finished. "And I mind me that I forgot to order our half-keg of ale from that Mr. Beddoes." She sniffed. "Shall I come with you?"

"No, no. You must have a lot to do with luncheon." I sought the door to my private rooms.

"Aye. It's little enough time to fix something that Mr. Bagshaw can stomach," Mrs. Clithoe said bitterly.

"I have confidence in your powers, Mrs. Clithoe."

I had found my gloves and hat, and was arranging a shawl around my shoulders when there was a loud knock at the door to my rooms. It was Harold Bagshaw, looking self-conscious.

"Uncle asked me to hand you these." He gave me a pile of thin, leather-bound household accounts books. "They date from 1875; I found them when going through the cupboards last week," he volunteered, following me as I carried the ledgers over to my table. "Uncle decided they should be kept at Larchbanks."

"I will find a place for them. Thank you, Harold."

He remained where he was, standing somewhat awkwardly upon the Axminster carpet. His head nearly grazed the low beams of the ceiling. I wondered how a wizened specimen like Mr. Bagshaw ended up with such a strapping nephew.

"Uh—Mrs. Dodson…"

"Yes, Harold?"

"I—do you remember that letter?" He regarded me anxiously. "The letter Major Fallowes wrote just before he died?"

I sat down at the table, interested to hear how Harold would account for purloining the letter. "Yes, of course."

Harold took the other chair. He seemed entirely engrossed in the pattern of the carpet, staring down at it and shuffling his feet uneasily. "Well, you—you may not have noticed, but I took it." He darted a look at me. "Last Sunday, when I was here."

"Yes, I know."

He abandoned the carpet to stare at me. "You knew! All along. I say, Charlotte—Mrs. Dodson. You are truly amazing. You seem to know everything."

"Mothers usually do." I was pleased to see that this patronising remark had a distinct effect on Harold's rather adolescent ardour.

"You're not nearly old enough to be my mother," he protested, but for once he sounded a bit uncertain about it. "But anyway, I— I have to confess that I lost the letter."

"No, Harold. You did not lose it. I have it back safe and sound." His hangdog look lightened a bit, and he opened his mouth, but before he could ask, I forestalled him. "Why on earth did you want it in the first place?"

He stared at me, puzzled. "Well, because of Uncle. You knew that."

"I did?"

"He needed to add the contents of your letter to the will. A sort of codicil."

"And you came down to obtain the letter for him."

He nodded, happy that I understood.

"Why didn't Mr. Bagshaw simply ask me to make him a copy?"

"I wondered about that myself," Harold said ingenuously. "But since I was coming down anyway to bring the papers for Mr. Sigerson, I was to just have a quiet look around to save you the bother of handling it. We didn't want to cause you distress by reminding you of that unhappy time."

I could just about hear Mr. Bagshaw mouthing these stale platitudes.

"The thing is, Mrs. D," Harold said, going on without giving me time to speak, "I told Uncle—well, I just said I hadn't been able to find it. I—I didn't want to tell him about losing it. So if you don't mind—"

"You wish me to say nothing about it to Mr. Bagshaw."

"If you don't mind." He grinned at me in relief. "I imagine he will ask you to copy it for him anyway—he's impatient to close probate."

My hands gripped each other involuntarily when I thought of claiming my legacy. I forced myself to relax. "Has he heard from Mrs. Staines, then?"

"No," Harold admitted. "The Foreign Office have been unable to discover anything, which is significant."

"But probate cannot be closed until Mrs. Staines is found or the six months specified in the will have elapsed, can it?"

"Well," Harold pointed out, "it's been two months now, and Uncle has been advertising for her since three months before the major died, so I suppose he feels the terms of the will have been met." He stood, nearly knocking over his chair. "I say, you never did tell me how you found the letter."

"I did not find it," I said gently, opening the door for him. "Mr. Sigerson picked your pocket and retrieved it." I gave him a little push over the threshold. "Good morning, Harold." He stumbled through the kitchen, thunderstruck.

I seized the market basket. Mrs. Clithoe was already involved with the range, adding kindling, shaking the dampers, shoving pots and pans around with vigour. I ventured a smile, and her stern face relaxed.

"I'll be as quick as I can," I promised her. "When Violet comes down, will you ask her to give the dining room a touch before she lays the table?"

"I'll tell her." Mrs. Clithoe snorted. "Flightsome wench."

"Exactly."

I left Mrs. Clithoe muttering and stopped to inform Mr. Sigerson of the visitors. He would no doubt be gratified that I was prepared to act as his errand boy and consult P.C. Ritter in the village, for such, indeed, was my intention.

There were voices behind the closed door of the library. I could make out Mr. Sigerson's barked question, and another's undecipherable rumble.

Mr. Bagshaw's rest must have been an uncommonly short one. But as I turned away from the library, I saw Mr. Bagshaw at the top of the stairs, talking to Harold. It could not be either of them closeted with Mr. Sigerson.

I turned back and tapped on the door. The voices within ceased. "Mr. Bagshaw has arrived," I said.

After a moment Mr. Sigerson bid me enter.

He was alone in the library.

One leaf of the French door stood open, however. I noticed a stub of pencil just beneath a leather armchair, and a sweet, spicy scent hung in the air, warring unexpectedly with the pervading odour of pipe tobacco.

"Mr. Bagshaw?" Mr. Sigerson turned from the mantel, as calmly as if he had not been talking to a vanished visitor a moment ago. "I didn't know he was expected."

"He was not," I said shortly. "He wishes to offer you a cottage in Cornwall, if Larchbanks should prove to be too exciting." I had blurted this piece of news out before reflecting that Mr. Bagshaw would no doubt have preferred to approach Mr. Sigerson himself on the topic of removing from Larchbanks.

"I could not think of moving my bees yet again." Mr. Sigerson knocked his pipe out into the grate. "And it would solve nothing," he added under his breath. "The danger cannot be avoided a second time."

"What danger?"

He glanced up. "You have excellent hearing, have you not, Mrs. Dodson? Does Mr. Bagshaw stay for luncheon?"

I waited a moment, but he did not elaborate on the expected danger. "He has brought his nephew and his luggage, and seems prepared for a rather more lengthy stay than luncheon would indicate."

Mr. Sigerson raised his eyebrows. "I see. You are, after all, going to the village."

I smoothed my gloves and flourished my basket. "Circumstances have so dictated it. I shall be glad to stop and inform the vicar of our discovery, and P.C. Ritter as well."

"Your discovery, Mrs. Dodson." When Mr. Sigerson bothered to, he could smile very nicely. "I deserve none of the credit."

There was no more to say. I returned his smile and left the room, shutting the door gently behind me.

I paused in the hall to straighten my hat, and Mr. Bagshaw caught sight of me from the top of the stairs. "Going out, Mrs. Dodson?"

"Some housekeeping matters to see to in the village," I explained.

"Wait just a moment, and I shall accompany you!" He darted off and was soon descending the stairs with his own hat and gloves.

"I thought you wished to rest." I did not really want company on my walk into the village, having hoped to use the solitude to think through the events of the past few days, searching for that danger that Mr. Sigerson felt coming closer.

"A walk is as good as a rest," Mr. Bagshaw said, opening the door gallantly for me. "Especially in this fresh spring air." He took deep breaths, pattering along beside me.

I enjoy walking, and that day I had a reason for setting a brisk pace. By the end of the drive Mr. Bagshaw was beginning to huff a bit.

"Mrs. Dodson," he panted. "I thought perhaps we could have a bit of private conversation before we get to the village."

Reluctantly I slowed my steps. Now Mr. Bagshaw would doubtless request me to copy the major's letter. "What is on your mind, Mr. Bagshaw?"

He took a moment to regain his breath, and his expression became sober. "I fear it will sound ridiculous," he said apologetically. "And indeed, I wouldn't blame you if you laughed! But lately, Mrs. Dodson, when I have visited Larchbanks—"

He paused, and I slowed my steps further. "Go on, Mr. Bagshaw," I said at last, when he didn't resume speaking. "I will not laugh, I promise you."

"It's just a feeling," he rushed on. "An overpowering feeling of—of danger, of impending doom. I—really, I'm quite concerned, Mrs. Dodson!"

Pink-scalped Mr. Bagshaw as conduit of dire predictions would have seemed quite ludicrous, if his words had not so nearly

echoed Mr. Sigerson's. I began to wonder what was wrong with my womanly intuition. These men were having feelings and seeing portents everywhere, and I had felt nothing stronger than bafflement.

"Your concern is really unnecessary, Mr. Bagshaw." I made my voice soothing. "There is nothing to fear. Miss Hanover's death was most certainly attributable to natural causes, or to a spider bite, like the one in Cowfold."

"Spider bite, was it?" He was silent for a moment. "Be that as it may, I would feel much easier in my mind if you were to—to vacate Larchbanks."

I did not like the sound of that. "Surely, Mr. Bagshaw, I need not remind you of the major's will."

"I do not mean you should be relieved of your duties, Mrs. Dodson," he said quickly. "This cottage in Cornwall I spoke of—if Mr. Sigerson takes up residence, he will need a staff. You would still be housekeeper, and paid the same wage, for the next six months."

"But what about Patience Staines? When she turns up—"

He shook his head gloomily. "I am afraid, Mrs. Dodson, that there is little possibility of that. The Foreign Office feel it is most likely she perished in the Boxer Rebellion, since nothing can be found of her through the usual channels. No, the estate will be disbursed at the end of the six months, and you will receive your share of it then. The contents of the library, I believe? Books and furniture? You can just as easily claim your inheritance from Cornwall."

"I do not think Mr. Sigerson will move his bees," I told Mr. Bagshaw. "He is rather eccentric about them, you know. And indeed, sir, I am afraid you refine too much upon a solitary incident. We are in no danger at Larchbanks, no matter what anyone may say."

He looked as if ready to pursue this thought, and I spoke quickly to distract him. "As to Mrs. Staines, I believe you may anticipate some challenge to the will from her step-son."

"Step-son?" He looked bewildered. "I received no instructions about a step-son."

"Nevertheless, one exists."

We had reached the outskirts of the village. Stafford-on-Arun was not large, neither modern nor ancient. There was little half-timbering or thatch, little of that picturesque quality that brings the antiquity-seekers from the cities. The sturdy cottages and larger houses were well enough in their way, made of roughly dressed native stone. Only the squire's residence, at the far end of the village, was actually ugly.

We passed a few small cottages, the more substantial dwelling of Dr. Mason, in its rather overgrown garden, and the vicarage, next to the church. Dating from Norman times, the church was the oldest building in the village, with a fine lych-gate and a glebe tower that required constant patching to keep it from falling on our heads. The vicarage, by contrast, was a stolid residence constructed in the middle of the last century.

Standing on the church steps was Percy Staines in company with the vicar. Both of them were the captives of Mrs. Hodges, whose piercing voice could clearly be heard vaunting the merits of this psalm or that as she went through the hymnal she held. I surmised, from the tenor of her remarks, that she was choosing music for Miss Hanover's funeral.

Reverend Hanover bore all the signs of a man bewildered by events. His clerical collar was askew, his sparse hair unkempt, and his gaze even more absent than usual. It was clear he paid little attention to either Mrs. Hodges or Mr. Staines.

"Mr. Simms, the curate," I told Mr. Bagshaw, who had paused beside me as I examined the group on the steps, "is, it seems, actually Percy Staines, Patience Staines's step-son."

"How unusual," Mr. Bagshaw cried, adjusting his pince-nez. "Now that you mention it, I recall some repellent lad causing a deal of trouble years ago. Made off with bits of silver, I believe."

"And the housemaid's virtue, according to Mrs. Clithoe," I added. Mention of the cook made Mr. Bagshaw blench.

"Astounding woman," he muttered.

"But a wonderful cook," I pointed out. "It is to obtain a few things for her that I came to the village. I must not tarry."

"Should I confront this Percy Staines, or whatever he's calling himself?" Mr. Bagshaw seemed undecided. "What is his purpose in such a charade?"

Enough people were in pursuit of the Orb of Kezir. I did not wish to add Mr. Bagshaw to their number. "Perhaps he was investigating the possibilities of inheriting the estate," I suggested.

Mr. Bagshaw drew himself up. "Impossible," he said, making at least six syllables of the word. "The will is quite clear on that point. Heirs of Mrs. Staines's body only, which I thought rather optimistic of the major, considering she was near fifty before she married. And that was only thirteen years ago, so any heir of hers could be no more than twelve."

Mr. Bagshaw seemed very earnest, so I did not allow my amusement to show. "The young man does not view it in that light."

"Then I shall set him straight." Mr. Bagshaw squared his shoulders. "And afterwards I'll nip over to the Rose and Crown. When your errands are finished, we can walk back together."

"Certainly." He picked his way up the church steps to tap Percy Staines on the shoulder, and I pursued my own way along the High Street.

I succeeded in obtaining a few more chops at the butcher's, and to propitiate Mrs. Clithoe's wrathful spirit even more, I took a small jar of *foie gras*. The fishmonger was happy to send up more sole. He had a nice piece of smoked salmon, too. We would have quite a cosmopolitan tea.

Emerging from the fishmonger's, I spotted Constable Ritter at Dr. Mason's gate, in earnest conversation with the doctor. I walked over to them.

"Mrs. Dodson!" Dr. Mason waved me closer. "A word, please."

Constable Ritter greeted me somewhat indistinctly around the peppermint he sucked. "That was a good tip of yours, ma'am,

about the collar. Verger says it was all undone when he found her, and tucked away, like, to show her neck."

"Not quite Miss Hanover's style, eh?" Dr. Mason winked at me.

"Certainly not," I said, turning this over in my mind. "I know of no circumstance under which she would expose her neck." She would just as soon have shown her bosom, I thought, but did not say. One must have some concern for the proprieties.

"If she were canoodling with some fellow, maybe," Constable Ritter allowed. "But then, Miss Hanover never had a fellow, did she?"

"Not that I can remember," Dr. Mason said cheerfully. "So, Ritter, I'll get you the autopsy report by the inquest tomorrow."

"How did she die?" I hoped my question would not be regarded as impertinent by the men. But I felt sure that they would tell Mr. Sigerson if he asked, and my need to know was at least as great as his.

Dr. Mason turned to me. "I couldn't determine with any degree of accuracy, but Ritter and I are putting our heads together. We'll have some tests done to rule out poisons."

"Tricky, surely," Ritter agreed, but he didn't seem as despondent as he had earlier. "Mayhap I can put my finger on it, all the same."

"I wished to speak to you, Constable," I said, when Ritter appeared about to leave.

"If it's about a certain party not being who he seems to be, well, I've already taken care of it," he said, reaching in a red-striped paper bag for another peppermint.

"You know about Mr. Simms—I mean, Staines?" For a moment I was lost in admiration at the unexpected depths of Constable Ritter, able to deduce Percy Staines's skulduggery with far fewer clews than I had.

But something nagged at the edge of my brain, and suddenly I realised what it was. The spicy scent I had noticed in the library that morning had come from the peppermint-sucking police constable in front of me.

Constable Ritter had been the one holding a secretive con-
clave with Mr. Sigerson in the library. He'd left in such a hurry
that he'd dropped his pencil. The one he was using now, to jot Dr.
Mason's conclusions in his notebook, was fresh, unmarked by his
nervous teeth.

The housekeeper…will attend
to all the necessary details
of marketing and ordering
goods from tradesmen.

Chapter Fourteen

HAD CONSTABLE RITTER, unlikely as it seemed, actually come to consult Mr. Sigerson about his investigation, a course of action Mr. Sigerson had seemed to expect?

Or did the constable's assurance of catching the killer mean he had evidence against Mr. Sigerson?

I did not know what to believe, a singularly uncomfortable position.

Constable Ritter swung jauntily away, carrying a sealed container that held, I surmised, the bits of Miss Hanover to be tested.

Dr. Mason stared at me quizzically. "What was that all about?"

"I don't really know," I said, trying to understand the implications of Ritter and Sigerson, conferring together.

Dr. Mason shrugged. "By the way, Mrs. Dodson." He leaned forward confidentially. "I've already told Ritter that the puncture marks were probably made after Miss Hanover's death."

I added this tidbit to the other snippets of information that

made no sense. "And you don't know what actually caused her death? Was it, perhaps, a natural one, and someone came along afterwards to make it appear, for some reason, the work of a vampire?"

He shrugged again. "Who can say? People will do such bizarre things. But judging from a few indicators we found about the body, I would suspect foul play. More than that I cannot say until Ritter has the tests performed."

We parted at the gate. I saw that the vicar still stood on the church steps, alone now. Percy must be busy packing; I hoped that Constable Ritter had made arrangements to keep him from absconding. The false curate's behaviour was not as yet, I believed, fully accounted for.

Approaching Reverend Hanover, I offered my sympathy on the death of his sister. He stared at me, blinking.

"Yes, poor Evaline," he said at last. "It is most strange, Mrs. Dodson. And now Constable Ritter has just come along, telling me that Mr. Simms is really someone else, and not a Trinity man at all! I really don't know what things are coming to anymore!"

"It is astounding," I agreed. "But it will all be set right sooner or later."

"Very true," Mr. Hanover said, drooping a little less. "I must take it to a Higher Authority, that's what. If you will excuse me, Mrs. Dodson?"

I let him go. In order to return to Larchbanks before luncheon, I would have to hurry my errand at the Rose and Crown.

This proved difficult. The public bar was crowded with village worthies, chewing over the exciting happenings. And the noise issuing from the saloon bar was even more deafening, with the clamour of journalists everywhere.

Mr. Beddoes was at the front desk, harassed and sweating as he confronted a crowd of strangers. "I've only got the one room left, gentlemen," he cried. "You'll have to make an agreement amongst yourselves if you want to share it."

Two of the strangers fell to haggling with each other. They

were easily placed as more journalists, young men with preternaturally sharp eyes and brusque manners.

A third man, middle-aged with a grizzled moustache and a slight limp, tried in vain to press his own claim. Mr. Beddoes, wiping his face with a large spotted handkerchief, paid him no heed, and the two young newsmen completely ignored their older rival.

Another man hovered on the outside of the controversy. I would not have noticed him, had it not been for two things: he wore his hat pulled so far down over his eyes that little of his face was visible, and that little he had concealed behind a scarf. I wondered, indeed, if Mr. Sigerson had nipped down to the Rose and Crown to hang about, despite his professed intention of not leaving the house.

A closer examination showed that this man, though stooped, would never be as tall as Mr. Sigerson. His hands, too, were unmistakably different, pale and with the fingers thickened and twisted as though with the knuckle disease or incessant work. He clutched a curious walking stick, highly polished. After I determined that he was not Mr. Sigerson in one of his silly disguises, I paid him no more heed, except to notice the fixed intentness of his gaze on the group around the landlord.

Catching sight of me, Mr. Beddoes abandoned the newsmen. "Mrs. Dodson! How may I help you?"

I made my way up to the desk, sweeping one of the journalists with a cold eye when he ventured a warm remark. Reddening, he went back to his argument.

"Mrs. Clithoe was to have ordered a half barrel of your homebrewed for us this morning," I began, "and she tells me it slipped her mind. Could you oblige us?"

"Certainly, certainly." Mr. Beddoes wiped his face once more, distracted. "But I don't know quite when I can send it up, Mrs. Dodson. We're rather busy just now."

"So it seems." The noise in the saloon bar swelled to a crescendo. "A rowdy group, these journalists."

"Poking and prying and asking more questions than me old mum," Mr. Beddoes said disgustedly. "Have I ever seen a vampire around! Are there any old coffins lying about! Did you ever hear such foolishness in your life?"

"It astounds me that anyone can believe what they read in the paper," I agreed. "Well, we are not in too much of a hurry for the beer, although Tim White is working at Larchbanks now, and he likes his pint."

"Aye, a good lad, Tim. Turned out all right despite his dad." Mr. Beddoes jumped as yet another journalist bustled forward, despite the cries of those still crowding around. "And does Mr. Sigerson care to try a cask or two of brandy?" He smiled slyly. "Just in, it is, fresh from France."

I disclaimed all desire on Mr. Sigerson's part for smuggled brandy, though I had heard it was of excellent quality, and very cheaply come by in Sussex. Mr. Bagshaw was nowhere to be seen, and I did not care to seek him in that boisterous atmosphere. Drawing my shawl around my shoulders, I left.

Just outside the door, however, I was accosted by the middle-aged man with the moustache. He raised his hat in a very gentlemanly way.

"Pardon me," he said politely. "I overheard you just now mention a Mr. Sigerson. Can you tell me, is he a Norwegian explorer by any chance?"

I regarded him with less than patience. "No indeed. Nor does he keep a coffin in the drawing room. If you'll excuse me—"

"Please, madam." The man accompanied me as I walked away, his slight limp no impediment to rapid movement. "It is imperative that I meet this Mr. Sigerson and see for myself—well, at any rate, could you take him my card?"

Sighing, I stopped. "Very well, if it means you will quit pestering me."

He scrawled a few words on the back of a card. I took the opportunity to study him, and realised I had been mistaken in assuming him to be a journalist. He had no tablet of paper, no

pocket bulging with pencils. And on his lapel was a small symbol, snake entwined around staff. He was a doctor.

The man fished in his pocket and found a crumpled envelope. Eyeing me keenly, he handed over his message. "It's important," he said again. "He can find me at the Rose and Crown—at least, if the landlord will accommodate me."

"There doesn't appear to be much likelihood of that." The man's gentlemanly bearing and his hopeful gaze softened my exasperation. "Those journalists have commandeered the available rooms. You had better throw yourself on their mercy."

"They would have none, I am sure." He smiled a little at me. "It is an unfortunate time to have business in this area."

"Perhaps, as a medical man, you can prevail upon our Dr. Mason to assist you," I said. We were just opposite the doctor's gate; I could see him on the doorstep, sending off a youngster with a bandaged finger.

"How did you—?" The man looked at me with surprise. "Are we acquainted, madam?"

"Not at all. But your emblem proclaims you, and—" I sniffed delicately. "The faint odor of carbolic attends you, even if you are not in your consulting room."

"Amazing." The man was more impressed by this feeble display than it warranted.

"We meet again, Mrs. Dodson." Dr. Mason came to his gate, looking curiously at my companion.

The man beside me returned the scrutiny, and something in his face changed. "Are you not Richard Mason, formerly of the Royal Fusiliers?"

Dr. Mason stared for a moment, and then clapped him on the shoulder. "Why, it's Jack Watson, is it not? Well met, well met. I thought you were fixed in London! Still in practice, are you?"

The two men ambled up the walk into the doctor's cottage, just as Mr. Bagshaw caught up to me.

"So, is all your business done, then?" Mr. Bagshaw was a little flushed from his visit to the Rose and Crown.

"I have executed my commissions." I pulled my gaze away from the doctor's cottage. "Did you accomplish what you came to the village for?"

He shook his head discontentedly. "With all of Fleet Street taking up temporary headquarters here, you'd think the pub would be a fine place to hear the truth of all this. But they don't seem to have any facts at their disposal. They are just trying to find the most sensational rumours they can."

I glanced back at the Rose and Crown, and noticed that the elderly gentleman with his hat pulled down had seated himself on the bench outside the door. He appeared to be watching Dr. Mason and his old friend vanish into the cottage. Although I couldn't get a clear look at his face, I was convinced that there was something malevolent in the stranger's attention. He had donned gloves that concealed those damaged hands; still clutching his curious stick, he leaned forward, as if he could follow the men at long distance into the house.

Shuddering, I turned away and set off briskly down the lane. I had no desire to attract the man's attention to myself. Looks do not kill, as the old saying goes. But some, I am convinced, could leave a scar.

Mr. Bagshaw trotted along by my side, remarking breathlessly on the fine day.

"Pleasant indeed," I agreed, keeping up a brisk stride. "It is no hardship to go out on a day like today."

"Pity you should have to run your own errands." He frowned. "Couldn't one of the maids have done it?"

"I am shorthanded just now," I said placidly, "and I enjoy the walk, just as you do, sir."

"Quite so, quite so." He moved along jauntily, though each step seemed to me slower than the one before. "Ah—have you given any thought to what we spoke of earlier?"

"Not really," I admitted. The air was marvellous, scented with blossom and the peaty smell of new-turned earth. I found it easy to shake off my nebulous fears, and hard to believe that the melo-

dramatic activities of the past twenty-four hours were not a dream.

Mr. Bagshaw cleared his throat. "Well, ah, actually I have something else to discuss," he confided. "That letter you had from Major Fallowes, just after his death. I wished to have a copy of it, to include with the will and other probate documents."

"I will be glad to give you a copy at such time as probate is completed," I said mildly. "You could have asked at any time, without going to the trouble of getting Harold to abstract it."

"Harold tried to do that?" Mr. Bagshaw made a *tsk*ing sound. "That boy is no good at listening to instructions. He came back with some cock-and-bull tale about not wishing to go behind your back. I never asked him to—simply asked him to be tactful and not rake up the distress of the major's death all over again." He shook his head. "He'll never make a solicitor."

I didn't pay much attention. It was later than I had thought to return, and Mrs. Clithoe would be anxious for the contents of my basket. Despite Mr. Bagshaw's faint protest, I lengthened my stride.

The gates of Larchbanks were before us, and I left Mr. Bagshaw to enter by the front door, while I went around to the kitchen. Mrs. Clithoe fell on the chops with glad fervour, and I went into my rooms to tidy from my walk. Then it was necessary to help Violet lay the table, since in my absence she moved quite slowly. It was not until I tapped on the library door to announce luncheon that I remembered the message I had been given.

Mr. Sigerson opened the door. "Luncheon is served," I told him. "And I have received a message for you." I hesitated for a moment, not having brought the card tray with me, but finally just handed him the envelope, and most reprehensibly lingered in the doorway while he opened it.

His eyebrows went up at the name on the card, and he turned it to read the back. "Here's a pretty kettle of fish," he muttered, going over to the fireplace and consigning card and envelope to the blaze that smouldered there. Armed with the poker, he made sure that not a trace of the card lingered.

"You are very thorough," I said abruptly. "You do not like this Jack Watson?"

"You read the card?" He wheeled to face me, his gaze narrow.

"Not at all. The gentleman recognised a former acquaintance in Dr. Mason, who called him by that name." I inspected my fingernails with a show of unconcern. "I fancy your friend will be lodging in Dr. Mason's spare room, since there is nothing available at the inn."

"My friend!" Mr. Sigerson's laugh was short. "My Judas, more like. But there, it was bound to come, sooner or later."

With these incomprehensible words, he walked up to me where I stood in the doorway. We were very close; I could see that the changeable hazel of his eyes had darkened nearly to black.

"Remember, Mrs. Dodson," he said, so softly I had to strain to hear. "Thurlow's cottage—when I give the word!"

*Of men of thought, it can
scarcely be true that they
eat…much, in a general way,
though even they eat more than
they are apt to suppose they do.*

Chapter Fifteen

I PASSED AN UNEASY AFTERNOON. Mr. Sigerson vanished directly after luncheon. When I looked out the library windows after sweeping the hearth, I saw him crouched behind the hedge, monitoring the activity of his hives.

Such placid behaviour on his part did nothing to ease my feelings. Quite the contrary. The gentlemen of the house had spent the morning throwing out hints and suggestions of danger and horror, and then one of them went off to observe bees, while the other one retired to his bedchamber to nap with a handkerchief over his face. (For so Violet had informed me, having walked into Mr. Bagshaw's room with fresh towels, only to be driven back by the resonant nature of his snores.)

I had much to do in the linen cupboard and the stillroom, and took on many of Rose's tasks as well. Violet was too unsettled to apply herself to housework. She insisted on claiming Tim's protection whenever possible. Since he was working on the front gate,

she perched on a nearby rock every chance she got. After summoning her for the third time, I gave up trying to get any work out of her. I was helping Mrs. Clithoe shell peas when Violet surprised me by dragging Tim back from the gate.

"This just arrived," Violet said importantly, handing me an envelope bedecked with official seals and addressed to me. Thanks to the squire's malice, I had been summoned to give evidence at the inquest the next morning. What I was to testify to, I had no idea, except that Miss Hanover had been as sour and self-righteous a few hours before her death as usual.

However, the other occupants of the kitchen were impressed by all the seals, and the official language when I read the summons out loud. Mrs. Clithoe and Violet made immediate plans to support me from the back bench, and Tim was torn between his self-imposed task of guarding Larchbanks against intruders and the more florid joys of the inquest.

Mrs. Clithoe soon heaved herself up from the table. "There's much to be done," she said, fixing Violet with a significant gaze. "Drawing-room tea for them—" she jerked her head toward the front of the house "—and a rattling good dinner as well, if that Mr. Bagshaw can stomach it."

"He asked me to let you know his chop was perfect at luncheon," I assured her. "He admires your talents exceedingly."

Ordinarily this little white lie would have elevated Mr. Bagshaw into an acceptable person in Mrs. Clithoe's eyes, but she had such a deep-rooted dislike of him that even my manufactured compliments weren't enough to overcome it. "I'm not serving any boiled fowl, that's certain!" All her chins wobbled as she made this forceful statement.

Tim managed to escape to finish his work on the lock, but Violet and I were at Mrs. Clithoe's beck and call, scrubbing, paring, stirring, and slicing. It grew very warm in the kitchen, and I was glad when it was time to set up tea in the drawing room.

We did not usually bother with the cake stand and muffineer. Mr. Sigerson preferred his tea sent to the library on a tray and

then, as often as not, ignored it. Mr. Bagshaw, however, expected more, and since the major's death we had all got into the habit of regarding him as the Ultimate Authority in Larchbanks affairs.

So Violet and I spread the embroidered cloth on the tea table, arranged little cakes and sandwiches on the three-tiered stand, set out the silver service, the cups and saucers, the table-napkins and plates, with great meticulousness.

As we finished, Mr. Bagshaw came in, Harold trailing sulkily behind him. "Tea? Splendid, splendid," Mr. Bagshaw said. "Now, where is Mr. Sigerson? We don't want to start without him."

"He does not always partake of tea." I filled the teapot from the urn, and checked that the muffins in their covered dish were hot, and the *foie gras* sandwiches were prominently displayed.

"Not have tea!" Mr. Bagshaw was scandalised. "Well, then, shall we go ahead, Harold? Make a good meal now, in case your train is late."

Piling the little sandwiches on his plate, Harold looked even more glum.

"Are you going back to Littlehampton tonight, Harold?" I poured his tea and handed it to him, smiling kindly to ease his expression of misery.

"Yes, yes, there seems to be no reason to keep him here." Mr. Bagshaw glanced at me and faltered for a moment. "No real reason, at any rate, and there are some matters in the office that must be attended to."

"He could stop until after dinner, and take the late train, could he not?" My conscience smote me at the sight of Harold's cast-down face. "Mrs. Clithoe is preparing a veritable feast, and will be disappointed to lose so hearty an admirer as Harold."

Mr. Bagshaw started nervously at the cook's name. "Well," he said, undecided, "it wouldn't do to upset *her*. Very well, Harold. You don't need to leave until after dinner."

"Surely I could stay the night, then." Two of the smoked salmon canapés vanished, slightly impeding Harold's plea.

"Then you wouldn't get to the office early enough tomorrow to

accomplish those tasks I wish you to do," his uncle answered, taking the remaining salmon for himself.

"Those tasks aren't vital, Uncle," Harold said persuasively, swallowing three or four potted meat sandwiches. His hand hovered over the cakes. "I don't like leaving Charlotte—Mrs. Dodson here without someone young and strong to protect her."

"Tim White is both young and strong," I said, "and I believe he will spare the time from protecting Violet to do the same for Mrs. Clithoe and myself."

"Quite so, quite so." Mr. Bagshaw managed to eat steadily without appearing to do so; already the *foie gras* was gone. "You see, Harold, you are quite unnecessary. And indeed, I am not entirely useless, you know." He leaned forward, lowering his voice to a conspiratorial whisper. "I have brought my weapon; I can defend the ladies if Larchbanks is threatened. Not that I think it will be," he hastened to add to me. "But in these times, who can say what will happen?"

"Exactly my point," Harold cried, abandoning his cake in his passion. "Just in case, Uncle, I should stay—"

"In case of what?" Mr. Sigerson spoke from the threshold. I was glad to see he'd taken the time to change and tidy himself from his apiarian pursuits; his hair was sleeked back from his high forehead, and in his frock-coat and fresh linen he looked smooth, impeccable—and dangerous.

Harold, at least, stood in awe of him. He gulped visibly before answering. "This vampire, or whatever it is that is killing people around here—don't you feel there is some danger from it, sir?"

Mr. Sigerson strolled over to the tea table, and accepted the cup I poured for him; no milk, no sugar, just lemon. "I do not feel threatened by a vampire." His eyes met mine briefly, and I could read the rest of his thought: that the threat was all too human. The formless anxiety that had plagued me that afternoon intensified, centering on the tall, enigmatic figure before me. I did not really suspect him, so much as I feared that his estimate of approaching danger might be correct.

Abruptly I rose. "If you gentlemen will pour for yourselves? I am shorthanded today, and must be about my duties."

Mr. Bagshaw bustled forward. "Of course, Mrs. Dodson. Kind of you to serve us, but we can manage. Now, Mr. Sigerson, what can I get for you? There are some very tasty *foie gras* sandwiches here somewhere."

"It is no matter," Mr. Sigerson was saying as I left the room. "Some bread-and-butter is all I require." But though he spoke to Mr. Bagshaw, I could feel his eyes on my back, and I could not repress a shiver.

When I regained the kitchen, dinner preparations were well underway. Violet marched past me with the laundry, bound for upstairs.

Mrs. Clithoe stirred her sauces, appearing distracted.

"Did Billy White have any news to deliver along with the washing?" I took the scrap basin to the scullery to empty.

Mrs. Clithoe followed me. "Me old dad is feeling poorly, Billy said. And me stuck here! I wish I could take him a bite and sup. He takes a deal of seeing to, me old dad does."

"Perhaps Violet—"

"She has to wait the table." Mrs. Clithoe snorted. "Got her cutwork apron on and everything."

"Well, I would be glad to take Thurlow a basket. Do you think you'll need my assistance with dinner?"

"That's right good of you, Mrs. D. All's ready, saving the sauces, and I can't leave the Béarnaise for more than a minute."

With Mrs. Clithoe's assistance, I packed a basket for her father and stepped out the back door.

The opportunity to leave the house was heaven-sent. I stood for a moment in the kitchen garden, just breathing in the fresh air. The sun slid towards the downs, and frogs added their rusty song to the birds' evening chorus. I glanced at the hives as I passed them on my way to the wicket gate. A few late-coming bees hummed their way home. I had grown accustomed to their presence, and thought with a touch of melancholy that I would miss

them when Mr. Sigerson's tenancy was over. The thought gave me pause; I was truly in an odd state when I could become overset by contemplating the presence or absence of bees.

The fact was, it was not the bees but their keeper whom I would miss.

This unwelcome revelation struck me, stock-still, with my hand on the latch of the wicket gate. In another moment I had recovered. I unlocked the gate, stepped through, closed it, locked it, all with only the barest consciousness of action. My mind was taken up with my monumental foolishness.

I had allowed myself to have warm feelings for Mr. Sigerson, my employer, to whom a housekeeper was no more than a glorified maidservant. And a man, moreover, with little of the milk of human kindness in his veins, a man whom I could admire only on a cerebral level.

And yet the sensations that I felt within me had little to do with cerebral activities.

Gradually, as I walked down the lane, my brain began to reassert its sovereignty. What I experienced, it argued, was merely a natural consequence of being widowed, without that lawful outlet for the passions that marriage provides. With the greatest tenderness did I conjure up the image of my beloved Maxwell. He had taught me the power of those passions, and the pleasure of slaking them. After his death I had assumed I would feel that rising tide no more.

It appeared I was mistaken.

The memory of my love for Maxwell was enough to show me that there was little of tenderness in the feelings Mr. Sigerson aroused within me. He was cold, but that very coldness had summoned heat from me. The only thing more certain than the futility of such feelings was the knowledge of how unwelcome they would be to him.

Lingering before I reached Thurlow's cottage, I made a quick resolve. Such emotions as I wrestled with were, perhaps, natural, but they could never be indulged without shame. I would stifle

the unseemly flutters of my heart. I would smother the febrile longings of my body. And I would never indicate, by so much as a word or a glance, that I had harboured them for even an instant. Mr. Sigerson was a gentleman; I, though a mere housekeeper, was a lady. Between us, decorum was the rule.

Thurlow answered my knock, his step more halting than usual. The basket of bread and cheese, soup and sausage and ale that I brought was greeted happily, and nothing would suit but that I should sit before the fire and let him get me a little supper. I prevailed upon him to allow me to heat the soup on the hob and toast some of the bread and cheese, but I bowed to his pressing invitation to share the repast, wanting to put off my return to Larchbanks, the vicinity of such unrest.

By the time I had listened to Thurlow's catalogue of minor ailments, and seconded his prescription of willow-bark salve for his rheumatics and goose grease for his cough, it was full dark. Dinner would be over at Larchbanks. I was suddenly anxious to be gone. Fears that in the bright afternoon had seemed nebulous and foolish returned in the dusk to mock me. I wanted stout walls between myself and any marauder who might, for whatever reason, seek out our innocent household.

I stepped out briskly along the lane, thankful that Thurlow's cottage lay beyond Larchbanks from the village; for it was from that direction that any trouble would arise, I thought.

But just as I rounded the bend that would show me the wicket gate into the Larchbanks grounds, I saw a flicker of movement ahead. Impelled by sudden dread, I halted in the shadow of a huge oak and strained my senses to discern what was occurring.

Distinctly through the still air came the rasp of a key in the wicket gate's lock, and the faint creak as it opened. A dark shadow seemed to melt through it, and the gate shut again.

I sped down the lane, my slippers blessedly silent on the packed earth, and stole across the verge to the gate. A murmur of masculine voices came to me, among which I thought I could discern Mr. Sigerson's deep, abrupt tones. I tried the latch of the

gate; as I had thought, it was still unlocked, and yielded to my gentle push with the slightest breath of sound. I slipped through.

There was no one in sight as I eased the gate shut behind me. The voices came from the old stable, Mr. Sigerson and another. I was on fire to decipher the words they spoke. With infinite caution, as though I stalked a toad for Stubby's collection, I moved through the scattered shrubs until the wall of the stable loomed before me. Touching it with my hand, I felt my way to the corner and peered around.

I could see both the men now; they were silent for a moment, and the scents of pipe tobacco and cigar smoke mingled on the breeze. Mr. Sigerson had his back to me, and blocked to some extent my view of the second man, but I needed no more than a glance to see that it was Dr. Mason's friend, Jack Watson, who had given me the message that morning.

"I knew you weren't dead, anyway, old chap," Mr. Watson remarked, finally. "You've tried that trick once too often."

"How could I fool you, Watson?" Mr. Sigerson sounded far more genial than I would have thought, given that he had named the other man a Judas. "It was my fondest hope that you would realise I had gone to earth, as I did before when pursuing this sort of vermin. This time, however, matters will come to a head in far less than three years."

"I suppose so," the man called Watson said, smoothing his moustache uneasily.

"There is no doubt of it." A match flared briefly as Mr. Sigerson lit his pipe again. "You have certainly led him right to me, Watson. I had not credited you with finding me out so quickly."

"As to that," Watson said, with a slight smile, "it was the sensational death of the local vicar's sister that has led me to you. It occurred to me that, should you yet live (which, my dear fellow, was my fondest wish!) you would not be able to resist the puzzle presented by this Miss Hanover's demise. But how can you suppose I have led Moran to you? I assure you, I was not followed from the village."

"So you think," said Mr. Sigerson—the name by which I shall
always think of him, although at that moment, with the rough
plaster of the stable wall under my fingers and the cold breath of
night on my check, it finally became clear to me that he bore an-
other, more renowned cognomen. "Nevertheless, Watson, let me
assure you that even as we speak, someone has followed you, and
is listening to our conversation."

With that he turned, and taking a long step to the corner of
the building, confronted me. I made no attempt at concealment;
it was patently too late for that.

"Ah, Mrs. Dodson," Mr. Sigerson said genially. "You should re-
member, next time you wish to remain unperceived, not to wear
that very appealing scent of yours. Gardenia, I believe?"

"Tuberose." I moved away from the wall. "Good evening, Dr.
Watson. I have read one or two of your accounts; they are enter-
taining."

Dr. Watson bowed, smiling. His famous friend scowled.

"I am surprised that you should find them interesting, Dod-
son. They are romanticised out of all knowing, with the touches
Watson insists on including."

"I must confess I thought them to be fictional," I said.

Mr. Sigerson threw his head back, enjoying his inward laugh-
ter. "See how she cuts us both down to size, Watson? Mrs. Dod-
son is a capital housekeeper, and not unacquainted with the prin-
ciples of detection. I suggest that, after I lock the wicket gate—
you didn't know I had copied your key, eh, Mrs. Dodson?—the
three of us adjourn to the library and pool our resources. If my old
enemy Colonel Sebastian Moran is about, no need to make things
too easy for him, is there?"

It was settled that the men would retire immediately to the
library, and I would join them as soon as I ascertained there would
be no interruption from Mr. Bagshaw, to whom Mr. Sigerson had
no wish to reveal his true identity.

My head was spinning as I carried the empty basket back to
the kitchen. Mr. Sigerson was not, evidently, to be feared as a

murderer. His deceptions had been deep indeed, but intended as protection against a threat, not solely to perpetrate a fraud.

Entering the kitchen, I blinked in the mellow light and fancied that I must have dreamed the whole fantastic encounter at the wicket gate.

Mrs. Clithoe turned from the deal table, where she had been setting her bread. "And how did you find Father, Mrs. Dodson? Does he go on comfortably?"

"There is nothing amiss beyond the complaints of age," I said, somewhat absently. "He was very gratified to receive such a good supper from you."

"And good of you to stay and give it to him." Mrs. Clithoe beamed at me. "You'll be glad to know that dinner passed off well, Mrs. D. Violet waited beautifully, and they et all the sole, barring a little piece I saved back for you."

I declined the treat, and went into the hall. Harold Bagshaw was descending, valise in hand and uncle beside him, giving him instructions on what he was to do with certain matters in the office.

"Have a pleasant journey, Harold," I told him, shaking his hand briskly and squashing the impulse to give him sixpence spending money.

"I don't like missing the inquest, Mrs. Dodson," he told me earnestly. "You should have legal counsel if you're to testify."

"And what do you call me?" Mr. Bagshaw puffed himself up, favouring his nephew with a hard stare. "I shall advise her if she needs it, which I'm confident she won't."

After some fussing on his part, Mr. Bagshaw decided to walk with Harold to the station and then drop in at the Rose and Crown, as that, he said disdainfully, was the only amusement Stafford-on-Arun offered. I could not resist asking what he would do if he met the vampire on his way home.

"I would naturally assume I had had one over the eight," he said with great dignity. "Do not distress yourself, Mrs. Dodson. It is not for me that the threat lies."

I could hear Harold demanding an explanation of that as the door shut behind them.

Taking a deep breath, I tapped on the library door. From within, the voice of the man I could think of only as Mr. Sigerson bade me enter.

In former times, when the bottle circulated freely
amongst the guests...the gentlemen of the
company soon became unfit to conduct them-
selves with that decorum which is essential
in the presence of ladies. Temperance is, in
these happy days, a striking feature in the
character of a gentleman.

Chapter Sixteen

PAUSING ON THE THRESHOLD, I allowed the actions of the previous week to rearrange themselves in my thoughts. Mr. Sigerson's journey on the day of Miss Hanover's death was not from any sinister impulse; it was his reaction to reading in the newspaper that his house near Littlchampton had been fire-bombed—an eventuality he had foreseen when he had removed to Larchbanks under an assumed name. I wondered briefly if it was his own life, or the lives of his bees, that he had sought to pre-scrve, and guessed that it was both.

And it was obvious now why he went about disguised. Among certain groups of people, such as policemen and criminals, his must be a readily recognisable figure. When you are *incognito* and presumed dead, you do not parade about indiscreetly. It re-lieved me somewhat to realise that all his disguises were not symptoms of a mental disease.

When I looked at him, standing beside the mantel, pipe in

hand, head bent to the flames, I realised that Dr. Watson's accounts of him, which after reading I had dismissed as sensationalistic fiction, might perhaps owe more to truth than to the doctor's skill with his pen.

Now that I knew his true identity as a public figure, a man whose wit and abilities were proclaimed throughout England, my softer emotions regarding him seemed even more absurd. I had a sudden impulse to withdraw. My puny efforts would be no match for this man's, and I feared his keen senses would detect, through some minute differentiation in my attitude towards him, the change in my feelings.

"Come in, come in." Mr. Sigerson raised his head and looked irritably at the door. "We have been waiting for you, Dodson. Have you tucked the ubiquitous Bagshaws away?"

I shut the door behind me. "They have gone out, Mr. Sigerson—that is—"

He shook his head when I would have supplied his real name. "I prefer that you give me my *nom de guerre*. Any other could be dangerous, and indeed I am Mr. Sigerson now."

"Very well, sir."

His mood lightened, and he turned back to his friend. "Have another brandy, Watson. And you, Mrs. Dodson? Will you take a brandy?"

The offer surprised me, and I acquiesced before I thought about the awkwardness of the situation. Dr. Watson came forward to guide me to one of the leather armchairs. The quizzical tilt of his eyebrows told of his surprise at finding me on such terms with Mr. Sigerson from so brief an acquaintance, and given our relative situations.

"Please sit here, Mrs. Dodson. Do you really want a brandy?"

I glanced at Mr. Sigerson, who wore one of the rare, genuine smiles so seldom seen on his saturnine countenance.

"She has said so," he cried. "Soda, madam? You see, I pay your abilities the compliment of quite masculine treatment. Next, I expect, Watson will offer you a cigar."

"My abilities are nothing extraordinary among my sex, sir, and do not require the sort of pampering gentlemen need," I retorted, restored to myself by his condescending speech. "And if you intend to smoke, may I ask that the window be opened?"

Again Dr. Watson raised his eyebrows, a chuckle escaping him. "You are not like any other housekeeper I've ever known, Mrs. Dodson. I can see that you know how to keep my unruly friend in check."

"Mrs. Dodson knows," Sigerson said, tranquilly lighting his pipe, "that I will not open the windows. Not tonight, at any rate. And she would not deny me the consolations of my pipe. But you had better not try a cigar, perhaps, Watson. That might be pushing her good nature too far."

Accepting the glass Dr. Watson handed me, I took a sustaining sip. Often in the evenings, Maxwell and I had shared a brandy while discussing the day's events. Perhaps it was an error in judgement to partake under the circumstances, but certainly the stimulant was welcome after the day I had passed.

"Now, Watson, divulge some of the medical details you've gleaned from Dr. Mason about Miss Hanover's death that would be useful to me," Mr. Sigerson said, with a glance at me that showed my refusal to inform him earlier still rankled. I half rose from my chair.

"You two must have so much to discuss. I will retire and leave you to it."

"Not yet, Mrs. Dodson," Mr. Sigerson said, fixing me with a look of command. "Three heads are better than two if we wish to get to the bottom of this affair."

I took another sip, and was emboldened to say, "I confess, I do not understand why it is so urgent to discover what happened to Miss Hanover. If her death was truly no accident, surely the authorities will investigate and find the answer."

"It is vital to probe this matter, in case it is entangled with my own concerns." Mr. Sigerson's face was tightly drawn, and now that my eyes were opened to his true identity, I could see the

tension for what it was—a man fighting for his life. The meditative quality of his voice did nothing to dispel that tension. "I have the gravest fear that in coming here, I have set in motion events that have caused this woman's death. If that is so, I will need to take steps to rectify the situation. Aside from that, solving this puzzle as quickly as possible will draw off attention from the place I have chosen to go to earth. The man who seeks my life, Colonel Sebastian Moran, is no one to trifle with." He poked savagely at the fire, his expression grim. "I blame myself that I did not sit tight, let him come at me at my home, where I had made all secure and sent away the servants. We might then have engaged man to man, instead of letting him stalk me in this insufferable way."

"Man to man!" Dr. Watson leaned forward. "I do not call incendiary bombs a gentleman's way of conducting a fight! He meant to destroy you before you had a chance to retaliate. It is fortunate indeed that you had left. Even now, I am sure he thinks you immolated."

"Not at all." Mr. Sigerson spoke with detachment, although discussing the destruction of his dwelling, and possibly himself. "Moran knows an empty building from one that's inhabited. Though too late to do for me, he did for my house, hoping to draw me out of hiding. I took care, however, when assessing the damage, to be undetectable."

"You were there?" Dr. Watson burst out laughing. "I was certain you were in the crowd the morning after the fire, but could discern you nowhere! Were you that very stout German burgher who kept saying that such things didn't happen in Dresden?"

"No." Sigerson glanced at me. "Suffice it to say I was there, and standing not three paces from you for several hours, Watson, and you saw me not. And yet Mrs. Dodson—er—rumbled my lay within five seconds. That is why we have included her in our cogitations tonight. I suggest we get down to it."

Respectfully Watson offered me more brandy, which I refused. He sat in the other leather armchair and began, "Dr. Mason very kindly invited me to view the body. Judging from the condi-

tion of the corpse, and certain indications about the nose and mouth, she was asphyxiated—smothered."

"Smothered!" Mr. Sigerson straightened at the mantel. "With what, man? Could you tell?"

Dr. Watson pulled an envelope from his pocket. "I collected a couple of threads we found inside her mouth," he said.

Mr. Sigerson caught up a magnifying glass from a drawer of the desk, pulled the lamp closer to the blotter, and on a clean sheet of paper emptied the envelope's contents.

Along with Dr. Watson, I stood at Mr. Sigerson's shoulder as he pored over the strands. "Wool, undoubtedly," I murmured.

Mr. Sigerson looked up at me. "Correct," he said. "Fine merino wool spun at Macclesfield millworks. I recognise the twist." He straightened and gazed down at the strands on the white paper. "Such wool is not often employed in shawls, so it is unlikely to have come from Miss Hanover herself."

"Her shawl is grey cashmere," I offered.

"Ah, you have the advantage of knowing the ground, Mrs. Dodson. So, not her own garment, but someone else's." He steepled his fingers and held them to his face, frowning.

Speaking of Miss Hanover's garments led my thoughts in another direction. "Dr. Mason said her collar was laid back and folded in neatly," I said hesitantly. "I've been thinking about that all day. Would a murderer or someone who wished to make it look like the work of vampires take so much effort with her collar?"

"What is your point, Mrs. Dodson?"

"It is more as if she did it herself," I murmured, trying to speak with confidence in the face of that daunting intellect. "Except that it would be quite out of character for Miss Hanover to do such a thing. I cannot imagine any circumstance—" An idea occurred to me and I stopped speaking momentarily to pursue it in thought.

"What is it? What circumstance?" Mr. Sigerson prodded me, coming quite near, his face thrust close to mine.

"She would indulge in such behaviour, perhaps, if she were

betrothed, or thought herself betrothed. She might wish to appear more—more—"

"Quite," Mr. Sigerson said, his lips quirking. "This is sheer conjecture, of course."

"Of course," I agreed, but still letting my conjecture carry me along. "It is true, however, that she was having proprietary feelings about Percy Staines—the false curate, you know."

"He is much younger than she was," Mr. Sigerson said, watching me keenly.

Pacing up and down the carpet, I brushed away this cavil. "He is perhaps twenty-seven or -eight, and she is—was—little more than forty. It is not unthinkable for her to conceive a passion for him. Other women have done it for men as unsuitable." Aghast, I stopped, but forced myself to go on before the men noticed my hesitation. "According to some gossip, she has been preoccupied with bridal thoughts lately."

"You are suggesting that Percy Staines is responsible for her death. But why would he kill her?" My employer's inquiry seemed designed rather to draw me out than to pose a question he could not answer himself.

I could not resist the bait. "She and her brother have been residents of the parish for the last fifteen or sixteen years. She would have been here, then, when young Percy made such a scandal in the village. Perhaps she recognised him. Mrs. Clithoe almost recognised him last Sunday, and Miss Hanover has seen a good deal more of him than anyone else has. Also, as a collector of gossip, she undoubtedly knew of the furore that was raised when he visited Larchbanks some years ago."

"So she discerned his true identity, you think." Dr. Watson's forehead corrugated with thought. "But why, if she knew him as a youthful malefactor, and as a present-day imposter, would she wish to marry him, assuming she did?"

I wondered how to explain to the gentlemen the desperation some women feel when they realise they are likely to be spinsters until they die. "Some women feel that even a poor choice of husband is better than none at all. He appeared to be one of the

clergy, and he probably had some glib reason for using the alias—
that he had reformed, but was afraid the townspeople would go
against him if they knew who he was. He is thought by the ladies
of the village to be handsome. Perhaps when she showed that she
knew who he was, he tried to sweet-talk her into keeping his
secret. She thought that gave her a strong enough hold to wring
marriage from him."

"There is no proof whatsoever," Dr. Watson protested.

"It makes a great deal of sense, though," Mr. Sigerson replied.

"But if he's such a bounder, why stay here where he's being
pressed to marry so distastefully? Why not just leave?"

"He is here after the Orb of Kezir." Mr. Sigerson seized the
narrative from me as I stopped for a thirsty gulp of what remained
of my brandy-and-soda. "If she reveals his secret, he will no longer
be able to pursue his enquiries here. Perhaps he thinks to put her
off until he can find the Orb and vanish. But she urges him to
make their intentions public, perhaps to read the banns. When
she offers her less-than-appealing charms, he is unable to feign
the necessary ardour. Perhaps she sees his distaste and threatens
him with immediate exposure. They struggle, and in trying to qui-
et her, he suffocates her with his cloak." Turning triumphantly
back to the desk, Mr. Sigerson pointed to the strands. "Woven of
merino wool from a mill that supplies goods to institutions such as
the Church of England for clerical garb!"

We were all silent for a moment, turning it over. "And the
marks on her neck?" Dr. Watson ventured.

"Intended to throw off suspicion. He hadn't meant to kill her,
I imagine, and panicked when he realised she was dead. He
hoped the Sussex Vampire would be blamed and that would be
that. He didn't realise that a horde of pressmen would descend on
the area, bringing a fever pitch of scrutiny."

"Richard Mason said the whole village has been talking of the
vampire." Dr. Watson had a meditative sip of brandy. "It would
have been a natural thing for your curate to seize on as a scape-
goat. Used his penknife to make the marks, do you think?"

"More than likely. When you go back tonight, old chap,

perhaps you could call in and tell Constable Ritter to confiscate Mr. Staines's penknife. He has cleaned it, I am sure, but it is possible to find and group even very small traces of blood."

"That would help, because there's no hard evidence here." Dr. Watson looked troubled. "Not a shred."

"Only a shred." Mr. Sigerson carefully fitted the strands back into their envelope. "Constable Ritter should have this, too. He is watching the false curate to prevent his escape. This will give Ritter a reason to have Staines detained." He caught my questioning look. "Ritter and I worked together once, several years ago, when he was a young P.C. in Hampstead. He has the greatest respect for my methods."

Watson accepted the envelope. "So you have solved the case of the Sussex Vampire." He frowned. "That has a familiar ring to it."

"This one is not for the annals, Watson." Mr. Sigerson held up an admonitory finger. "It is muddled and incomplete, and I have not distinguished myself. Much of the credit is owed to Mrs. Dodson. Do not think of publishing it."

"Don't worry, old chap." Dr. Watson clapped his friend on the shoulder. "You have wrapped it up quite neatly."

"Perhaps." Sigerson picked up his pipe again and regarded us from his position at the mantel. "And then there is the little matter of the murderous Colonel Moran."

"Oh, yes." Watson slumped a bit. "That is still on the table, isn't it?"

Sigerson nodded. "That is why, tomorrow morning early, when you receive a telegramme from the prefect of police at Dieppe, you will go at once to Newhaven and embark for France. You may be sure that news of your wire will be all over the village."

"To Dieppe? There is a trail to pursue there?" Dr. Watson's face showed his puzzlement.

"No, there is a trail to lay. You will draw off Colonel Moran, or at the least such of his henchmen as he's been able to gather." Mr. Sigerson clapped his friend on the back. "You should be in no danger, Watson, but I hope you carry your revolver?"

"Yes, I do." Dr. Watson was troubled, his loyal brow wrinkled in distress. "But, I say, do you really think it necessary? It leaves you alone to face danger. I don't like that."

"With any luck," Mr. Sigerson replied, "you will draw the danger off until I can get my defences in place. If I am to battle Colonel Moran, I prefer to chose my own ground." He bowed to me. "And to have the women in a place of safety, with all due respect, madam."

I bowed back, unable to say anything around the tightness in my throat. It seemed impossible that the matters they coolly discussed could actually threaten; but these men had been in danger together before, and I guessed that they did not exaggerate it now.

"How shall I arrange for this telegramme?" Dr. Watson picked up his stick, resigned to his role in the drama.

"It is all arranged," Mr. Sigerson said briskly. "Ritter and I have already discussed it. That new fellow from the Yard—what is his name?" He passed a hand over his forehead. "They come and go, it seems. At any rate, Scotland Yard is on the way, ready to apprehend Moran, if they can manage it. If this little matter of Miss Hanover's murder wraps up well, we can turn our attention to settling Moran once and for all."

"That will be a relief." Dr. Watson stood, pulling on his gloves. "You look burnt to the socket, old man."

"Nonsense. A perfectly understandable bit of strain." Mr. Sigerson escorted Watson to the door. "I shall be fine once I finish my monograph on the bees' dance of communication. Absolutely irrefutable, Watson! The Americans will be choked with chagrin, especially that Philistine, Henry Alley."

"But what of *The Whole Art of Detection?*" Dr. Watson paused, his hat in his hand. "Have you made no progress there, my dear fellow?"

"Later, later." Mr. Sigerson waved it away. "I have years to finish it, Watson—years in which my methods will be rendered obsolete by advancing science. And you can have no idea how absorbing bees are."

He accompanied Dr. Watson to let him out of the gate. It was

late; the case clock in the hallway struck eleven when I went the rounds of the downstairs windows, making sure all was secure. I could not stop my hand from shaking as I checked the fastenings. So much had happened since tea-time. The hard-won peace of mind I'd achieved after Maxwell's death was gone, replaced by seething conflict that threatened my well-being as much as the onslaught predicted by Mr. Sigerson threatened Larchbanks.

When I returned to the front hall, Mr. Bagshaw was just coming in, followed by Tim White, who'd been watching at the front gate all evening without seeing anything, including the visit of Dr. Watson. The doctor had more stealth than Mr. Sigerson had given him credit for, I reflected, accompanying Tim to the kitchen. Mrs. Clithoe and Violet had already retired to their rooms at the top of the house, and it fell to me to pack up a bite for Tim to take out with him to the stable. Not only did I lock the door after him, I bolted it with the heavy bar which had in all probability not been swung across to its socket for the last fifty years.

At last the house was quiet. Instead of seeking the solitude of my own chamber, I stole back into the front hall, wondering if I should check the French doors in the library. But from the other side of the door came the faint sound of pacing feet. Back and forth, back and forth... For a moment my renegade imagination conjured a picture of the man I knew as Mr. Sigerson, his passion directed not at bees, not at foiling criminals, but at the woman in his arms, who drew forth from him greater depth of feeling than he'd ever experienced—that woman being me.

Trembling at my own folly, I took myself to my solitary couch, to spend the night in unquiet slumber.

*There is no act of our lives
which can be performed without
breaking through some one of
the many meshes of the law.*

Chapter Seventeen

SUCH A CROWD ASSEMBLED the next morning for the inquest
into Miss Hanover's death that the proceedings were moved
from the Rose and Crown across the lane to the parish hall. Even
then several men had to stand in the back, shuffling their feet and
slipping out every so often for a smoke and a pull at their flasks,
judging from the activities outside the window nearest me.

Among those standing was the false curate, Percy Staines. It
surprised me a little that he was not in custody, but I supposed
there wasn't enough evidence to detain him yet. Perhaps the po-
lice were hoping for revelations from the inquest. I could see Con-
stable Ritter beside the door, keeping a close eye on our suspect.

The coroner was a leather-faced official from Arundel, whose
scowl did not change from the time the proceedings began. He
called first upon the verger, Mr. Trotten, who testified to finding
Miss Hanover's body.

"After Vespers it were," he said in his slow country voice.

"Mayhap as much as an hour—'twere gloamin' outside. Thinks I at first, Now who's left yon bundle of clothes in vestibule? But when I raise up me lantern, see, out shines her eyen, like so." He widened his own eyes, producing a rustle throughout the spectators.

"Was she alive?" The coroner fired the question at him impatiently.

"Nay. Dead as they lyin' yonder." Mr. Totten jerked his head in the direction of the graveyard. "Died with eyes open, she did. Firstways I thought she was taken ill, so surprised did she look, but she didn't move when I touched of her. With two leetle marks, just here." He put one thick finger on his neck. "Red, they were. Specks of blood, like as two teethmarks."

There was a gratified murmur from the multitude at this evidence of sensationalism. Beside me, Violet shuddered luxuriously. "Ooh, Mrs. D. It makes me blood run cold!"

I hushed her, storing up the information. Nothing contradicted our suppositions of the previous night. Percy Staines would naturally have been present at Vespers; he and Miss Hanover might have arranged an assignation after the service. Aghast, perhaps, at what he'd done, he'd left her there.

Next to be called was Dr. Mason. He gave evidence in his concise, matter-of-fact way.

"No sign of heart trouble. No sign of any degenerative disease. Miss Hanover was quite a healthy specimen. Based on lividity of the tissue and other indications, my judgement would be that she was suffocated. No, the puncture marks were undoubtedly made after death—I should judge with a sharp penknife. Otherwise, don't you see, she would have bled a great deal more than she did. Certainly not. No hint of vampirism to be found anywhere."

Around the room, journalists scribbled away. Their creativity would no doubt be equal to the task of turning that emphatic denial into a positive confirmation of vampires at work.

At that moment I was called. I answered the coroner's few questions with composure, smiling tranquilly at Squire Rutledge, who sat in the front row twitching with the urgent desire to

direct his own questions at me. This, however, the coroner did not allow.

The parish hall was full of familiar faces, displaying absorbed interest in this exciting event. At the back of the room, Percy Staines worried his fingernails. His forehead glistened with nervous perspiration, and he could not meet my gaze.

Also standing behind the benches was the elderly man I had noticed the day before at the Rose and Crown, holding his walking stick in caressing hands. His eyes, deeply lidded, moved incessantly over the crowd, his head turning back and forth like a cobra in search of prey.

Behind Squire Rutledge was a grizzled middle-aged farmer, with stout boots and gaiters and a countryfied coat that didn't quite cover an expansive middle. He appeared in no way unusual amongst the crowd of sensation-seeking country folk, unless one noticed the shape of his ears, just barely visible beneath the old-fashioned hat, and the slender, long-fingered hands that were clasped over his paunch. I did not indicate by any sign that I had guessed this farmer to be the tenant of Larchbanks in one of his disguises. Having sent Dr. Watson off, he would naturally want to view the inquest proceedings for himself.

"And you saw no evidence that Miss Hanover was frightened or upset?" The coroner did not bother to look at me while he put his questions.

"She seemed her usual self," I answered, lowering my eyes modestly.

"You may step down," the coroner droned. "Call Mrs. Eurydice Hodges to the stand."

Mrs. Hodges brushed past me, her pleasure at being center of attention concealed beneath a thin veneer of sorrow at her bosom companion's death.

I resumed my seat next to Mrs. Clithoe. We were occupying a bench in the back of the room, near a window that overlooked the High Street. Mr. Sigerson, in his farmer's kit, was three or four rows in front of us.

As I took my place I saw Percy Staines slip out of the door. Constable Ritter followed almost immediately, and right outside my window they accosted each other. I could not hear what was said, but Staines shook off Ritter's restraining arm and reached for the little flask I had seen him use before. He made an elaborate show of twisting off the cap and tilting it to his lips, as if he'd only come out for a nip like some of the country men who stood around. They shot scandalised looks at him; though he had left off his clerical collar, he still bore the unmistakable stamp of the clergyman, and such public tippling seemed out of place to them.

Grimacing as the liquor ran down his throat, Staines offered the flask with scornful courtesy to Ritter, who pushed it away.

Just then I noticed Mr. Bagshaw hurrying up the street. He had not been quick enough with his toilette to accompany his household.

Staines saw him and scowled, and Mr. Bagshaw scowled back. Their conversation the day before must have ended acrimoniously, probably with Staines threatening a challenge to the will. I reflected that Mr. Bagshaw would be relieved if Staines was convicted of murdering Miss Hanover. Then probate would not be held up by his designs on the estate.

Mr. Bagshaw pushed by to enter the hall, and with an unsteady shrug, Percy Staines followed. And Ritter followed him. If they had been elephants, they would have grasped each other's tails with their trunks. That such a frivolous thought took possession of me was an indication of how the events of the past days had upset the tone of my mind.

There was a brief flurry at the back of the room as the string of would-be elephants entered. Craning my neck in a most ungenteel way, I could see that the sneering, elderly man had evidently decided to leave just as Mr. Bagshaw was entering. Their collision was forcible enough to bring muffled curses from each of them. The elderly man pushed past Mr. Bagshaw and left the room.

Percy, too, shoved past the solicitor and advanced down the

aisle between the benches, looking for a vacant place to sit. But by this time the coroner had had enough of the unruly stir at the back of the room. He directed his frown at Percy, who responded by backing up until he was standing again behind the last row of seats.

"You were saying?" The coroner prompted Mrs. Hodges, who didn't need much.

"Bride of the Devil," she said, her shrill voice ringing out. "Terribly queer, I thought it."

The newspapermen wrote furiously, although judging from the papers I had perused that morning, they'd all heard the story before. The coroner, still bored, managed to extract the facts of Miss Hanover's strange behaviour from the embroidery with which Mrs. Hodges wished to surround it. The schoolmistress stepped down with a gratified smirk.

"Call Mr. Peregrine Simms, Curate," the coroner droned, evidently not up on the latest developments of the case.

Now others in the room were directing their attention to Staines. He was very pale, and sweating furiously. He blotted his face on his sleeve as he took the stand.

"You accompanied Miss Hanover back to the vicarage?" The coroner shuffled through the scraps of paper that littered the bench.

"Yes." The false curate ran his tongue over his lips.

"And did she say anything, do anything, to cause you alarm?"

Staines darted a look at the coroner and wiped his face again. "I—I don't know what you mean. She seemed the same as usual."

"What did you talk about?" Staines's nervousness finally made an impact on the coroner. He pushed away his papers and frowned at the witness.

"We—we discussed the church fête. The tea marquee. The jumble sale. That's all I remember." Staines gripped his hands together and stared straight in front of him.

The two villagers in front of me exchanged significant glances. Inevitably, rumours had gone around that the new curate was not

what he seemed, but from the feminine whispers I could detect, his support among the parish ladies was still strong.

The coroner stared at him, while I wondered why Constable Ritter did nothing. I went so far as to glance over my shoulder at him as he stood in front of the door, and received a wink for my troubles. There was no sign of the Scotland Yard detective who was supposed to arrive that morning.

"No further questions." Staines's audible sigh of relief was echoed by Violet, next to me. He left the stand with more haste than grace, and plunged out of the room. Ritter melted through the doors after him.

The rest of the inquest, for me, was anticlimactic. I did not know what was in the minds of those who were handling the investigation, to let the curate off the hook. What could restrain him from leaving the area, if he was not under suspicion of this crime?

The verdict was brought in, as "Murder by persons or things unknown," making it clear the country folk had made up their minds that vampires were indeed loose in the area. This view filled me with impatience.

"You see," Violet said to me on the way home. "All them men believe in the vampire."

"Men." Mrs. Clithoe, stumping along beside us, exhaled in an angry *whoosh*. "What do they know of aught? 'Tis the Evil One working through men that makes such trouble in the world."

"Violet, you can't think—"

"'Things unknown,' they said." Violet paid no attention to Mrs. Clithoe or, for that matter, to me. "They has their reasons."

"Triflers. Despoilers." Mrs. Clithoe, for her part, had no interest in Violet's prattle. She clenched her massive fists around the old leather purse she carried. "Eternal hellfire awaits!"

"Poor Mr. Simms," Violet sighed. "You could see he took it terrible hard."

I gave up any attempt to reason with them. All the way home I had Violet in one ear and Mrs. Clithoe in the other. When we

reached Larchbanks, I escaped to my own parlour under the guise of going over the household accounts.

Mr. Bagshaw had indicated that he would not be in to luncheon, planning instead, I gathered, to loiter around the Rose and Crown and chew over the inquest. Mr. Sigerson had asked at breakfast not to be disturbed until he rang, as he intended to work on his monograph. I took this to mean that he, too, would be in the village, his disguise allowing him access to all the gossip. It was infuriating, but until Constable Ritter or Dr. Mason called, or one of the male residents of the house deigned to return and acquaint me with their reasoning, I would not know why Mr. Staines had been allowed to escape the inquest unscathed.

I did indeed spend some time putting my accounts in order, but the fresh wind coming through my open casement, bringing the scent of new-blown roses and honeysuckle, was most distracting.

Finally, I gave in to restlessness. Mrs. Clithoe was just setting out the servants' dinner, but despite the appetising aroma of hotpot I was not hungry. I left Tim and Violet sitting down with the cook, and selecting a flower basket and some secateurs from the cloak-room, escaped into the sunshine.

Though the park at Larchbanks had been neglected, the kitchen garden and cutting beds were still kept in some order, and the roses on their sun-warmed walls were just bursting into bloom. I strolled along the path, cutting blooms of creamy Souvenir de la Malmaison and rosy Madame Isaac Pereire. Their fragrance was so intense as to be almost visible. I imagined that I could see it, floating upwards in the sun-moted air as a shimmering, rainbowed vapour. The beauty of the flowers and their rich scent stirred an ache inside me of longing and nostalgia—to return to that fuller, richer life I had once led, to turn away from a future of lonely drudgery.

For a moment, I felt like casting myself full-length on the turf beside the brick path and giving way to the emotions that buffeted me. Indeed, a few tears slipped down my cheeks before I could regain mastery of such weakness.

I did not want to go back inside until the traces of tears had been obliterated. Instead I strolled to the orchard, drawn by the contented hum of the bees, and stood for a while watching them from the shade of the apple trees. A couple of the industrious insects discovered the flowers in my basket, and bustled from one to the next, so involved in their task and their own importance that my looming presence made no impression on them whatsoever. They nuzzled the roses' golden hearts without knowing or caring that I could, at any moment, put an end to their existence. A shiver of apprehension chased up my backbone, and made me glance uneasily behind me.

There was no one around, of course. Larchbanks stood, as usual, drowsing under the midday sun. I could even hear, if I strained my ears, the clank of cutlery and the subdued murmur of conversation from the open kitchen door as the staff enjoyed their dinner.

My gaze passed the drawing room windows, the library—

A thin dark line showed between the French doors of the library. It was no doubt a shadow, a trick of the bright sunlight, that made them appear ever so slightly open.

I allowed my eyes to pass over this discrepancy, to travel up into the sky for an intent perusal of certain puffy white clouds, as if I suspected them of harbouring rain. And then I turned away from the orchard, back through the walls of the garden, strolling casually, a woman with nothing more on her mind than selecting the right vase for her flowery booty.

But once I had gained the cover of the garden, I bent my footsteps to finding the most direct route to the French doors. There was probably nothing amiss, but I took care to go as quietly as I could, and to pull my grey shawl up around my head, in order to blend in a trifle with the stone walls.

Creeping along those walls past the drawing room, I reflected that I had never expected to spend so much time in clandestine pursuits around Larchbanks as I had during the past week. And yet, what should have been repugnant to the daughter of a vicar

and one whose moral fibre had never before been called into question was, instead, exhilarating.

The curtains of the French doors were closed, as indeed Mr. Sigerson preferred them to be. But I had not been mistaken. The doors were very slightly ajar. And the wood beside the latch showed clearly the marks of coercion. Someone had forced a way into the library since I had made the rounds of the house before leaving for the inquest that morning.

I could hear rustling noises inside, and the faint sounds of other movement. Thankful that the closed curtains hid me, I pushed the window open a little more. Through the resultant gap, most of the room was visible.

At first I could not find the source of the noises. Then I heard a whispered chant, and saw Percy Staines, on his knees beside one of the deep desk drawers, pulling everything out and tossing it over his shoulder. He was muttering to himself, and after listening a moment I could understand the words: "It must be here. Where did the old bugger hide it? It's here somewhere."

I meant to step silently through the curtains and confront him.

Instead, my foot caught in the hem of my skirt and I stumbled against the French door, entangled in the trailing fringes of my shawl. The windows' leaves burst open, precipitating me helplessly into the library.

Milk…is a good deal thinned with water, and sometimes thickened with starch, or colored with yolk of egg, or even saffron, but these processes have nothing murderous in them.

Chapter Eighteen

PERCY'S REACTION WAS as dramatic as my entrance had been. He leapt to his feet, his eyes bulging. His face was that of a man near the brink of madness; he put out his hands, as if warding me off, and with a piercing, endless shriek worthy of Mrs. Clithoe, tore out of the room. By the time I regained my balance and reached the hall, he was halfway down the drive, his long, black-clad legs moving with astonishing rapidity.

Mr. Bagshaw, just turning in at the gate, managed to jump out of the way in time to avoid being mowed down by Staines, who vanished in the direction of the village.

"What's ado?" Mr. Bagshaw came panting up the drive at a brisk trot. "Has Mrs. Clithoe been at it again?"

"No, indeed," I said, staring thoughtfully at the dust cloud that the false curate had left hanging in the air. "I found Mr. Staines in the library, rifling the desk. Upon seeing me, he fled."

"Rifling the—why, of all the effrontery!" Mr. Bagshaw cleaned

his glasses agitatedly. "What was the fellow after? B'god, Mrs. Dodson, things get queerer and queerer here!" He pushed past me to the door of the library and stood contemplating the carnage. Joining him, I realised that Percy must have been searching for some time. Books were flung on the floor, papers strewn everywhere, all the desk drawers were gaping open, and a small wooden box with a locked hasp had been smashed with the poker.

Mr. Bagshaw was rendered speechless for the space of a full minute. When at last he could talk, his outrage knew no bounds. "The fellow should be locked up," he sputtered. "We must fetch the constable immediately. We must see that the full weight of the law is brought against him. That such a thing could happen, right here, right under my nose!"

"It is shocking indeed." I picked up the inlaid wooden box, turning it in my hands. The major had found it in Spain, during his last billet there, when he'd commissioned the desk and Bible stand. It had contained a couple of old doubloons he was fond of saying had come from the coffers of Philip II. This I had taken leave to doubt; suffice it to say that the doubloons, spurious or not, were no longer in the box.

Mr. Bagshaw plucked a paper up from the heap on the desk and looked at it despairingly. "What is to be done, Mrs. Dodson? Impossible to restore order before Mr. Sigerson discovers it."

"Indeed, I would not try." I removed the paper from his grasp. "Mr. Sigerson must know, and the sooner the better."

"I don't understand." Mr. Bagshaw wrung his hands. "Whatever was the wretched fellow after?"

"Perhaps something that would prove him the heir of his stepmother," I suggested. There was no point in mentioning the Orb of Kezir, although I felt sure that Percy had risked one last rummage for it. Or was it to be the last one? If he was bold enough to search the library in broad daylight, what might the night bring?

I began to pick up books and restore them to their shelves. That much, at least, was within my power, although I did not think it wise to touch Mr. Sigerson's papers. And fearful that

something importing to his true identity might turn up, I would not let Mr. Bagshaw touch them either, when he began to fuss around the desk. "Leave it be, if you please," I told him. "Mr. Sigerson's papers are private. He will wish to tidy them himself."

"Really, Mrs. Dodson," Mr. Bagshaw began. "As a solicitor, I am well acquainted with the confidentiality of personal papers—"

"What has occurred now?" The voice was Mr. Sigerson's. He stood in the doorway, surveying the wreckage of the desk.

"My dear sir—" Mr. Bagshaw bustled forward. "I wouldn't have had this happen for the world! So very sorry—really, I think the fellow must be deranged."

"Don't bother to tell me," Mr. Sigerson said, speaking more to me than to Mr. Bagshaw. "I suppose it is Percy Staines again?"

I nodded. Mr. Sigerson paced swiftly to the French window, gave one comprehensive glance around the small terrace outside, turned and subjected the room to the same searching gaze, and nodded. "You must stop confronting intruders in this intrepid fashion, Mrs. Dodson," was his only remark. "So far you have been lucky. Next time—"

"Indeed, yes," Mr. Bagshaw cried. "I had not realised that Mrs. Dodson chased him off, singlehanded. Very foolhardy, madam."

"It was rather easy," I said, remembering the look on Percy's face. "I surprised him, and he ran away."

"Your flowers," Mr. Sigerson said, reaching through the window to rescue my basket. The roses were no longer as fresh and lovely as when I had picked them; already their petals were wilting.

I regarded them ruefully. "I must put them into water. I shall return, sir, and help you set the library to rights."

Mr. Sigerson shrugged and threw himself into the chair behind the desk. "It will take most of the afternoon," he grumbled, "and I can see that the pages of my manuscript are intolerably mixed."

"Manuscript?" Mr. Bagshaw perked up his ears. "You are writing a book, Mr. Sigerson? How interesting."

Mr. Sigerson's nose twitched. "Yes, extremely interesting," he said, bending the force of his personality on the hapless solicitor. "About bees, my good fellow. You are interested in bees?"

"Well—" Mr. Bagshaw blinked. "I have never really—"

"Let me tell you a bit about them." Mr. Sigerson jumped up and pushed Mr. Bagshaw into the nearest chair. "The bee is an amazing creature, with a social structure that man might do well to emulate, although of course the philosophical implications of so rigid a monarchy might be difficult to reconcile with the Jamesian proposition of Free Will...."

I closed the door gently behind me as I left the library. Arranging the flowers was accomplished by finding a large vase and thrusting them into it; I was surprised at the charm this artless method produced. By the time I had placed them in the drawing room and returned to the library, Mr. Sigerson was once more seated behind the desk, working rapidly through his papers, and Mr. Bagshaw was nowhere in sight.

"Mr. Bagshaw decided not to stay?" I restored volumes one and two of Shakespeare's *Tragedies* to the shelves.

"He felt in need of a rest, he said." Mr. Sigerson's gaze met mine for a moment, and his lips quirked up in a brief smile. "I am persuaded you could also use a rest, Mrs. Dodson, after the shock of your experience."

"Not nearly so much of a shock for me as for Percy Staines," I remarked, smoothing the crumpled pages of Hakluyt's *Voyages*. It was a first edition, I noticed absently, and might bring a pretty penny when the contents of the library were sold. "He looked as if confronted by a ghost when I fell through the window."

"Perhaps he thought you were a ghost." Mr. Sigerson fished up my shawl from beneath one of the curtains. "Were you wearing this? Miss Hanover, I believe you said, customarily wore a grey shawl?"

"Why, that is so!" I went to take my shawl from him. "I believe you have hit on it, Mr. Sigerson. He has been nervous, over-wrought, since committing his heinous crime. My entrance was a

shock. Nothing more natural than for him to believe me his victim, come back to haunt him."

"You and Watson would seem to have similar gifts for narrative," Mr. Sigerson said, his voice cool. I took it as no high compliment, considering his remarks to Dr. Watson the previous evening.

This dash of figurative cold water made me realise I had been in danger of forgetting my place. Despite his condescension in soliciting my viewpoint on the problems that beset Stafford-on-Arun, he was still the master, I the servant.

We worked in silence for a while. Tea-time approached, and I wondered how Mrs. Clithoe was bearing up under the continued strain of cooking for Mr. Bagshaw, who had arisen that morning complaining that the *foie gras* sandwiches had disagreed with him.

"I must go," I said at last, after a glance at the watch pinned to my shirtwaist. "We serve tea in the drawing room in half an hour, sir."

Mr. Sigerson grunted by way of reply. He was no longer bothering to straighten his desk; instead, with a pencil in hand, he was lost in annotating the pile of manuscript before him.

The kitchen was a scene of frenzied activity. Violet prepared the sandwiches—mustard-and-cress this time—and Mrs. Clithoe was deep in the intricacies of pastry for the Beef Wellington we had planned for dinner.

I unlocked the plate cabinet and assembled the tea service, wondering how much longer we could keep up this scale of entertaining with only Violet and myself to assist Mrs. Clithoe in the kitchen, on top of trying to keep the house in order. I did not like to ask Mr. Bagshaw to authorise hiring someone from the village. He kept a very careful eye on the outgo, and if I proposed someone to take Rose's place, he would very likely dock poor Rose while she recovered from her nerve storm.

This difficulty occupied me as I poured drawing-room tea for Mr. Bagshaw and, belatedly, Mr. Sigerson. As Mr. Bagshaw was

still brooding over the outrage of the afternoon, and Mr. Sigerson evidently brooding likewise over his manuscript, tea was not a conversable occasion. At least it was soon over, but not before Mr. Bagshaw had downed all the mustard-and-cress sandwiches, and several Maids of Honour.

There was no rest after clearing tea. While preparing the vegetables in aspic to serve as a remove to the Beef Wellington, I confided my concerns about Rose to Mrs. Clithoe.

"All for that want-stomach, Mr. Bagshaw," she huffed, embellishing her creation with wonderful pastry ornaments. "What I say is, we do what we can, Mrs. Dodson. If that nasty Mr. Bagshaw doesn't like it, mayhap he'll take himself off the sooner."

This sensible view did much to alleviate my concerns. Rose would surely be up to returning in a few more days, and until then we would, as Mrs. Clithoe remarked, cut our clothes to suit our cloth.

After dinner, Mr. Bagshaw complained of headache, and after procuring a hot water bottle and a posset from an exasperated Mrs. Clithoe, removed himself to his room. I helped clear away, and then went to finish my self-imposed task of restoring order to the books in the library. When that was done, I would consider my responsibility there finished, since Mr. Sigerson's papers were in no worse case than usual.

He was in the room before me, pacing up and down in front of the hearth, his pipe in his mouth and his hands clasped behind his back. "Need you fuss with that?" His greeting was irritable.

"I shall only tidy away the books, sir, since they would suffer from being left in heaps," I retorted with some asperity. "It will be finished soon, and you will have your solitude back."

His scowl lightened a little. "It is not solitude I require so much as assistance in unravelling the tangled threads of this problem."

"You do not feel then," I said after a moment, returning the *Life of Samuel Johnson* to its place on the shelf, "that once Percy Staines is apprehended the problem will be solved?"

He stared at me blankly for a moment. "Oh," he said at last. "Staines. Yes, of course. His was undoubtedly the hand that felled the vicar's unfortunate sister." He waved his pipe in dismissal. "That, I'm afraid, is not the problem that exercises me tonight."

I shelved a volume of Tennyson. "It is your enemy you concern yourself with," I stated, more to myself than to him. "You fear his assault."

"I anticipate it," he said with a slight frown. "It would have been better to have stopped where I was. Now I have thrust the household of Larchbanks into danger."

"Nonsense," I replied stoutly, though a tremor of fear did stir through me. "So implacable a foe as you have described this Colonel Moran to be would not use the same method twice. This time, he will no doubt wish the attack to be face to face, so as to make sure of your decease." The words increased my inward perturbation. In vain did I wish for some method to ensure this man's safety! But I might as well wish for him to return my regard; one event was just as likely as the next.

"You are probably correct, Mrs. Dodson, as usual." Mr. Sigerson's eyes met mine for a brief moment. I blinked, thinking I must have imagined the momentary warmth I saw there. "It is that which has me in a puzzle. I would like to anticipate the mode of our coming confrontation, to be prepared. But how to anticipate a madman?"

I turned away, busying my trembling fingers among the books. "You think him mad, then?"

"I am sure of it." I heard Mr. Sigerson's footstep behind me; his hand on my shoulder turned me to face him. "Mrs. Dodson, I—" He hesitated, searching my face. "I really must tell you—"

A movement at the French window behind him caught my eye. I saw a round, staring face pressed against the glass. For one paralysed instant I believed it to be the mad assassin himself, come to wreak his vengeance.

For that space of time I could not move, could not act. I be-

lieve Mr. Sigerson must have thought *me* mad, reading the horror on my face.

Then everything happened at once. I shrieked, and flung myself on Mr. Sigerson, trying to bear him to the floor, out of range of attack.

He staggered under the impact—I am not one of those sylphlike women—but managed to thrust me behind him with unexpected strength, turning to face the threat from the window.

And in a repetition of the afternoon's events, the French windows swung open, and a figure fell into the room.

For the space of a couple of heartbeats there was silence. Then I scrambled out from behind Mr. Sigerson as he began to approach the figure. "It is Percy Staines," I croaked, in a voice I hardly recognised as my own. I understood why he had fled, screaming, that morning! It took a while to bring my breathing under control.

"It was," Mr. Sigerson said in an odd voice. I crept nearer to the man who lay sprawled on the floor, black-clad arms and legs splayed around him. He made no motion. Mr. Sigerson knelt beside him, and then sprang up. "There is nothing that can be done for him." He vanished through the French windows into the night.

With a few deep breaths, I mastered myself, and approached Percy. He lay face-down on the Turkey carpet. I ventured to pick up his hand, and place my fingers upon his wrist. I could discern no pulse. His hand was cool and rather clammy; I dropped it quickly.

Pushing at his shoulder, I managed to turn him enough to expose his face and upper torso to the light; the term "dead weight" took on new meaning for me. I could not repress a gasp as I looked into his contorted countenance. The once-handsome features were almost unrecognisable. His eyes were open and glaring, his eyebrows raised high in doomed surprise.

I forced my gaze away from that horrifying face and noticed that his neckcloth and collar were loosened. There on his neck,

showing as two small, red points, were the marks I had heard described at the inquest—was it only that morning?

I was still staring at them when Mr. Sigerson's footstep sounded on the terrace and he came back through the French windows. He uttered a muffled exclamation and dropped his handkerchief over the dead features. "My dear Mrs. Dodson," he exclaimed, helping me to my feet. "I am sorry indeed that you saw such a fearsome sight."

I passed a hand over my forehead. "I have seen death before," I managed, but I did not refuse the glass of brandy Mr. Sigerson pressed into my hand. "What did you find outside?"

He poured another brandy for himself. "The marks are indistinct, and it is difficult to see them in the dark. But I would guess that Mr. Staines walked up the drive and came around here, perhaps looking in the front windows. He appears to have been accosted by someone, and dragged the short distance to the terrace. There are clear marks in the gravel beneath the windows, but I could see no defined track of the second person in the gravel or on the grass." He swirled the brandy in his glass moodily, then tossed it off. "I met Tim White on his way to the stable, and asked him to go for Constable Ritter." He eyed me. "You have not finished your spirit, madam."

Mechanically I raised the glass to my lips. No matter how I tried to find something else at which to look, my eyes were continually drawn back to the sprawling, black-clad figure on the floor. And I was stricken with the notion that we had been wrong. Could Percy have murdered Miss Hanover, if he himself was murdered later?

When I managed to express these thoughts to Mr. Sigerson, he accorded them one of his quick frowns. "Make no mistake, Mrs. Dodson," he said, flicking his fingers at Percy's mortal remains. "Staines must have killed Miss Hanover. There is no doubt in my mind. She was suffocated with his cloak. And—" He knelt beside Percy's body, going through his pockets. I watched with horrified fascination. "Eureka!" Mr. Sigerson triumphantly held up

a silver-chased penknife. "Ritter was unable to procure this before." He took a lens from his waistcoat pocket and scrutinised the blade. "I fancy there may be a bit of a stain here, where he made the vampire's marks." He wrapped the penknife in his handkerchief and then, with a muffled exclamation, studied the frightful expression of the corpse's face. He bent, sniffing at the contorted lips. "Spittle," he muttered, "foam, that smell—hmm."

Constable Ritter arrived just then, bringing with him Dr. Mason and a cart to take away the body. The library seemed full of men. Ritter and Mr. Sigerson conferred in one corner, while Dr. Mason examined Percy's body. Though the commotion did not wake Mrs. Clithoe and Violet, who slept on the third floor, Mr. Bagshaw made an appearance in his dressing gown and slippers, demanding to know what had happened. It seemed for one moment that he would pack and remove himself immediately to the Rose and Crown, but we were not to be so fortunate. He joined the men in the library, and from the expression on his face as he glimpsed the body, was never nearer casting up his accounts.

After giving my version of the events to Constable Ritter, I slipped away. I was fatigued to the point of unconsciousness, and yet into the night I lay in my bed, unable to close my eyes without seeing the staring gaze of dead Percy Staines.

However, just before sleep finally came to me, I remembered that Mr. Sigerson had been about to say something to me, when all the excitement had started. Something that I had thought might be of a personal nature. Would I ever know what it was?

*It is held as a rule, that a gravel
soil is superior to any other, as
the rain drains through it very
quickly, and it is consequently
drier and less damp than clay.*

Chapter Nineteen

M R. Bagshaw was waiting impatiently in the dining room
when I took in the curried eggs next morning.

"You are abroad early today," I said, noticing that his tie had
been knotted hastily and a fleck of shaving-soap still adorned one
leathery cheek. "I fancied after the disturbance last night you
would be recouping your strength."

"Disturbance," he said, with a great deal of energy. I lifted the
lid from the chafing dish; his nose twitched. "I wonder you can be
so moderate in your choice of words, Mrs. Dodson, indeed I do!
One would think murder and depredation a common occurrence
at Larchbanks!"

I drew myself up. "Not common, sir. Quite the contrary. It has
really strained the staff's resources to cope with it all." I thought
of Violet, who, upon being informed of the death of the false cu-
rate that morning, had commenced having hysterics, much to old
Thurlow's gratification. He had hobbled up the kitchen walk

at first light to glean every drop of tittle-tattle for his cronies in the village.

I meant, by my words, to imply that we could do without visitors of Mr. Bagshaw's ilk just then, but he drew a different conclusion.

"The house should be shut up," he proclaimed, advancing on the curried eggs. "We must see to it, Mrs. Dodson. I'm sure Mr. Sigerson will be only too happy to escape the malign influences here." He mounded eggs on his plate and looked around pettishly. "Where are the kippers? Where is the toast?"

"In a moment." I retreated to the kitchen, wondering if I should seriously consider removing to Mr. Bagshaw's Cornish cottage.

Violet still wrung her hands, but in relative quiet, having been cowed into quiescence, I guessed, by Mrs. Clithoe. This worthy lady was stolidly toasting bread and poaching kippers as if a murder or two in the house was nothing to get worked up about. Thurlow, his nose deep in a tankard of ale, had pulled his bench into the open doorway, where the sun made a square of brightness on the stone-flagged floor.

"Who'll be next? That's all I say. Who'll be next?" Violet's voice grew shriller, and I decided against sending her into the dining room with the tray of toast and kippers.

"I do not believe you need worry, Violet," I told her briskly, on my way out with the tray. "And there is a great deal of work to be done, if you could see your way clear to doing it."

Mr. Bagshaw accepted the additions to his breakfast with a grunt, perusing the newspaper that had been delivered earlier. Mr. Sigerson was not yet in evidence.

Ordinarily I would have sent Violet up to bring Mr. Sigerson a cup of tea and inform him of breakfast. This morning Violet seemed incapable of any such rational action. And Mr. Sigerson was not likely to be found tamely asleep in his bedchamber.

The library door was shut. I knocked, and after a moment was bid to come in.

The thick haze of smoke in the room told its own story. Through it I could perceive Mr. Sigerson, his face haggard, the front of his smoking jacket scattered with ash. He stood beside the mantel, a pipe clenched between his teeth.

"Breakfast, sir." Here, too, were newspapers, scattered over the divan, the pages mutilated where some snippet had caught my employer's fancy.

"Is it morning so soon?" He glanced at the heavy curtains, drawn tightly against any hint of the outside.

"Mr. Bagshaw is down already." I longed to throw the curtains back, open the windows, and let in the crisp breeze from the downs.

"I shall have to hurry, then, if I wish to seize a morsel." Mr. Sigerson's face relaxed briefly in a smile, and he brushed past me through the door. "I will go up and attend to my toilette."

I watched him mount the stairs, taking two at a time in long strides. Turning back into the library, I noticed from the corner of my eye that instead of going into his own room, he had proceeded further down the hall, past the modern convenience as well, in the direction of Mr. Bagshaw's room.

I managed a quick cleaning of the library hearth, a brief airing of the room, before hurrying back to the kitchen. Mr. Bagshaw would, I knew, have made great inroads on the eggs and kippers, and since Mr. Sigerson had for once evinced an interest in food, I was determined to see that he got some.

Mrs. Clithoe was sitting at the deal table, placidly consuming her own hearty meal. Violet drooped across from her, taking mournful sips from her teacup. There was no sign of Thurlow; he was probably halfway to the village by now, to discuss the happenings from his usual bench in front of the Rose and Crown.

"Mr. Sigerson will want his breakfast soon," I announced, heading for the range. "Don't get up, Mrs. Clithoe. I can prepare it."

The cook let her massive form back down in the chair. "He's fond of a rasher or two, is Mr. Sigerson," she reminded me.

Violet shuddered luxuriously. "How anyone can eat at a time like this," she moaned. "Poor Mr. Simms. Struck down, right here at our feet, and him so young and handsome!"

Mrs. Clithoe snorted. "A deceiver, that's what he were! Why, it's all over the village that he was an imposter! Never was a curate at all." She looked significantly at me. "I did hear as he was Major Fallowes's niece's step-son, that nasty boy who caused all the trouble years ago. Sniffing around, he was, to see what he could get, once the old major was dead. Such goings-on!"

Violet was unconvinced. "I don't know about that," she said, tossing her head. "All I know is that the vampire is here—waiting! Waiting for one of us!" Her voice climbed higher, and I could see another bout of hysterics threatening.

Mrs. Clithoe leaned across the table and delivered one deliberate slap across Violet's cheek. "None of that, now." She filled Violet's cup. "Drink your tea and give over thinking about what doesn't concern you."

Violet stared at her, caught between outrage and submission. I turned the rashers and then went to put my hand on Violet's shoulder. "Would you like to go to your mother and stay with Rose for a couple of days?"

She hesitated, looking up at me. The safety of home was evidently not strong enough to override the excitement of Larchbanks.

Mrs. Clithoe disapproved. "Send the girl home!" she exclaimed. "Now, Mrs. Dodson, you know we're shorthanded as it is. Not that there's been much work lately out of that one," she added, with a disdainful nod towards Violet, "but she's better than nothing."

"We can manage." I went back to the range, taking up the rashers and arranging eggs on a serving plate. "Mr. Bagshaw wishes us to shut up the house anyway."

"Him!" Mrs. Clithoe surged to her feet. "I don't leave my kitchen at any man's bidding, least of all him," she said deliberately. "There's nothing here for the godly to fear." She eyed Violet. "I

set no store in that vampire notion. And be you sure, girl, that none would be interested in killing you."

Violet bridled at the assumption that she was of no importance to a vampire. I left them to it, and carried Mr. Sigerson's breakfast into the dining room.

Mr. Bagshaw was still there, discussing a cup of coffee. He eyed my tray with great interest. "What's this? I really couldn't eat another bite, Mrs. Dodson."

"Indeed?" The chafing dishes held only the remains of the curried eggs and kippers, and the toast rack was empty. "This is Mr. Sigerson's breakfast. He will be down soon, I expect." The toast rack needed to be refilled, but I could not leave Mr. Sigerson's breakfast undefended against so rapacious an eater as Mr. Bagshaw.

Instead I busied myself checking the coffeepot, and as Mr. Sigerson came in I poured him a cup, lifted the cover from his dish, whisked away the toast rack, and left the room.

When I returned with fresh toast, Mr. Sigerson was deep in his breakfast, answering with monosyllabic grunts Mr. Bagshaw's rain of questions.

"So they found nothing to help them, no clews whatsoever? These country police—just not up to such an inquiry." Mr. Bagshaw seemed to find a degree of satisfaction in the dereliction of the rural constables. "Why do they not call in Scotland Yard?"

"As to that," Mr. Sigerson said, reaching for the toast, "the Yard can only be called if there is a connection to a case in the metropolis; you should know that, Mr. Bagshaw."

"Well, yes," the solicitor said, taken aback. "But surely they cannot imagine this is a Sussex matter? We have no such troubles in the ordinary way. It is someone from London, some pernicious outsider, causing all the ruckus."

"Perhaps." Mr. Sigerson glanced at me, where I lingered by the door. "I, at any rate, have the utmost confidence in Constable Ritter. In fact, I am expecting him to call round at any moment. He wishes to look over the ground in daylight."

"Poking and prying again?" Mr. Bagshaw frowned. "I do not know how much more of this my nerves can stand."

"Perhaps you should return to Littlehampton." Mr. Sigerson made the suggestion smoothly, and I sent him a grateful look. If only Mr. Bagshaw would leave, and cease annoying us with his requests for hot water bottles and his constant complaints about the cleanliness of his boots and the state of his digestion! I made no doubt that after all the curried eggs he'd put away, he would want a special posset or some such quackery from Mrs. Clithoe, and she rumbled like an irritated bull mastiff at the mention of his name.

Unfortunately, Mr. Bagshaw could not desert us, or so he claimed. "No, no," he said, rising from the table. "I could not think of leaving you here to withstand the assaults of our crude village constable, Mr. Sigerson. I can never forgive myself for being instrumental in your ill-advised tenancy here! If you would but avail yourself of that other property of which I spoke—"

Mr. Sigerson held up one hand. "Enough," he barked, and Mr. Bagshaw fell silent. "I have explained that my bees are not to be disturbed, at least for the next few days," he added more quietly. "I have no wish to remove, and no fear of staying. The staff, however, is a different matter. I agree with you, Mr. Bagshaw. The women especially should find sanctuary somewhere else." His gaze found mine briefly, its message commanding.

I lifted my chin. "Violet may well be better off with her mother and sister," I said steadily. "But Mrs. Clithoe does not wish to leave, and I for one will not attempt to make her go."

Mr. Bagshaw blenched. "No, no," he said hastily. "If she will not see reason, there's an end to it." His voice pettish, he added, "I must say, Mrs. Dodson, I'm surprised you don't assert your authority over your staff."

Collecting the empty plates onto my tray, I paused in the doorway. "In this case it would be difficult." I met Mr. Sigerson's gaze steadfastly. "Because I myself have no intention of leaving."

Mr. Bagshaw shook his head at the stubbornness of women.

But I thought I saw in Mr. Sigerson's face a small flicker of reluctant admiration.

The front door bell rang as I crossed the hall. I had not expected Constable Ritter to come to the front. But I could think of no one else who would show up so early unannounced.

It was not Constable Ritter. Instead, Harold Bagshaw burst across the threshold.

"Harold! What in the world—"

"Is Uncle all right?" His face showed a mixture of worry and excitement. "I came as soon as I got the message."

Mr. Bagshaw bustled into the hall behind me, drawn by the sound of his nephew's voice. "Message? I sent you no message. What nonsense is this, my boy?"

"Perhaps Mr. Harold Bagshaw, like those travellers who throng the village these days, simply longs to be part of the ferment here." Mr. Sigerson, leaning in the dining room doorway, offered this suggestion with more benignity than I expected.

"A telegramme—it came first thing this morning." Harold thrust a crumpled piece of paper at his uncle. "If you did not send it, who did?"

"Who indeed?" Mr. Bagshaw stared at it. "Handed in here last night. Most extraordinary!"

For myself, I was beginning to wonder what kind of hotel we were running. Mrs. Clithoe, I was sure, would not greet with favour the appearance of another Bagshaw on the doorstep, and I wished to clear the house of visitors, not add to their number.

But, resigned, I told Harold he'd have to take his own bag up. Carrying my tray, I went back to the kitchen.

Mrs. Clithoe, deep into her baking, was too preoccupied to make much fuss. Violet heard the news with a simper, and began reconsidering her decision to stay with her mother for a while.

My stock of patience was running low. "If you intend to work," I said finally, "you may stay. If you are going to stand around and make eyes at the men, Violet, you will be better off out of the way at your mother's."

Violet took offence at this. "I'm sure I don't know what you mean, Mrs. Dodson."

Sighing, I gave it up. "Where is Tim this morning?" I had not seen him yet, and he was usually in the kitchen early.

"Oh, he took his bite before you were up," Mrs. Clithoe explained, pushing her spectacles atop her cap. "Said he had an errand in the village for the master."

I puzzled over this while I stowed the silver back in its cabinet. Now that I thought about it, Mr. Sigerson had worn a certain air of satisfaction that morning. His pipe must have brought him some, at least, of the answers he sought.

With Violet following me, I went to do the bedrooms, determined to get some work out of her before she had hysterics again. Mindful of what I had seen before breakfast, I myself took Mr. Bagshaw's room, leaving Violet to make up the bed in Harold's chamber.

Before tidying the room I tried to see what Mr. Sigerson had been looking for. Mr. Bagshaw was a fastidious man. His dressing table bore a neat line of stomach remedies; the book on his bureau sported a bookmark and was placed precisely in the centre of the gleaming mahogany.

Feeling guilty of a breach in etiquette, I rummaged through the sponge bag that hung on the washstand. It held soap, sponge, and a styptic pencil; nothing more. His shaving tackle was equally innocuous.

While I made the bed and dusted, I pondered what Mr. Sigerson might have been looking for. At last, overcoming my scruples against snooping through a guest's things, I threw open the wardrobe and made a close inspection of Mr. Bagshaw's dressing gown, and then his slippers.

In this last occupation I was discovered by Harold Bagshaw. He bounded into the room and stopped short at the sight of me on my knees beside the wardrobe, scrutinising the soles of his uncle's slippers. "I say, Charlotte—Mrs. Dodson," he began. "What's up?"

I put the slippers back in the wardrobe. "Do you notice it?" I asked Harold, sniffing delicately.

His nostrils flared. "Notice what?"

"I thought I detected an—odour, and wondered if perhaps your uncle had stepped in—something." I turned my head away in an excess of refinement. "But if you do not smell it, then it must be my imagination."

"Odour—oh, I see." His forehead wrinkled. "Mice in the walls, could it be?"

"That may be it. We shall have to get a cat." I headed for the door, hoping I had distracted him from finding me at my inglorious task.

But Harold, with the obliviousness of the young, had almost certainly failed to notice. "Charlotte—Mrs. Dodson," he breathed, catching at my hand. "Since we are private here, let me tell you, please—"

"You may tell me anything you want, Harold." I beamed at him maternally. "Anything you might tell your own mother. I am quite ready to listen."

"Well, it isn't—dash it all, Mrs. Dodson! It's nothing like that!" He scowled, trying again to seize my hands, but I eluded him.

"In that case," I suggested, gaining the hallway, "suppose you save it for another occasion. I am rather pressed for time right now, you see." Clutching my duster, I slipped into Mr. Sigerson's room. Violet was already at work there, and together we finished the bedmaking and dusting that was all Mr. Sigerson allowed.

Harold emerged from his room as we finished, but Violet managed to absorb his attention by gushing out all her fears and anxieties into his manly ear. I descended into the kitchen, to pour a cup of tea and meditate on the fact that the hem of Mr. Bagshaw's dressing-gown was dusty, and the soles of his slippers contained traces of gravel.

Constable Ritter arrived when I was rinsing out my cup. He refused my offer of a cup of tea, pleading lateness to his appointment with Mr. Sigerson.

I led him to the library, where Mr. Sigerson was once more smoking and staring moodily into the empty hearth. He greeted Constable Ritter with enthusiasm. Neither of them said anything when I followed them out the French doors.

"It was just here that I noticed the signs of dragging." Mr. Sigerson proceeded briskly to the steps that led down from the side terrace to the front of the house. Rounding the corner, he stopped short.

Ritter nearly ran into him, and I paused at the top of the steps, craning around to see what was causing the trouble.

Mr. Bagshaw and Harold glanced up from their own perusal of the ground. They had, it was clear, made a thorough job of it. Harold's face glowed with enthusiasm.

"I say, this is something like," he said, beaming at Mr. Sigerson. "I feel like a regular sleuth-hound."

Mr. Sigerson forbore to remark on this, although it seemed, from his rigid shoulders, that it cost him some struggle.

Constable Ritter, however, was less restrained. Pushing to the front, he confronted Harold and his uncle. "Proper muddle you've made of things, too," he grunted, looking in disgust at the stirred-up gravel of the path. "We shan't find any tracks now, after you've been over things like a herd of elephants."

Mr. Bagshaw was indignant. "How dare you speak to me in that fashion, Constable? If my nephew and I wish to stroll about the grounds of Larchbanks, what's it to you?"

"May I remind you," Constable Ritter said stolidly, "that there was a crime on these here grounds last night?" He bent a magisterial glare on Mr. Bagshaw. "May I inquire, sir, just what you were doing between the hours of nine and eleven last evening?"

Mr. Bagshaw sputtered a bit. Catching sight of me, he cried, "Really, Mrs. Dodson. It's just another example of the slackness of the household at large. Could you at least dispel this ridiculous policeman's suspicions by telling him what time I retired last night?"

"Mr. Bagshaw," I said composedly, "ascended the stairs at a

quarter past nine, at the conclusion of dinner. I did not see him again until after Mr. Staines's body landed in the library."

"There," Mr. Bagshaw said triumphantly to Constable Ritter. "I trust you are satisfied now. Come, Harold." He marched away, followed by his nephew, who looked back wistfully.

Constable Ritter exchanged a look with Mr. Sigerson, who nodded slightly. "Just so, Ritter. Shall we have a look?"

At this interesting juncture Violet appeared to call me away for a consultation about luncheon. I had never been more reluctant to return to my place in the kitchen.

Generally speaking,
decomposing bodies are not
wholesome eating, and the line
must be drawn somewhere.

Chapter Twenty

I HAD NO MORE THAN ENTERED the hall when I heard a loud crash from the dining room. Rushing in, I found Violet standing by the table, an empty tray clutched in one slack hand, and about her feet a heap of broken china.

"Oh, Mrs. Dodson," she quavered, catching sight of me. "It was a face—an evil face at the window! Oh, I'm sure it was him—the vampire!"

"More probably Mr. Bagshaw, checking on the luncheon preparations," I said, frowning at the destruction. "Really, Violet. If you cannot keep your wits about you better than this, you would be better off at home."

"I will go home," she sobbed, dropping the tray as well, so that she could fish her handkerchief out of her sleeve. "I won't stay here no longer, Mrs. D, no matter what. There's something wrong here, I can just feel it. Oh, Mrs. Dodson, I'm so frightened!"

Relenting, I stepped across the crockery to offer her a comfort-

ing embrace. "Now, now, Violet. It's no wonder your nerves are overset. Tim shall escort you to your mother's. I'm sure Rose will be glad of your company, if you can refrain from adding to her fears."

Of this last I took leave to doubt. But at least it would be Mrs. Wilkins's task to keep her daughters under control, and not mine.

Even Mrs. Clithoe, upon witnessing the dustbin full of Crown Derby china—the tea rose set, a particular favourite of mine—was compelled to agree that Violet's presence was more hindrance than help. The cook dropped into a chair and cleaned her spectacles in agitation.

"It's all of a piece with the rest of her behaviour," she grumbled. "Would you believe, Mrs. Dodson, that she wouldn't go to the village for me today? I shall need some nice collops of veal for dinner, but she wouldn't set foot outside when I asked her to."

"It is very annoying," I agreed, alarmed by the febrile glitter in the cook's eyes. I was impatient to be following the trail with the constable and Mr. Sigerson, but failure to soothe Mrs. Clithoe might precipitate a true crisis. "Perhaps Tim could obtain the veal when he escorts Violet home."

"Him?" Mrs. Clithoe snorted. "He wouldn't know veal from lamb, that lad. No, Mrs. Dodson. I'd better go in meself."

"But what about luncheon, Mrs. Clithoe?" I glanced around the kitchen. It was, as usual, in immaculate order; Mrs. Clithoe was not the sort of cook who disdains to use the scullery. All traces of breakfast had been cleared away; a pot of soup simmered on the back of the range, and one of her special plum-cakes, smoothly iced and finished with marvellous butterflies made from coloured marzipan, stood in the larder. "The cake is beautiful, but—"

She drew herself up to her full, imposing height. "That cake is for Vicar, and it must mellow till tomorrow. You won't have forgot, Mrs. D, that tomorrow is Miss Hanover's funeral."

"Of course. You are kind to think of that. The vicar will be needing refreshments." We both knew that everyone in the village would bring the vicar food, but Mrs. Clithoe wanted her contribution to stand out, and indeed it would.

"As to luncheon, I have prepared a buffet of cold meats and soup, Mrs. Dodson. Just now I don't feel up to more."

"Very well, Mrs. Clithoe." I sympathised with her; very little more domestic disturbance would send me howling to the hills. "Take your time in the village. We could all stand to get away for a space, I'm sure."

I left her collecting her basket and bonnet, and ran up the back stairs to superintend Violet's packing. Tim White was duly summoned from the vegetable garden to escort our last remaining housemaid to her home, and I knew we wouldn't see him again until late in the afternoon, since Mrs. Wilkins would no doubt press him to take his noon meal there.

I laid the table, using the Royal Worchester, a pattern I considered unpleasantly sinuous, and left the tray in the butler's pantry between dining room and kitchen. When I returned to the hall, Mr. Bagshaw and Harold were coming down the stairs.

"Ah, Mrs. Dodson." Mr. Bagshaw stood in front of the looking glass to put on his hat. "Harold is off, back to the office. We thought we would find a bite to eat in the village before his train."

"Very well." I held the front door open for them, and reflected that it was a relief to see them out of the house. Harold was not a bad lad, but Mr. Bagshaw's finicky ways and constant prying into the household were beginning to annoy me. I thought of telling him that Mrs. Clithoe would be in the village as well, but decided instead to hold my tongue.

The kitchen was empty when I returned to it. Carefully I poured the soup into a tureen, and took soup and cold meats to the dining room. There would only be Mr. Sigerson and possibly Constable Ritter at luncheon; nevertheless, I did not skimp on presentation.

Constable Ritter, however, was not in evidence when I entered the library. Mr. Sigerson slumped in one of the big leather armchairs, his pipe sending smudges of smoke into the air, his thin hands locked together beneath his chin.

"Luncheon, sir," I said from the doorway.

He did not move, save to motion impatiently with one hand. "I do not wish any luncheon," he growled.

"Shall I clear it away?"

"Never mind that." He gestured to the chair opposite his. "Sit here, and let us put our heads together. This case is full of contradictory evidence, and I confess I am not giving it my total concentration."

I sat in the chair, folding my hands in my lap, trying not to show how gratified I was by his invitation. "You and Constable Ritter discovered nothing?"

"There was precious little to discover at best," he admitted, going to the hearth to knock the ashes out of his pipe. "And after Bagshaw and his nephew had been scuffling around in the evidence, there was nothing left of any importance." He reached into one pocket. "Save for this."

On his palm was the glint of gold—one of the major's gold doubloons, stolen the day before.

I stared at it. "It could have fallen from Percy's pocket last night. Or from the pocket of the person who killed him. Or it could have been dropped by the person who rifled the library, if that person was different from Mr. Staines."

Mr. Sigerson cocked one eyebrow at me. "I thought you saw Staines in the study."

"I did." Patiently, because I could see that Mr. Sigerson was testing me, I said, "I did not, however, see him in the act of taking the doubloons. He might have come upon the room in the same condition as we found it, and simply decided to rummage around a little on his own account."

"Precisely, Mrs. Dodson." Mr. Sigerson filled his pipe from the humidor on the mantel and strode around the room. "And yet, for all your caution, we both know that it was Percy Staines who was responsible for ransacking the library, in search of that precious, perhaps mythical, Orb of Kezir. Just as we know, although proof is scanty, that it was Staines who killed your Miss Hanover."

"But who, then, killed him? And why?"

"That is the question," Mr. Sigerson admitted. "One of them, anyway." He waved the stem of his pipe at me. "Why was Staines here last night? He evidently came under his own steam. Tim White, who strikes me as a very healthy young man, owned that he dropped off to sleep by nine o'clock, and was undisturbed until five this morning. However, he claims he would have heard and responded to any vehicle arriving."

"That is probably true," I concurred. "He worked for a space in his uncle's livery stable, sleeping above it—"

"And thus would have been trained to respond to the sound of a carriage or horses, even in his sleep." Mr. Sigerson nodded briskly. "So the assumption is that Staines walked here, taking some pains to remain unobserved. He could not have been carried any distance except by two or more people, and he was not killed until shortly before he fell through those doors."

I looked at the French doors as he spoke, and could not repress a shudder. Although it was daylight now, the sun covered the clouds as he spoke, and a momentary gloom was cast over the library. The delight I had previously taken in the rows of books and the beamed ceiling had been spoiled. I could never again be in this room without seeing, in my mind, that black-clad form tumbling in through the windows.

Mr. Sigerson observed my momentary distress. His dry, unemotional voice pulled me back. "So what does the evidence indicate, Dodson?"

"He came to meet someone," I said obligingly. "Obviously, the person who killed him."

Mr. Sigerson nodded in approval. "It was someone he knew, someone from whom he expected no violence. Taken together with the condition of the ground, the two rhododendron leaves I found on the back stairs this morning, and the method of killing him, which Constable Ritter believes to be by offering him a flask tainted with Prussic acid—"

"So that is the cause of the smell of bitter almonds that

lingered about him?" I recalled the terrible rictus of the features and the spittle on the lips of the dead man.

Mr. Sigerson dropped one hand on my shoulder for an instant. His voice held an unaccustomed gentleness when he spoke, though his words were prosaic in the extreme. "Your garden shed contains a strong solution of Prussic acid, clearly labelled as an eradicator of moles. We have no way of knowing if any is missing, but it seems likely." He cast himself into his chair again, looking across at me with hooded eyes. "What does all this add up to, in your view, Mrs. Dodson?"

It was unpalatable, but obvious. "The murderer came from inside the house."

"Excellent." Mr. Sigerson's brief smile came and went. "And with your nimbleness of mind, Mrs. Dodson, I am sure you have reached the same result I have as to this person's identity." He took a moment to light his pipe. "I only wish," he said absently, "that this other matter were so simple of solution."

I was still grappling with the presence of a murderer among my household. Those leaves on the back stairs—was he thinking it possible that one of the servants could have slipped out to kill Percy Staines? What possible motivation could lie behind such an act?

Unbidden, a picture rose in my mind of Mrs. Clithoe, her righteous wrath at the curate's duplicity overflowing into homicide. But surely, tainting a flask of liquor with Prussic acid was far too subtle for her straightforward nature. I could see her wielding a cleaver or some other lethal kitchen tool while in the grip of a Spasm. Further than that, my imagination would not stretch.

"I am afraid," I said to Mr. Sigerson, "that you have credited me with too much percipience. I can think of no one in my household who is capable of such an act."

"Come, come, Mrs. Dodson." Mr. Sigerson spoke impatiently around the stem of his pipe. "You are allowing your very considerable deductive powers to be clouded by feminine vacillation. Looked at through the eyes of logic, instead of sentiment, there is

only one person here who could have planned and carried out such a scheme."

I knew he was right, and yet I could not bend my brain to work out this final problem. Instead I found my thoughts skittering around and around in my head, noticing the way Mr. Sigerson's long fingers held the bowl of his pipe, the scent of lilies of the valley coming faintly through the French doors, the creak of settling timbers in the hallway.

Mr. Sigerson watched me, his expression unreadable. "Very well, Mrs. Dodson. If one of us knows, that will be enough." He went over to the desk and withdrew a folded note. "I have written my conclusions out here for Constable Ritter, and would be obliged if you would have this conveyed to the village immediately."

"I will take it myself if you wish," I said, rising from my chair. "Everyone else is gone."

"Everyone?" He sprang to his feet. "Tim White? Mr. Bagshaw and his nephew?"

"Yes." I stared at him in consternation. "Harold returns to his office, and his uncle is giving him lunch at the Rose and Crown. Mrs. Clithoe has gone after the veal for dinner, and Tim is escorting Violet to visit her mother for a few days."

Mr. Sigerson took himself in hand. "You must go immediately, then," he said, pushing me towards the door. "Do not lose a moment! Take the note to Constable Ritter, and ask him to attend me here. But do not come back yourself, Mrs. Dodson. You must remain in the village."

There is no excuse for the slowness of my perceptions that day. I was almost out the library door when I realised Mr. Sigerson's intentions.

"You anticipate an attack on yourself—an attack from your enemy." I stopped in the doorway and stared at him.

He did not deny it. "Your presence will be most unwelcome, my dear Mrs. Dodson."

"I cannot leave you here alone—"

He gripped my shoulders, gazing down at me. "Believe me,

Mrs. Dodson—Charlotte. I dread the possibility of putting your
life in danger far more than encountering Moran alone."

"As it happens," came a voice from behind me, "the encounter
is already upon you."

Mr. Sigerson's hands loosed their grip. I turned and saw a sinister
figure standing in the dining room archway. It was the man I had
noticed in the village and at the inquest, with pale skin and reptil-
ian eyes shadowed by his hat. This he removed, revealing a bald
pate ineffectually crossed by a few thin strands of hair. His other
hand clutched his stick, his thumb caressing its handle in the pe-
culiar way I had noticed at the inquest.

"So, Moran." Mr. Sigerson stepped around me, shielding me
from the oily gaze of the man who had sworn to kill him. A small,
wicked-looking revolver had appeared in his hand. "You have
tracked me down, I see. Your quarrel is with me and me alone. You
will let Mrs. Dodson go."

The man known as Moran cackled gleefully. "It's amusing,
ain't it? You have your revolver on me, and I have my stick." He
lifted it, pointing the handle at Mr. Sigerson. "Interesting piece of
work, this stick. Made for me by Moelson, Von Herder's chief as-
sistant. You remember Von Herder?"

Mr. Sigerson nodded, his jaw tight. Screened behind him, I
wondered if I might slip across the library and gain the window
before Colonel Moran could stop me. Then I could summon help,
although in the time it would take me to get to the village and re-
turn, anything might happen. The thought of Mr. Sigerson facing
this villain alone decided me. The two of us had a better chance of
overpowering Moran than did Mr. Sigerson alone.

Moran was speaking. "Yes, Moelson is a clever fellow—even
cleverer than Von Herder, especially with explosives. This stick,
now. You might guess that it contains some sort of weapon, would
you not, Holmes?"

"Please." Mr. Sigerson held up one hand. "Here I am known
by my *nom de guerre*. Do me the courtesy of using it."

"You may expect no courtesy from me," Colonel Moran said, his mouth working. "I have my choice of weapons here. Vitriol would be nice for your lady friend, would it not? The pain alone would keep her from summoning help, if the knowledge of her seared flesh did not cause her to wish for the blessed release of death."

I must have made some sound. At any rate, I found myself pressed against Mr. Sigerson's back, as near to cowering as I have ever been in my life.

"You forget that I have my firearm trained on you," Mr. Sigerson's calm voice broke in. "You will have no opportunity to try your fiendish weapons here, Moran."

"And then there's the fire," Moran said, not heeding Mr. Sigerson. He spoke almost dreamily. "A certain chemical, harmless until it comes in contact with the air, at which point it bursts into flame. It was that way I burned you out before, Holmes. But I made a mistake in not facing you then. You got away. You won't get away this time."

"Put the stick down, Moran," Mr. Sigerson said, gesturing with his revolver. "I know you are alone. You have crossed swords with me before, and you have never won. You will not win today."

Moran shook with rage. "That is where you err, my dear detective. Today I shall make an end of you, once and for all!"

I could feel Mr. Sigerson's arm tense. Before he could shoot, a gout of brilliance snaked across the hall from the stick carried by Moran. A shriek of pain such as I have never heard human utter filled the room. Mr. Sigerson's weapon went off; simultaneously his legs buckled, and he sank to the floor.

Luncheon…should be a light meal, but its solidity must be, in some degree, proportionate to the time it is intended to enable you to wait for your dinner, and the amount of exercise you take in the mean time.

Chapter Twenty-one

THERE IS NO REASON, AFTER ALL," said Colonel Moran, "to waste this delicious luncheon."

He sat at table in the dining room, napkin tucked beneath his chin. I had served him from the tureen of cock-a-leekie soup. Though my hands were shaking, I managed to set down the soup plate without spilling any.

Mr. Sigerson, tied to a chair near the dining room door, suppressed a groan. I dipped another napkin in the water jug on the sideboard and went to lay it on his burned hand.

"No point in fussing over him, woman." Colonel Moran lifted a spoonful of soup to his lips and sipped delicately. "He's going to be dead soon. A little burn like that is nothing."

I put the napkin on Mr. Sigerson's hand, replacing the now-dried and uncomfortable one I'd put there before. I had trussed him to the chair, following Colonel Moran's orders. Rope not being in plentiful supply in the house, I was told to tear strips from

the Irish damask tablecloth. To console myself for this mutilation, I reflected that the linen was certainly more comfortable for Mr. Sigerson than rope would have been—and far weaker, when it came time to attempt our liberation.

I had to confess, however, that liberation seemed unlikely with Mr. Sigerson bound so thoroughly—hands in front of him, arms secured around his chest, ankles tied together. I had obeyed Moran's instructions as mechanically as possible, seeking to efface myself, to become the deferential automaton expected by those of his class, a being robbed of initiative or wit.

All the same, my hands had trembled when I had been obliged to pass the linen strips closely about Mr. Sigerson's form.

The blistered skin on his right hand oozed. Moran would allow no other aid than the inadequate water-soaked napkin.

"Dammit," he said pettishly. "Why so much fuss over a little burn? I wish you to bring me the cold meat, woman. And don't come too near."

I thought of tripping and letting the heavy platter fly into his hateful face, but before I could get close enough, he motioned me to set it down. His other hand played with the carved handle of his stick, which was pointed directly at Mr. Sigerson. I put the platter where he indicated.

"Now stand over there, next to poor Sherlock." Moran crammed a morsel of roast beef into a roll, and stuffed it into his mouth. He pulled his soup plate closer and began to spoon it in again. "Delicious," he murmured. "The standard of cuisine at Dartmoor is, I'm afraid, very low. Even the meanest country inn far surpasses it."

I stood against the wall and considered my position. Foremost in my thoughts was Stubby, the dearest creature to me on earth, not yet equipped to make his way unaided through life. I did not wish to die and leave him with no one.

And beside me was the man who, for well or ill, was the recipient of my womanly emotions. I did not wish him to die either.

Yet it was clear that Colonel Moran meant to kill him, and

more than likely myself as well. Death seemed to be the most I could expect from life.

While Moran was engrossed in his soup, I glanced around the dining room, through the windows looking out over the drive. No one appeared on the drive, although when Moran had insisted on eating lunch, I had thought that surely Mrs. Clithoe or Mr. Bagshaw would return from the village to save us. Just two arms' lengths from me was the swinging door into the pantry, and thence into the kitchen. I wondered if Moran had noticed this door. Paneled below and hung above with the same wainscoting and linen-weave silk that covered the walls, it was nearly invisible.

However, even if I could gain the door, it would win me no clear advantage. Without a telephone, I could not summon help quickly. I had no weapon superior to Colonel Moran's walking-stick arsenal. He would only have to hunt me down—or perhaps merely destroy Larchbanks to ensure my demise. And he would have my employer at his mercy.

I would have to think of something which would save, not only myself, but also the man beside me.

And there was not a useful thought in my head.

Beneath the apron I had worn to serve luncheon, I could feel the outline of the housewife that hung from my belt. In it were scissors, thread, a telescoping foot-rule, and other small items. I glanced down at Mr. Sigerson, and his eyes met mine, a long look that seemed to speak much.

"Now bring me the covered dish there," Moran commanded. "Or stay—I shall help myself. That way I can better keep an eye on you." He stood at the sideboard, lifting covers and filling his plate, keeping that innocuous-looking walking stick pointed in our direction. Staring at it, I was almost faint with the effort of keeping my face expressionless. I wanted so badly to seize it—to hurl it from the window, or break it, or somehow render it useless. The man himself, without his bizarre weapon, could be easily dealt with.

I clasped my hands under my apron and slowly inched the scissors out of my housewife. They were small, fitting in the palm of my hand, and very sharp.

"Quite appetising," Moran said, settling himself at table again. "I looked in earlier, but the housemaid was just bringing the plates then. Woman—where is the wine?"

I had not brought any wine, knowing that Mr. Sigerson preferred to drink water with his meals. "It is down cellar," I said, as meekly as I could—longing to box his ears for that mannerless *Woman*. "Shall I fetch you some, sir?"

I could feel silent tremors from Mr. Sigerson, and realised that he was laughing! Really, the man had no sense of the seriousness of our position. Did he not know that I would kowtow to the Devil himself, if it would keep us both alive?

"No, no," Moran said irritably. "I certainly couldn't trust you to bring the wine back—you'd run away, I'm sure. I shall have to do without." He brooded over his plate for a moment. "Now I wonder," he said absently. "Would the cellar be a good place for your demise?" Gazing at Mr. Sigerson, he chewed reflectively on a second roll stuffed with Mrs. Clithoe's tender roast beef. "I had planned to have it occur outside with those ridiculous bees of yours."

Mr. Sigerson stopped laughing. "My bees," he said in a steely voice, "will not do your bidding, Moran."

Moran shrugged, impaling a gherkin on his fork. "That matters little," he said, pointing the fork at my employer. "I can make it appear as if they have destroyed you. Whether they would, in reality, attack you is unimportant."

"Nonsense." Mr. Sigerson twisted once in his bonds, and then recovered himself. "Why concoct elaborate schemes to cover your deeds, Moran? Your quarrel is with me, not with my bees, or with Mrs. Dodson. Send her away, unbind me—face me, man to man. You have boasted of your courage, have you not? This smacks little of courage."

Moran was plainly stung. His unhealthy countenance grew

more livid, while his eyes brightened with malice. "You prate of courage, and then ask me to undertake the unequal task of facing you, in the prime of manhood, when my strength for the past fourteen years has been sapped by incarceration? No, no, my dear Holmes. Physically I admit I am no match for you—now, at any rate, although it would have been otherwise before you played that foul trick on me and sent me to prison." His hand tightened on the handle of his stick, and I tensed, dreading to see again that brilliant tongue of flame, leaping towards the helpless form of Mr. Sigerson.

But Moran, though biting his lip in frustrated rage, did not let himself go. "No," he whispered. "I have learned many lessons in prison, Holmes. I no longer care anything about your absurd gentlemanly code of honour. I enjoy having you helpless, and I shall enjoy even more killing you in a way most certain to bring you infamy and ridicule after your death. My only regret is that you won't be alive to appreciate the depths to which I will sink your reputation." He laughed, rather wildly, and pushed back his chair. "I must get on with it, in fact. When the inmates of this house return, they will find you humiliatingly dead. If it were not for that, I should enjoy putting my signature on the scene."

I felt cold down to my fingertips, and faint. Taking some deep breaths, I forced myself to hold the thought of my son like a talisman. I would survive—I must survive, to care for him. To ensure my own existence, I believed I could even sacrifice Mr. Sigerson.

"Your signature will be on my death no matter how you contrive it," Mr. Sigerson said, his voice like a cold splash after Moran's wild speech. "Already the Yard is on the way here. The local constable is fully apprised of your threats against me. Watson—"

"Watson!" Colonel Moran took a sip from his water goblet and spat, right in the center medallion of the Bokhara carpet. "Don't threaten me with your tame fool Watson. How do you think I found your earth?"

"By all means underestimate him," Mr. Sigerson said. "But killing me will not free you. It will only increase the furore of the manhunt for you. You will join me in death soon enough, Moran, although we will have different destinations once there."

"As to that," Moran said, pushing away his empty plate, "I do not fear death; I have already been through hell. I want satisfaction now, and I will get it. Woman!"

I jumped, so involved had I been in the dialogue between these two enemies.

"Is there no sweet to finish my meal?" Moran looked at the sideboard, scowling at the paucity of dishes.

"Mr. Sigerson does not care for sweets, and therefore—"

"Damn 'Mr. Sigerson.' I want a trifle, or a syllabub, or some such thing. We had only the meanest of everything in prison. Now I, at least, will dine like a gentleman, even if Sherlock has no stomach for gentleman's fare." Moran sketched the parody of a bow at his bound prisoner, and Mr. Sigerson gravely inclined his head.

"Well, there is nothing prepared," I said, trying to maintain my meek pose. "There is only plum-cake in the larder, and a few jam tarts."

"That will have to do," Moran said pettishly. "No syllabub, no wine. You do not appear to live very well, Holmes." He nodded at me. "You may free your employer from the chair. But don't untie his hands. And don't get between him and me, my dear. Otherwise I shall be forced to shoot you before I intended to."

My head swam. I took more deep breaths and fell back into my role of empty-headed servitor. "How shall I free him? I have nothing to cut with."

"Must I do everything?" Moran pushed back his chair and rose to his feet. "Is there no carving set on the sideboard? Holmes, your house is run like a sheepherder's cot."

As we were having cold meat, already carved, the carving set was put away in the sideboard. Still keeping his horrid weapon trained on us, Moran opened drawers at random until he found it,

but he did not hand me the long, sharp knife. "On second thought," he said, "you must just untie your knots. No doubt they were poorly made to begin with. And remember, don't block my aim. It would be a damned shame to have to kill a pretty woman like you so soon."

I did not care for the tone of voice with which he delivered this putative compliment. I knelt at Mr. Sigerson's side, slipping my little scissors into my pocket so I could work on the knotted linen strip that bound him to the chair. I did not wish Moran to confiscate my scissors, perhaps even shoot me out of anger, so I spent several minutes undoing what I had done before.

At last Mr. Sigerson was freed from the chair. I untied the strip that bound his feet together, though Moran had not told me to do so. While I was busy, I could hear him, lifting the lids of the serving dishes for one more go at Mrs. Clithoe's viands.

"Now," he announced when I stood, "we will all go to the kitchen. It is back here, is it not?" Gesturing with his gun, he pointed toward the hallway and the green baize door. "And I will have plum-cake and tarts. And then out to the orchard for Sherlock's ignominious demise."

He uttered that wild laugh again. Since he didn't know about the butler's pantry, I didn't show him that passage to the kitchen. We went in procession out the dining room, and then into the hall. I went first, by Moran's order; Mr. Sigerson followed, with Moran's walking stick pointing directly between his shoulder blades.

In the kitchen, full of knives and heavy pots and other implements of destruction, I hoped to manage a way to realign the balance of power. But Moran was clever. He placed himself where he could see me through the larder doorway while I cut into Mrs. Clithoe's marvellous creation of a cake and put the slice on a plate. She would be beside herself at this mutilation, but I hoped she would forgive me.

The jam tarts were dusted with confectioner's sugar, giving me at last an idea of how we could be saved. Deliberately I dropped

the fork I had got out of a drawer, and stooped to pick it up. Hoping that my skirts shielded my next action from view, I also picked up the little stoneware crock which held the rat poison.

"This fork is dirty now," I muttered to no one in particular. Under cover of opening the cutlery drawer again, I gave the top of the jam tart a liberal dusting with rat poison—arsenic, I believe. Then I opened the crock which held the confectioner's sugar, and added some more of that, to disguise any taste.

"Hurry up, woman." Moran, I saw, as I turned from the larder, kept his wicked weapon trained on Mr. Sigerson constantly. "I can't wait all day for my sweet."

He gestured to the deal table, and I put the plate down, then obeyed a further gesture to join Mr. Sigerson against the wall. Moran sat with the weapon cradled in his arm, still pointed at Mr. Sigerson. I looked longingly at the chopping block on the other side of the kitchen, where Mrs. Clithoe kept her cleavers and such.

As Mr. Sigerson's hands were bound in front, I could not even surreptitiously work on his bonds with my scissors. My hands were shaking too much anyway. I had never deliberately tried to poison someone before. Even though Moran was deserving of death, it still gave me a horrible feeling.

Moran ate greedily, not noticing anything unusual about the jam tart. I wondered how long it would take before he became ill, and if he would shoot us when he realised what I'd done.

"Excellent," Moran murmured, savoring a bite of plum-cake. "Your cook is quite good, Sherlock. Perhaps after your death she would come and work for me."

"It is an interesting thought." Mr. Sigerson's shoulders shook in private laughter once more. "Mrs. Clithoe would only work for you if Mrs. Dodson did, too. She is very loyal."

"Dodson? Is that you?" Moran looked me up and down. "I wouldn't mind employing you as well. A good-looking young housekeeper, eh, Sherlock? Quite a change."

Mr. Sigerson was no longer laughing. I knew he was going to speak, and I poked him with my elbow. I did not care for the innuendo in Moran's voice any more than my employer did. But if the poison worked, it would all be moot. Though I yearned to hear Mr. Sigerson defend my honour, it seemed like a bad idea to goad Moran into acting more quickly. I struggled to maintain my impassive façade.

"Delicious." Moran pressed the back of his fork onto the plate to capture the last crumbs of jam tart. "And now, on to business. The bees, I noticed, are out in the orchard."

Mr. Sigerson shuddered. Moran watched, smiling. "Don't you like the idea of dying with your bees?"

"I have seen someone die by bee sting," Mr. Sigerson said in a low voice. "It was—ghastly. I would prefer some other form of death. Why can't you just shoot me like a man instead of subjecting me to that torture?"

Moran's smile broadened. "Because I wish to torture you, of course. Interesting that as you see death approach, you lose some of your famous *sangfroid*. I expect you will be gibbering when the end is upon you. Too bad all those sycophants who idolised you couldn't see that. Too bad your tame dog, Watson, won't know how the thought of little bees stinging your life away unmans you."

Watching Mr. Sigerson closely, I thought that he was up to something. I had seen him work around the hives with no more protection than gauntlets. Was his purpose to ensure that Moran took us into the orchard? Would there be a cue for me to act? I palmed my little scissors once more, hoping that Moran would fall down dead before he could kill us. I wasn't sure how quickly arsenic acted on the human system, or if the small amount I had used would be enough.

"If you're not shaking too much, Sherlock, lead the way. Your comely Mrs. Dodson will accompany me." Moran grabbed my arm, pulling me against his side. He carried his weapon in the crook of his other arm, as gentlemen do when they go shooting. I

found his touch loathsome, but the tip of his stick still pointed directly at Mr. Sigerson's back.

Perhaps arsenic, like toadstools, took days to act. I kept my scissors ready, and allowed Moran to lead me out the kitchen door.

There is faintness, depression, and sickness, with an intense burning pain in the region of the stomach, which gets worse and worse... The pulse is small and irregular, and the skin sometimes cold and clammy, and at others hot.

Chapter Twenty-two

COLONEL MORAN GESTURED with his stick. "Stand over there, Holmes." He was careful, I noticed, not to go near the hives himself. Bees buzzed in the flowering trees above our heads, but the hives themselves appeared deserted, without the usual apiarian traffic.

Moran finally noticed this. "Where are the bloody bees?" He sounded fretful. "Take off the lid or whatever you do to get inside. Get them riled up, now." He lifted his stick. "Because, by God, if they won't do for you, I certainly will."

Mr. Sigerson held up his hands. "I cannot take off the lid with my hands tied."

Moran hissed a curse, then pushed me away from him. "Go open those hives, woman."

He was more afraid of the bees than he wished us to know, it seemed. I, too, was not eager to take off the top of a hive and risk an assault by angry insects.

"Why don't you let her untie my hands? I thought I was sup-
posed to be the one to be stung." Mr. Sigerson had not, I think,
foreseen this result.

"I will do it." I went past him, reminding myself that I would
not die from a sting or two, and hoped it was true.

I lifted off the top of the first hive. It was empty of bees. Paral-
lel ranks of slender panels filled the interior; they appeared to be
made of some honeycomb-like substance. I turned to Moran.
"This hive is unused."

"Keep going." He gestured with his stick for emphasis. I
moved to the next hive and took the top off.

The fragrance of honey billowed out. Inside, the ranks of pan-
els glistened with the sweet, golden substance. A few bees
crawled around, intent on their business. None of them paid the
least attention to me.

Still holding the top of the hive, I turned around. "No bees."

Moran was some twenty-five feet away. He had his stick
trained between myself and my employer. My remark appeared to
infuriate him.

"What do you mean, no bees? I can hear the bloody bees.
They must be somewhere. You have hidden them, Holmes. It is
just like you to spoil sport in this fashion."

Mr. Sigerson shrugged. "You are so unfortunate as to be here
when the bees are swarming."

I looked closely at Moran. He wiped the sweat from his face.
His skin appeared yellowish in the bright sun. He didn't look well,
but he didn't look as though he would die soon either.

"Swarming? What is that?"

Mr. Sigerson didn't answer. He pointed up into the trees.

Poised in the branches of the tree beneath which Moran
stood was a dense black cloud of changeable shape, bigger than
Mrs. Clithoe's soup tureen. It glittered in the sun. Looking more
closely, I could see that it was composed of constantly moving
bees.

"What the devil—" Moran looked into the tree for a moment

too long. Bound wrists held in front of him, Mr. Sigerson sprang at him.

Moran leveled the deadly firearm again, but Mr. Sigerson was close enough to club the weapon upwards. A fierce gout of flame shot towards the heavens.

Gathering my skirts, I ran towards them. Mr. Sigerson's rush had knocked his opponent to the ground. With his hands tied, and wounded, Mr. Sigerson appeared to be no match for Moran's cunning.

Indeed, as I came up to them, Moran managed to get one hand free and land a blow on Mr. Sigerson's wounded hand. My employer cried out, but did not give ground. Moran's other arm, along with his heinous weapon, was pinned between their bodies. My dear employer, his face contorted with effort, pressed down on Moran's windpipe with his bound hands, the linen strip that confined them acting as a garrotte. Moran's free hand flailed around, beating the air, and occasionally Mr. Sigerson.

I hovered over them, wondering how best to serve Mr. Sigerson's cause. I had no weapon but my tiny scissors, and could not abstract Moran's evil stick from between the straining bodies of the two men. And even if I could, I would not be able to operate it.

Frantically I looked around, hoping to see the approach of Tim or some other member of the household. The orchard was empty of all but the contestants locked in combat. The wide blue sky, the scent of fresh-bruised grass arising from the combat, the hum of the bees—these peaceful sights and sounds made an odd contrast to the life-or-death struggle going on at my feet.

Moran clawed at Mr. Sigerson's wounded hand again, and my employer's fierce pressure on his opponent's windpipe faltered. I gave up dithering and waiting for someone else to help. Kneeling, I grabbed Moran's free hand and twisted it in the brutal way Stubby had shown me—another part of his Jujitsu course.

It was Moran's turn to scream. I should have felt remorse for causing a fellow human being so much pain. But my emotions

were far more primitive than that, and guilt did not form a part of them.

Mr. Sigerson applied renewed pressure, and Moran's eyes glazed. His arm went limp. It was over.

Slowly, Mr. Sigerson straightened. Over Moran's unconscious body, we regarded each other.

I looked away first. What I saw in my employer's gaze was hard to read. It would mean nothing until expressed in words. I got to my feet, shaking out my skirts.

"Is he dead?"

"I don't think so." Mr. Sigerson stood, wincing, and reached down to take the stick from Moran's slack fingers. "Would you care if I had killed him?"

"His death is fully justified." After all, had I not attempted to kill Moran myself? Obviously the poison had not worked, but if it had, I would have taken a human life. Or perhaps not human, not any longer. His evil career, his long incarceration, had rendered Moran less than human. I knew, however, that had he died at my hands, I would not have been unchanged. Although Mr. Sigerson—Mr. Sherlock Holmes—had undoubtedly been responsible for the deaths of reprobates before, I found myself glad that this was not one of those times.

"We should bind him." Mr. Sigerson looked around as if a plentiful supply of rope might be found in the immediate vicinity.

"And unbind you." I took out my scissors and cut the bonds that held his wrists together, then pulled the shreds of fabric from his burned skin. The wound looked frightening. "We must call the doctor for this."

"A scratch." Mr. Sigerson dismissed the seared flesh. "I can attend to it." He walked stiffly to the occupied beehive and reached inside with his uninjured hand, "Honey," he said, bringing out a dripping handful, "is a most excellent dressing for a burn."

Despite my faint protest, he smeared his hand with honey and pulled what remained of his sleeve down. "Now," he said, "a rope.

Mrs. Dodson, if you will watch Colonel Moran, I will look in the stable—"

But this I would not allow. "I will go to the stable," I said, using the voice that even Stubby will not contravene. "You, after all, have a much better chance of figuring out the use of that most abominable weapon."

"True," my employer admitted. "Though I will not try. Knowing Moran, there is probably some fiendish booby-trap built into this thing that will cause it to explode in inexperienced hands. But it makes a good club, don't you think?"

He turned back to Moran. "In fact," I said, clearing my throat, "he might not need clubbing if he awakens."

Mr. Sigerson looked at me. "And why is that, Dodson?"

His reversion to the casual use of my last name should have angered me, but instead I felt a warm, collegial glow. "Because I sprinkled his jam tart with arsenic."

Mr. Sigerson stared for a few moments, then threw his head back in the soundless laugh that characterised him. "You—you who seemed so distressed that I might have strangled Moran with my bare hands—you have poisoned him?"

I pressed my lips together. "It seemed like a good idea at the time," I said, and turned to go to the stable.

His touch on my arm stopped me. "You are a most intrepid woman, Mrs. Charlotte Dodson," he said, his voice softer than I had ever heard it. "I am constantly amazed by your talents. Against all logic, all rational thought, you have inspired in me emotions I have only once experienced, and then only as a pale shadow of what I now feel."

Insensibly, as he spoke I moved towards him, until we were eye to eye. "Mr. Sigerson—"

He pulled me to him, his hands at my waist. "Don't you think you could use my real name now?" His breath stirred the hair at my temple. "Sherlock."

I tried, but my mouth would not form the word. "I have thought of you only as my employer. I cannot—"

"I am not your employer." He scowled, his hands tightening. "We are colleagues, you and I."

"You have come to mean so much more to me than that." I put my hands in his hair and brought his head to mine. Our lips met.

The kiss started as a sweet pressure, but the exigencies of our situation, the terror we had experienced, caused an outburst of passion between us. A flame seemed to consume me. Perhaps it was owing to my enforced loss of the conjugal embrace. Perhaps it came from him, and not from me. At any rate, I lost track of time and space. I was whirled from the orchard at Larchbanks into a vortex of swirling heat.

How long we would have remained thus I have no idea, if we hadn't been interrupted in a most unwelcome fashion.

"What is this? Mrs. Dodson, what has happened? Mr. Sigerson, please! I must insist!" The shocked voice of Mr. Bagshaw finally penetrated my consciousness. "There is a dead man lying in the orchard. What is the meaning of this?"

I pulled away from Mr. Sigerson, trying in vain (I supposed) to smooth my hair. For his part, I was glad to see, he looked flushed and almost dazed; his eyes were heavy-lidded and his chest heaved as if he'd run all the way from the village.

"Mr. Bagshaw." I tried to collect my thoughts, while stepping in front of Mr. Sigerson to shield him from the solicitor's censorious gaze. "We have had a bit of trouble. This man on the ground is the dangerous criminal, Colonel Sebastian Moran. He wounded Mr. Sigerson, commandeered his luncheon, and then forced us out here in order to assassinate us. I must suppose him to be a lunatic. Thanks to Mr. Sigerson's quick thinking, Colonel Moran was vanquished. I have never been so near to fainting in my life! Mr. Sigerson was—reviving me."

"You are still in shock," Mr. Bagshaw pronounced. "You are babbling in a manner most unlike yourself, Mrs. Dodson." He turned his gaze to Mr. Sigerson, who stepped forward with his wounded hand held in front of him. "I must ask, though, why this

Colonel Moran, whose name I recall seeing in *The Times* recently, would descend on Larchbanks in such a fashion."

"Perhaps," Mr. Sigerson said, his voice only slightly unsteady, "he had heard that Mrs. Clithoe spreads a most palatable luncheon."

Mr. Bagshaw did not appear convinced. "If, as you say, he ate the luncheon, that is a possibility. But more likely is that he discovered that you, Mr. Sigerson, are actually Mr. Sherlock Holmes. It was most ill-done of you, sir, to put Larchbanks at risk in that fashion."

"Not to mention the staff." Mr. Sigerson smiled warmly at me, a real smile. I had to look away or I would have cast myself upon his chest once more. "You are right, Mr. Bagshaw. I do most sincerely apologise."

"No matter." Mr. Bagshaw waved the apology away. He fingered something in his pocket and rose on his toes a time or two. Now that I looked more closely at him, I could see that he was nervous. Could the illustrious nature of his tenant have induced a kind of hero worship in him?

Nothing could have been further from the truth. Mr. Bagshaw pulled out from his pocket the item with which he had been fidgeting. It was a pistol.

"Yes, most inconsiderate," Mr. Bagshaw went on, his voice gaining confidence as he pointed the pistol at Mr. Sigerson. "But as it happens, it fits in well with plans of my own."

The relations of landlord and tenant are
most important to both parties, and
each should clearly understand his
position. Notice must be given,
so as to terminate....

Chapter Twenty-three

I ASSUME THAT IS SOME KIND OF WEAPON." Mr. Bagshaw ges-
tured at Moran's lethal stick, which was now on the ground;
Mr. Sigerson must have dropped it in the heat of our passionate
encounter. "Please kick it aside. If you tried to use it, I would have
to shoot Mrs. Dodson, and that would be a pity. She is an admira-
ble housekeeper, in her way."

"I must suppose," I said, with a touch of acerbity, for that
lukewarm "in her way" was surprisingly wounding, "that whatever
future you have planned for us is, at the least, unpleasant. Why be
concerned about shooting me now, when you will undoubtedly kill
me later?"

"Because a bullet wound would not form part of my plan." Mr.
Bagshaw beamed benevolently when Mr. Sigerson kicked the
weapon away. "Excellent. I had a far different plan in mind, but
that was before I found out who you are, Mr. Holmes. I must say,
it's quite a thrill to meet you. I shall certainly regret having been

the cause of your demise. Now, if you would both come closer to Colonel Moran—"

We moved as he directed us. My limbs felt stiff and heavy with fear; I confess I trembled, though I hid my shaking hands beneath my apron. And there I discovered, once again, my housewife, with the scissors put tidily away inside it. A spark of hope bloomed within me.

"It is too bad we didn't get Moran tied up," Mr. Sigerson remarked to me. His voice was cool; he was once again the detached observer. My spirits rose insensibly. This man had been in great danger many times without succumbing to the Angel of Death. Perhaps he could survive this time, as well. "As he is not dead, he may yet escape."

Mr. Bagshaw looked worried.

My employer eyed Mr. Bagshaw keenly. "So it was you, I presume," he said, "who killed Percy Staines. Why? Did you have something to conceal? Embezzlement, perhaps?"

Mr. Bagshaw's face flushed. "A few minor peccadilloes," he said airily. "I would have been in a position to replace the funds I—borrowed. Before probate on the estate was completed, as a matter of fact."

"By skimming off the lease money for Larchbanks?" Mr. Sigerson nodded. "And you probably are charging the estate more for wages than you pay the servants. I'm sure you have several strategies to confuse those who will oversee the sale of the estate. And thus your theft is hidden."

"It was not theft." Mr. Bagshaw was stung. "I only borrowed funds from a certain necessity. It was all to be for Major Fallowes's benefit, but the silly old fool didn't see it that way. He had no idea of the importance of investing for the future. Always so conservative, so hidebound. I merely hoped to prove him wrong, and show him how profitable it would be to—"

"Speculate?" Mr. Sigerson's lip curled. "You lost, I suppose."

"The dashed shares never paid out," Mr. Bagshaw said sulkily. "And the major was most upset when I hinted that I might have

purchased them. He was too ill at the time to look into it, but I knew when he recovered he would have the books audited." He shot me a glance. "At least he did not confide that to you, as he did everything else. Your influence on him was most pernicious and unsuitable."

His pursed lips and censorious tone made a bubble of hysterical laughter rise within me. I squashed it before it could burst forth. "Fortunately for you, he died."

"Fortune had nothing to do with it," Mr. Bagshaw snapped. "I made sure his last attack of the lung disease carried him off. All would have been well, if young Percy Staines had not wanted the estate for himself."

I was surprised at the intensity of the rage that rose up in me. "You killed the major. That sweet man, who never harmed you, who thought only of the comfort of his staff—"

"Spare me your encomiums on Major Fallowes." Mr. Bagshaw was near to snarling. "I don't wish to hear any more sentimental twaddle about how saintly he was. The old fool was a hidebound stick-in-the-mud. His death was his own fault."

"Thus it always is with murderers," Mr. Sigerson said to me in a conversational voice. "They excuse their behaviour on the grounds that the victim is asking to be killed. They justify it by saying that the victim deserved to die." He addressed Mr. Bagshaw in that same polite voice. "Pray, what was your motivation for killing Percy Staines?"

"He was not worth a moment's mourning." Mr. Bagshaw sniffed. "He killed Miss Hanover—he as much as admitted it to me."

"That is well known to the police." Mr. Sigerson sounded bored. "Pray tell me something I don't know. How, for instance, was he a threat to you?"

"The bounder said he would contest the will, and that would have brought a most unwelcome scrutiny to the books," Mr. Bagshaw said candidly. "Then he offered to disappear again if I would split the estate and help him find—"

When he failed to finish his sentence, I chimed in. "The Orb of Kezir. Really, the credulity of you gentlemen is beyond belief. The Orb, if it ever existed, is long since gone."

"And if by chance it does exist," Mr. Sigerson added, "it belongs to Mrs. Dodson. Not to you, Bagshaw. Larchbanks is not an open coffer for you to plunder."

"Larchbanks *will* be mine," Mr. Bagshaw said, his voice covetous. "The old major never valued it as he should. It could be a nice little estate with a bit of refurbishing. I shall buy it when it comes on the market. No one else will be interested. Patience Staines is dead—"

"Do you know that for a certainty?" I stepped forward in my eagerness, and Mr. Bagshaw pointed his pistol at me instead of Mr. Sigerson.

"Please come no closer. Yes, the confirmation came yesterday, and I received the office boy's telegramme about it today, after seeing Harold off. It was while I was in the telegraph office that I discovered that the famous Dr. Watson had been in Stafford-on-Arun, summoned from hence to the Continent in the search for that dastard Colonel Moran. It was but a small leap from that knowledge to the secret of your identity, Mr. Holmes." Mr. Bagshaw bowed. Mr. Sigerson did not return the courtesy. "It appears you triumphed over Moran, at any rate."

"I generally do succeed in my encounters with criminal gentlemen such as yourself," Mr. Sigerson said. "You would be wise to remember that. I have, for instance, had you investigated, prompted by the gravel I found in your house slippers the morning after Percy Staines's death." Mr. Sigerson's voice was still unemotional. "Constable Ritter was good enough to forward my concerns to Scotland Yard. When the inspectors arrive later today, they will bring with them details about your speculative losses. If Mrs. Dodson and I are harmed, you will be the first person the Yard looks at as perpetrator of that harm."

For a moment Mr. Bagshaw was taken aback; then he seemed to regain his equilibrium. "Perhaps, if I had been forced to use my

earlier plan, that would be true. But now, Mr. Holmes, fate has blessed me with the perfect circumstances to deflect suspicion from myself." He indicated the prone form on the grass in front of us. "It is most tragic that you will both expire after an epic battle with the arch-criminal Colonel Sebastian Moran, who will also be quite dead."

A memory of Stubby formed in my mind's eye, from his last visit at Easter. His sandy hair an unruly thatch, his face browned by hours spent in pursuit of sport, he asked me to talk of his father. We sat together on the divan in front of my fire, his head a delightful weight against my shoulder. At such times, he let down his boyish guard and listened as I told the stories he knew so well already, of our life together before Maxwell's death. Sitting thus, we felt again my dearest Maxwell's presence.

I could not leave Stubby motherless when he was already fatherless. Nor could I, with any hope of success, leap upon Mr. Bagshaw and pit my small scissors against his pistol. Again I searched the sky, the fields, hoping for assistance.

And like the answer to a prayer, Assistance appeared, in the form of Mrs. Clithoe. Behind Mr. Bagshaw's back, she loomed in the arched gateway between the kitchen garden and the orchard, one hand holding an immense iron frying pan as though it weighed nothing, the other carrying the cake stand that held her marvellously decorated plum-cake, borne aloft like Lady Liberty's torch.

I gaped at this incredible apparition, and Mr. Bagshaw laughed condescendingly. "Please, Mrs. Dodson," he said, smoothing back his hair. "Do not try to distract me by so old a trick as pretending someone is behind me. I assure you, I am too up-to-the-mark to fall for that."

I glanced at Mr. Sigerson to see if I was, perhaps, hallucinating the stalwart form of Mrs. Clithoe, now advancing swiftly, if ponderously, across the grass. Mr. Sigerson, too, stared at her massive form. She was really there.

Made uneasy by our fixed gazes, Mr. Bagshaw finally turned,

but it was too late. Mrs. Clithoe was already upon him, and in the grip of a first-class Spasm.

"Unbeliever," she roared. "Want-stomach! Wretched, miserable cur of a man!"

Mr. Bagshaw brandished his weapon, but Mrs. Clithoe, with one sweep of her paw, brought the frying pan down and knocked it out of his hand. The cracking noise that accompanied this action must have been some of the small bones in his hand breaking.

Mr. Bagshaw yelled, but Mrs. Clithoe paid no attention. And for once I was not inclined to soothe her from her distress.

"You see," she said, turning to us and bringing the cake stand down to eye level. "You see what that Creature, that whining manshape of the Evil One, has done. See!"

The neat slice I had been forced to cut from her cake in order to satisfy Colonel Moran's sweet tooth had been enlarged without ceremony, leaving ragged edges and messily bisecting one of the colored butterflies she had affixed with such care.

I found my voice. "What a shame!"

"Vile insect!" Mrs. Clithoe turned back to Mr. Bagshaw, just as he found his weapon in the long grass. He lifted it awkwardly with his left hand, pointing it straight at her heart. The report as he squeezed the trigger was deafening.

I clutched Mr. Sigerson's arm, sure that I would see Mrs. Clithoe laid low by the bullet. But as Mr. Bagshaw fired, she brought the iron frying pan up, preparing to chastise him with it. The bullet clanged into the frying pan and deflected, and simultaneously Mr. Bagshaw dropped the weapon to clap his uninjured hand to his arm, crying out in pain. Then the frying pan came back down with a resounding thud upon his head, and he collapsed neatly into the grass at Mrs. Clithoe's feet.

Miraculously, the cake had not fallen off the stand during this contretemps. Mrs. Clithoe turned to us. Her voice resumed its normal rumble. "And might a body ask," she said with awful politeness, "just what has been going on? You and the master look like you've been drug through a hedge backwards." She glanced at

Moran's supine body. "And who may this be? Will he be stayin' for tea?"

This time I could not repress the hysterical giggles that swamped me. "No, Mrs. Clithoe," I gasped. "He will not stay for tea."

"But others will be here," Mr. Sigerson added. He put a comforting arm around my shoulders. "And despite the horrid depredations wrought by Mr. Bagshaw, I feel sure your cake will provide ample sustenance." He gazed soberly at her. "And, Mrs. Clithoe?"

She had already turned, sublimely unconcerned with the petty fates of those laid low by her cookery—for even Colonel Moran could be seen as a victim of her jam tarts. "Yes, sir?"

"Thank you." Gravely, Mr. Sigerson approached her massive form and gave her the salute on both cheeks. "Thank you very much."

*Affections of the head and chest also
frequently occur as a consequence
of these kinds of burns, but no
one who is not a medical man
can treat them.*

Chapter Twenty-four

WE SAT IN THE LIBRARY, a ragtag group. I had no doubt that I looked as disheveled as Mr. Sigerson, or rather Mr. Sherlock Holmes. It was difficult to think of him by any name other than his *nom de guerre*, as he had termed it to Dr. Watson.

Dr. Watson was there, summoned from Newhaven; a thick fog had kept him from departing, as well as his own reluctance to leave the field. Also present was our own Dr. Mason, who had finished cleaning Mr. Sigerson's wounded hand and was binding it up, a privilege Dr. Watson had reluctantly conceded.

Constable Ritter sat in a chair pulled close to the fire, his notebook at the ready, the scent of peppermint pervading the air around him. He wasn't talking, though. That was left to one of the Scotland Yard representatives, a Superintendent Potter.

"Let me see if I've got this straight," Superintendent Potter said again. He, too, had a notebook, and he recorded in it every word and syllable that had been said since his arrival some forty-

five minutes earlier. He had taken command of the orchard, and until the two men he brought with him were finished crawling around in the grass, Mr. Sigerson had not consented to have his arm tended, concerned that he might miss something, or that his bees might be harmed. He had actually coaxed the swarming bees into the empty hive, a performance that had convinced the Scotland Yard detectives there was nothing new to learn in the orchard. The two underlings had taken charge of Colonel Moran and Mr. Bagshaw, both of them just regaining consciousness.

I had tried to tell Superintendent Potter of the dose of arsenic I'd sprinkled on Moran's jam tart, but he had brushed me aside, and, as I did not know if I wanted Moran to live, I sat quietly in my chair, on the other side of the fire from Constable Ritter, and like him, said nothing.

Superintendent Potter strode back and forth across the hearth-rug. "So," he said. "To sum up, Colonel Moran got the drop on you and Mrs. Debson here."

"Dodson," Mr. Sigerson said, giving the superintendent a glance of dislike. "Pray get the facts straight, Potter." He muttered under his breath, "Even Lestrade could do that much."

"Sorry," the Superintendent said. "Only it's such an honor to work with you, sir. I must confess, we had wondered—that is, Chief Superintendent Lestrade had wondered, if perhaps the whole Moran thing was blown out of proportion. After all," he added condescendingly, "you two are getting a bit past it. And the Dartmoor people said Moran was rather feeble. How did you say he managed to get the better of you?"

"With this." Mr. Sigerson picked up Moran's walking stick. He had had a few minutes to brood over it before the doctors had arrived. Now he swivelled to face the open French windows, lifted the stick, and fired a gout of flame towards the terrace.

Superintendent Potter was impressed. "Yes, that would do the trick," he conceded. "May I see that?"

I cleared my throat. "Gentlemen, weapons testing must be done outside." I would have stood to make my pronouncement

more emphatic, but since Mrs. Clithoe had bashed Mr. Bagshaw with the frying pan, my legs and indeed my entire body had been surprisingly shaky. I held my cup of very sweet, very hot tea with both hands as I sipped, and it had done me good.

"Of course," Mr. Sigerson said, contrite. His glance at Potter was cool. "You may indeed see it, Mr. Potter. Or at least, Scotland Yard's weapons experts may. I have done only the most cursory inspection, and am convinced the weapon is booby-trapped to explode in the face of those who tamper with it. You would be wise to convey that information to your munitions experts. At any rate, it was wrong of me to fire it in the house like that. I beg your pardon, Mrs. Dodson."

Dr. Watson raised his eyebrows, giving me a look of surprised scrutiny. I wanted desperately to be alone in my room for a good cry. Though Mr. Sigerson accorded me the utmost respect in all his descriptions of what had taken place that day, I could sense him withdrawing from me. That inflamed encounter in the orchard might as well not have taken place.

My hands still shook as I raised the teacup to my lips. Dr. Watson came to lay his palm on my forehead and look into my eyes. "This woman is in shock," he proclaimed. "Can you not wind up your infernal questions, Potter?" He seized the brandy decanter and splashed a goodish tot into my tea. I sipped again and was heartened by the fiery glow the brandy imparted.

"I will finish in good time," Superintendent Potter said, glaring at Dr. Watson. "To resume, Colonel Moran got the drop on you with his ingenious fire weapon."

"It's caused quite a nasty burn," Dr. Mason put in. He fixed Mr. Sigerson with a stern look. "You must care for that, now, Mr. Holmes, or it might fester and cause you to lose your hand."

"Nonsense." Mr. Sigerson brushed aside any risk to himself. "The honey cleanses the wound. I wish you would turn your attention to Mrs. Dodson." He looked at me, then, as he had not done since Mr. Bagshaw interrupted us in the orchard, a long look, in which I could read a certain tenderness. I had another sip of tea.

Superintendent Potter still consulted his notes. "Moran then forced you to watch him eat luncheon?"

"The fiend," Dr. Mason growled. "To be forced to watch someone eat one of Mrs. Clithoe's luncheons without being able to partake would drive any man mad."

"Yes. He seemed quite peckish." Mr. Sigerson looked at me again. "When he demanded a sweet, Mrs. Dodson managed to put arsenic on the jam tart he consumed."

Superintendent Potter wheeled around and looked at me, for nearly the first time. "What? Why was I not told of this before?"

"I tried to tell you, but you did not seem ready to hear." I spoke in my most ladylike voice. Indeed, I felt rather too ladylike for my liking, what with trembling, palpitations, and the curious weakness that pervaded my body.

"Really, madam." Superintendent Potter glared at me. "You should have spoken up. The old reprobate will probably die on us, and there goes my trial."

"What a pity." I took myself in hand and sat up straighter. "Perhaps next time you will listen to the ladies as well as the gentlemen, Superintendent Potter. Each witness may have something of value to impart."

"Hear, hear." Dr. Watson gave me another splash of brandy in approbation. I would soon be tipsy, at this rate.

"I must alert my men. Doctor—"

Both doctors sprang to attention. Superintendent Potter was puzzled for a moment. "Dr. Watson," he decided. "Pray come and pump the man's stomach before it's too late."

They bustled to the door, only to be met there by one of the superintendent's underlings, who held his hat in his hand and looked shamefaced. "Sir," he said haltingly. "I regret to report—"

"What?" Superintendent Potter was impatient. "We must hurry, Simkins. Moran has ingested arsenic, perhaps a fatal dose. His stomach must be immediately pumped."

Simkins cleared his throat. "As to that, his stomach is already emptied. He cast up his accounts in the orchard."

"That might not be enough," Dr. Watson said. "I will just get my apparatus."

"And then," Simkins went on doggedly, "him looking so sick and all, Mr. Townshend and me started looking for something to carry him on, like. And whiles we were looking, he vanished."

"Vanished." Superintendent Potter looked dazed. "You mean, you left this dangerous criminal unsupervised, and even though he'd been nearly strangled and poisoned with arsenic, he vanished?"

"That's what happened." Sergeant Simkins did not look happy.

"How exactly did he get the drop on you?" Mr. Sigerson was already out of his chair and striding to the door.

"Holmes, your hand—"

"It's fine. I must look at the ground, if these two—gentlemen—haven't trampled all the tracks away." He was through the door, his dressing gown swirling about him.

Needless to say, all the men went after him. I stayed where I was, enjoying a moment of solitude in which to compose myself. Despite the success that had crowned our ordeal, I was prey to a deep depression, brought on by the end of everything. Mr. Sigerson was free to go back to being Mr. Sherlock Holmes, and would no doubt take his bees and leave shortly. Mrs. Staines was known to be deceased, meaning that the estate would be sold up. I would receive my inheritance, and for that I was thankful. But it was the end of my safe harbour, my refuge. I would have to find another situation, or if I could afford it, a small cottage somewhere, in a village much like Stafford, where strangers would be looked at with suspicion and my every move would at first be scrutinised. At another time, perhaps, this would have seemed no insurmountable obstacle to future contentment. Now it was too overwhelming to contemplate.

At least I had survived to nurture my son. That was the most important thing. As I thought it, I felt a deep thanksgiving within me. Stubby would not be an orphan.

A scrabbling sound at the French door attracted my attention.

I looked, expecting Mr. Sigerson. Instead, when the leaves swung open, Colonel Moran stood there.

If it could actually be called standing. He listed precariously to one side, an arm clutching his stomach, his white face glistening with sweat. I sprang to my feet, and acting on instinct, grabbed his walking-stick weapon from where Superintendent Potter had placed it, leaning against the fireplace.

Colonel Moran spoke. "I want my weapon." His voice was gravelly and hoarse.

"You may not have it."

He advanced into the room, his legs unsteady. His face was really a dreadful colour. "I must have it. Give it to me, woman."

My back stiffened. "I am Mrs. Dodson, and I will not give you this hideous thing. If you come any closer, I will hit you over the head with it. You are in no condition to defend yourself, sir. I suggest you sit there and let the gentlemen from Scotland Yard take charge of you."

He wiped the sweat from his brow and shook his head. "I will not be taken. And I want my weapon. It is crucial to my future plans."

"You have no future," I said coldly. "Surrender yourself now. You might survive if you allow the doctor to pump your stomach."

His forehead furrowed. "Why my stomach? This malaise is the result of Holmes trying to throttle me to death."

"I poisoned you with arsenic on the jam tart you consumed so greedily."

He stared at me. And then, weakly, he began to laugh.

"Mrs. Dodson, is it? I shall remember that." He backed towards the French door. "You are quite the heroine, are you not? I suppose women have changed, along with everything else, while I was in prison. Very well, I shall not take my gun. Keep it, but be careful how you use it."

"I have no intention of using it. The police will take charge of it."

"That's good." He had almost reached the window. I nerved

myself to put my words into action and club him with his revolting weapon, but felt a strange reluctance to hit so pitiable a figure. Nevertheless, I took a step forward.

As if by magic, a small pistol appeared in his hand. "No, Mrs. Dodson. I shall not shoot you, if only because a Valkyrie like you would probably catch the bullet and fling it back at me. But I will not allow you to impede me." He reached the open leaves of the French window and stopped in front of the curtains. "Remember me to Holmes. He is indeed a fortunate creature." His face twisted, and he raised the pistol. "He does not deserve his good fortune. I am afraid I must kill you after all, if only to cause him pain."

"Go ahead," I said with the calm of disbelief. "You will bring them all down on you. In your weakened condition you will not be able to elude capture. True, I will be dead. But you will either die of arsenic poisoning or be incarcerated again, perhaps in a stronger fastness even than Dartmoor."

"Curse you," he snarled. I raised his weapon, putting my hands on it as Mr. Sigerson had done earlier, and felt the small button on the crook end. It was booby-trapped; Colonel Moran's satisfaction when I said the police would be taking it apart told its own story. But Mr. Sigerson had used it safely enough. I stepped forward, not wishing to set the curtains afire, and gently pressed the button.

A gout of flame pulsed toward Colonel Moran. He yelped with alarm and dove through the windows. Feeling quite powerful, I strode after him.

For a man stricken with illness, he was quite nimble on his pins. The shrubbery shook where he'd vanished into it.

Before I could follow, Mr. Sigerson rounded the corner of the house, his head bent to scan the ground, his pace increasing as the track he followed neared the French door. "He has gone back to the house! My God, Charlotte!" He loped forward, only to stop short as he saw me there, the lethal stick held in my hands.

Superintendent Potter thrust forward. "Madam, that is an exhibit in a criminal case. Please do not—"

I ignored him, speaking to Mr. Sigerson and Dr. Watson. "He went into the shrubbery. He has a pistol."

Mr. Sigerson wheeled around, but Dr. Mason stopped him before he could follow Superintendent Potter and the two minions of Scotland Yard, who plunged through the bushes in immediate pursuit. "You must not do any more, my good man. Your injury is not as inconsequential as you would like to believe. Let Scotland Yard handle it from here."

"Mishandle it, more like." Mr. Sigerson allowed himself to be led toward the library. "Watson, will you go with them? You know my methods."

"Of course, Holmes." Drawing his own revolver out of his pocket, Dr. Watson in his turn plunged into the shrubbery.

Mr. Sigerson came toward me. "You suffered no hurt? He did not try to harm you?"

"I am unhurt." My brief spasm of energy was at an end, however. I went back into the room with Dr. Mason behind me, and sank into the first chair I saw. "He was quite ill, actually, but didn't realise why until I told him about the arsenic."

Mr. Sigerson indulged in one of his soundless laughs. "That must have opened his eyes to your qualities, Mrs. Dodson."

"He wanted his gun." I laid the stick across the desk. "I would not give it to him."

"You should have. He might have got ugly."

"He was not that attractive to begin with."

Again the soundless laugh.

Dr. Mason laughed aloud. "You are invincible, Mrs. Dodson."

"Not at all. I was frightened, but he made me angry, too. 'Woman, hand me my weapon.' It was not to be borne."

"And so he pulled out his pistol." Mr. Sigerson looked at me soberly. "You took too big a risk, Charlotte. He might have killed you."

"I fired his infernal weapon at him. That drove him off."

Dr. Mason took my wrist. "Your pulse is quite tumultuous, Mrs. Dodson. I believe you should lie down for a while."

LORA ROBERTS

"Will not the detectives wish to interview me again?" The thought of my bed, the tranquillity of my room, was tempting.

"They can wait. I shall say I have prescribed a sedative, and indeed, if you wish it, I will."

I needed no sedative. And much as I desired to rest for a while, I did not wish to leave the scene of action to the men.

The library door opened, and Mrs. Clithoe appeared. After saving us from Mr. Bagshaw, despite the subsequent confusion, she had simply gone back to her kitchen and proceeded with her work, barely tolerating Superintendent Potter's questions about her actions in the orchard.

"I have cleared up luncheon," she announced, her massive forearms crossed in front of her. "In view of the number of men a-swarmin' around the place, I've prepared a substantial tea. Should I set it out in the drawing room, Mrs. D?"

"That would be fine, Mrs. Clithoe. I will help you. And thank you very much for carrying on. You are a marvel."

"Should you not rest?" Dr. Mason regarded me with worried eyes.

"If Mrs. Clithoe needs no rest, neither should I. She is a great heroine, you know."

Mrs. Clithoe sniffed. It had been difficult to convince her that Mr. Bagshaw was guilty of worse sins than carving an enormous slice from her prized cake. She had simply dealt with him as his crime deserved, in her view.

"It's reward enough to be shut of that Mr. Bagshaw. He won't be around no more, will he, Mrs. D?"

"No, but I expect Harold will show up any time now, so we should make sure to have a very substantial tea. In fact, let's not bother with dinner at all, Mrs. Clithoe. We've all been through a lot. We'll have a good tea and leave it at that."

"With no help, that's the best we can do." She stalked down the hall to the green baize door and I followed her broad back. "No telling when Violet and Rose will be fit to work," she grumbled.

I wondered when to tell her that soon none of us would have

positions, but decided to leave that for another time. We worked in companionable silence for a while, arranging sandwiches on a tray (and adding more in view of Harold Bagshaw's possible appearance). I pointed out that if we sliced the cake and arranged the slices, no one would know it had been profaned, and Mrs. Clithoe reluctantly agreed to that. I felt a bit queasy at putting the remaining jam tarts on the cake stand, but she had no such shrinkings.

Dr. Mason was in the room when we repaired to the drawing room. "I thought I might be of assistance to you in setting up," he said, directing a keen look at me. "You have been going a bit too hard, Mrs. Dodson. Why don't you sit there and allow me to play housemaid for once?"

Mrs. Clithoe gaped at him, and as I had already decided that she would make the doctor an excellent cook-housekeeper when Larchbanks was shut up, I stepped into the breach.

"I couldn't allow you to do that, Doctor. But if you will sit, we will be ready in a moment—that is, if you care to stay. I have heard Mrs. Frawley say that you do not usually take tea."

He shrugged. "Mrs. Frawley does not give me tea as a general rule. I am looking forward to one of Mrs. Clithoe's legendary meals. That bread you were so kind as to designate for me was spot-on, ma'am."

Mrs. Clithoe beamed. We arranged the dishes, and went back to the kitchen for the urn, where she confided that Dr. Mason was a most gentlemanlike fellow, and it was a shame and a crime that so feckless a body as Mrs. Frawley was forced upon him.

"He deserves someone who would cook him good meals," I agreed. "Did I not hear in the village that Mrs. Frawley is planning to leave him to take care of her aged mother?"

"I'm sure I don't know." Mrs. Clithoe poured boiling water into the urn from the heavy kettle with no apparent effort, and I let the subject drop.

When we returned to the drawing room, Dr. Watson had joined Dr. Mason, and Mr. Sigerson was with them as well. They

broke off a solemn conclave when we bore the teapot and urn through the door. Mrs. Clithoe retired to the kitchen, and I poured for the gentlemen.

"Did they recapture Colonel Moran?" I added lemon to Mr. Sigerson's cup and passed it to him. "Milk, Dr. Watson?"

"Just a drop. No, I'm afraid the bounder got away entirely. He had picked the lock or somehow opened the wicket gate. He must have had a conveyance waiting."

"Did not Potter secure the perimeter of the grounds?" Mr. Sigerson took his cup, but waved the plate of sandwiches away.

"Evidently not. He did trace the wheels as far as the main road, but of course he lost the track there. You could have done no better in this instance, Holmes."

"I would have made sure the back door was covered before going in the front," Mr. Sigerson grumbled. "Now I must dodge the fellow again, and this time without my bees, I'm afraid. At least I have nearly finished my monograph."

"That's good news, old fellow."

I passed the cake plate. "And Mr. Bagshaw? What of him?"

"He at least is in custody, and will go to gaol." Mr. Sigerson's voice was hard. "I made it clear to Potter that you were not to be called at the trial. My statement should suffice, and if they want someone to give evidence, I shall do it. You have been through enough, Mrs. Dodson."

"Thank you, sir." I kept my voice pale and colourless, but that didn't stop Dr. Watson's sharp eyes from travelling between me and my erstwhile employer. Mr. Sigerson must have been behaving in an uncharacteristic way to have caused the good doctor to go on alert.

"Bliss." Dr. Mason took a bite of cake, his eyes closed. "She is an angel."

"You should have seen your angel earlier, bringing that frying pan down on Mr. Bagshaw's skull." Mr. Sigerson sounded genial. "You would have thought differently then."

"Man's a jackass." Dr. Mason shrugged.

"If Mr. Bagshaw was correct about Patience Staines's death, Mrs. Clithoe will be at liberty when Larchbanks is closed up," I said. "She would like a position in the village, I think, one that will give her ample time to tend her father. Old Thurlow will not move from his little cottage, and I do not think there is room for her there. She is, aside from being a very good cook, capable of light housekeeping as well."

Dr. Mason looked thoughtful. The front door bell rang.

"That will be Harold Bagshaw. If you gentlemen will excuse me? We are shorthanded just now, and I must answer the door."

The door was already open when I got to the hall; Sergeant Simkins had attended to it. But instead of Harold, young Billy White was there, handing over a telegramme with a flourish. I called him back for a penny tip, then took the telegramme from Simkins, examining it curiously. It was for me, from the headmaster of Stubby's school.

With grave misgiving, I opened it and read the short message it contained. When I looked up, Mr. Sigerson was standing in the drawing room door. "You have had bad news," he said at once.

I took a deep breath. "It seems events follow one upon the other. I must go. My son has contracted the chicken-pox, and must be removed from school until he recovers."

"You will bring him here?"

"As to that, you are the master here. If you prefer that Stubby—that young Max recover elsewhere, it can be arranged."

"Of course you must bring him here. I have had the chicken-pox, as have most of the staff, I presume, and those who haven't can go elsewhere. He will want to recuperate in familiar surroundings."

"Thank you. That is good of you." I tried to keep my voice calm, but my emotions welled up in the most distressing way. I worried about my son; I also had concerns about his meeting with this man who had become so important to me. And beneath it all was an unstable mixture of relief at just being alive, with the knowledge of the pain of parting ahead. I had no expectations of

an offer of marriage from Mr. Sigerson. His was a solitary person-
ality. The most I could hope for was a few weeks of his compan-
ionship, and with Stubby present, that companionship would not
take the form I had dared to wish for.

"Let us resume our tea, as it is all the sustenance we will get
tonight." I went past him into the drawing room. "I cannot leave to
collect him until morning, anyway. And I have much to do tonight
in preparation."

There can be no doubt that chicken-pox, like small-pox, is contagious, and under certain states of the atmosphere becomes endemic.

Chapter Twenty-five

YOUNG MAX WAS INDEED full of chicken-pox. He was dressed and waiting for me, but listless, his handsome little face covered in blotches, his eyes tired. I felt sure we would have a compartment to ourselves on the train ride home. No other passengers would want to ride with a lad who looked as plague-stricken as he did.

He was very happy to see me, and happier still to go home for a while, such home as he had. It caused me a pang to know that I could not provide him with a permanent home; that just as he'd grown to know and love Larchbanks, it would be taken from him.

The cab that had conveyed me from the train to the school waited outside while I checked the case Matron had packed for him. His school was much larger than the establishment my dearest Maxwell and myself had run. I had not arrived until the noon hour, though I'd started at five that morning, and the racket of the

boys was overpowering. As he was quarantined, Max was not even allowed to say good-bye to his friends. After a few words with Matron, we were on our way.

While Stubby slept on the seat facing me, I consulted *The Times* I'd picked up in the train station, looking for the solicitations of those who bought and sold books. I had heard of people buying whole libraries at a time, but I did not wish to dispose of the whole collection; some of those books were dear to me, and I would afford myself the luxury of keeping them. A purchaser of Larchbanks, if such a person appeared, might be interested in the library furniture and even some of the books. However, in case such a purchaser did not appear, I wished to be prepared to sell the items some other way. It would be a shame to dismantle the room, but as my well-being, and that of my son, were at stake, I would do it if I had to.

When I finally got around to reading the front page of *The Times*, I was amazed to see that our little contretemps had received a considerable mention; that wholesale invasion of journalists into the village could not have happened without some consequence. Mr. Sherlock Holmes figured large in all the stories. I was relieved to see that my name was not mentioned, nor was the name of Larchbanks. That sort of notoriety is of no benefit to a woman who seeks a respectable position, nor to a house wishing to be sold advantageously.

I read every word about Mr. Holmes. I was trying to train myself to think of him so, as a famous person, an icon of criminology, not as a mere investigator of bees who was at liberty to build a life with his housekeeper. For a few moments I allowed myself to daydream—that upon my return, he would take to Max immediately, that they would forge a bond, that Mr. Sigerson—Mr. Holmes—would see the benefits of a family and wish to create one with us.

I knew as I dreamed it that it was not to be. I am accorded a good judge of character by most who know me, and my judgement of Mr. Holmes was that he would ever be a solitary creature,

unable to open himself to another, especially a woman, sufficiently to create such a bond.

The shadows were lengthening when we arrived at the Stafford-on-Arun station. I had arranged with Mr. Fenster to meet the train with his hack. The village presented a serene aspect. Thurlow raised a hand to us as we went past the Rose and Crown; he and his cronies sat on the benches in front, unimpeded by journalists. I did not see Dr. Mason as we passed his cottage, but thought I would send a note asking him to call and look at Stubby to ensure that no infection was setting in.

Larchbanks, too, had a peaceful look, its honeyed stone walls glowing as it caught the fading light. Tim had mowed the lawn; despite the depredations of the moles, it looked smooth and velvety in the twilight. The scent of new-mown grass perfumed the air.

I had told young Max nothing of the actions of the previous days. He was unwell enough to want simply to retire to "his" room and feel at rest, and the tale I had to tell would not be a restful one. Later, when he was in better health, he would relish the story. For now, I supported him through the kitchen and into the little dressing room that adjoined my bedchamber. When he was settled, Mrs. Clithoe tiptoed ponderously in with a jug of barley-water and a plate of his favorite lemon biscuits. Clasping one, he drifted off to sleep again.

I joined the staff in the kitchen. Rose and Violet were both there, Violet a trifle shamefaced, both anxious to talk about recent events.

"You could have knocked me down with a feather," Violet declared. "Mrs. Hodges, she says to my mum, 'That there fellow at Larchbanks is really Mr. Sherlock Holmes.' And Mum let out such a screech, you could hear her clear to Cowfold."

"She did," Rose said, giggling. "So when I heard that, I knew it was safe to come back. Mr. Sherlock Holmes can take care of any amount of villains."

"Actually, it was Mrs. Clithoe who took care of the villains." I

gave the cook a warm smile. She simpered a bit, but kept stirring her big pot of soup. It smelled like beef with barley, another one of Stubby's favorites. I would have embraced her if I had not known it would cause her embarrassment. "She swatted Mr. Bagshaw over the head with her big iron frying pan."

Violet and Rose turned awed stares on Mrs. Clithoe. "Poor Mr. Harold Bagshaw," Violet murmured. "Can't be very nice having your uncle be a murderer."

"Mr. Harold will come to no harm, with the stomach that lad has," Mrs. Clithoe pronounced. "He did send in a telegramme, Mrs. D, a-sayin' he'll be here bright and early tomorrow."

"Yes, I believe they have discovered that Mrs. Staines, who was to inherit Larchbanks, has been dead for some time."

"Heathens," Mrs. Clithoe said, her voice brooding. When she tasted the soup, however, her expression brightened.

"We do not know what her cause of death was, but she has been dead for several months at least. So this estate will be sold." I looked at the faces around the scrubbed deal table. "It grieves me to say so, because I am sincerely attached to you all. However, in all likelihood the new owner will wish to install his own staff, and we will be out of work."

Violet tossed her head. "Well, I'm not going to London to find an employer. Mayhap they'll be taking on help at the castle."

Rose nodded. "I'm going to help Mum with the sewing. She's getting more business than she can do herself."

Mrs. Clithoe was massively unconcerned. "Me old dad will take me in if I don't find a good place." She turned to me. "What will you do, Mrs. D?"

"I don't know yet." I tapped the deal table for emphasis. "But I do know that before we hand over the keys to Larchbanks, the house must be in perfect order. We have our work cut out for us, ladies."

They nodded soberly.

"And now, should we be laying the table for dinner?"

"Mr. Sigerson—Mr. Holmes, I should say—isn't here tonight,"

Mrs. Clithoe remarked. "He did say as he would leave your instructions in the library, Mrs. D. And Mr. Harold isn't coming till tomorrow, so it's just us."

"In that case, let us have a nice little supper right here in the kitchen," I said, as briskly as I could. I did not realise until then how much I'd been looking forward to seeing Mr. Holmes again. "I will just look in on Max."

My son slept easily, his breathing light and regular. I dashed off a note to Dr. Mason, asking him to call in the next day, and put it on the tray in the hall for Tim White to deliver after dinner. Then I went to the library, to wonder how soon Mr. Sigerson would return to put the finishing touches on his monograph about the dance of the bees.

The room seemed strangely deserted. I entered, closing the door behind me so I could immerse myself in the emotions that stirred on seeing the desk, the French doors. Here many scenes in the recent drama had played out; here I had almost heard him declare his feelings for me.

Gazing at the desk, I noticed that the stacks of paper no longer overflowed its top; they had been replaced by a single square envelope positioned in the centre of the polished wood. Foreboding filled me.

I snatched up the envelope. It was inscribed in his hand with two words: "Charlotte Dodson." Reluctant to open it, I looked around the room, noting that no pipes adorned the mantelpiece, no newspapers were stacked beside the chair. The room bore all the appearance of an unoccupied place.

Only one folded sheet in the envelope. I spread it open with trembling fingers.

Mrs. Dodson.

The salutation seems cold, and yet I cannot call you my dearest Charlotte, for I have no right to do so. I think you know how I feel. Fate intervened to keep me from telling you, and perhaps that was for the best. I am not a

domestic man. I have not the temperament for the sort of union you have every reason to expect from a lifemate.

domestic man. I have not the temperament for the sort of union you have every reason to expect from a lifemate.

You are an amazing woman. I never thought to experience one-tenth of the feelings you have caused within me. I shall always remember you with the utmost warmth and longing. My only regret is that I did not find the Orb of Kezir, which would have kept you free from want and provided for your son. If ever you are in need of my services, pray do not hesitate to call on me. And if I am in need of an accomplished editor for my monograph, perhaps I could call on you.

Believe me to be your devoted servant,

Sherlock Holmes

I read this in one great gulp, which nevertheless left me gasping for air, dizzy as though I had run for miles. Blindly I put out my hand for support, and found only the carved oak Bible stand. When I lurched against it—for I felt as if the very earth spun too quickly to keep me upright—it fell to the ground with a heavy thud. The Bible was pitched off to lie on the floor in an ignominious heap, its pages crumpled. The stand itself seemed unharmed.

The library door burst open, and Tim appeared with a stick in his hands, Violet peering anxiously over his shoulder. "Are you all right, Mrs. Dodson?" He looked around the room.

"I am fine." My composure reasserted itself. I tucked the letter into my pocket and surveyed the wreckage. "I was—thinking about the furniture, but when I tried to move that heavy thing, it tipped over."

"Your legacy," Violet said, with a wise nod. "You'll be wanting to have it all valued."

"Yes. But it can certainly wait for a better time. Is supper ready?"

Tim sniffed the air. "Smells about ready."

"I shall be there shortly. I'll just tidy up."

Tim lifted the stand and set it back up. "We'll save your plate, Mrs. D."

After they left, I picked up the Bible. It felt heavy in my hands. I smoothed the crumpled pages, noticing that the major had left a bookmark in place and underlined several passages. "Seek and ye shall find," he had marked in a shaky hand. "Ask and ye shall receive."

I had sought and not found. I had asked and not received. I plopped the Bible back on the stand, and turned to go.

My housewife caught on a protruding bit of carving, and I turned impatiently to loosen it before it brought the whole thing down again. Then I saw that it was not carving that protruded, but a small, square opening in the thick base of the reading stand. It looked much like the secret drawer of the desk, but deeper, as the extra thickness of the stand where it joined its supporting leg allowed. I tugged on the edge of the drawer, but it wouldn't budge. I could just get one finger into it; I felt something hard and sharp.

Along the bottom ledge of the angled reading stand were small carved acorns. The two middle ones twisted when I moved them, one after the other, but nothing happened. I gave them one last twist at the same time, and the drawer popped out.

That which lay in the drawer caught the light and glittered most beguilingly. I lifted it out, my back to the window, crouching over it like a miser over his hoard.

It was truly the most magnificent gem I had ever seen, rivaling those I had gawked at in the Tower of London during my visit to the metropolis many years ago. An oval stone as big as Stubby's closed fist was faceted to catch the light and send it back in multi-coloured sparks. Its glittering fire proclaimed it to be no other than the queen of gems. Bands of finely chased gold inset with small coloured stones encircled the diamond, the whole surmounted by an ornate finial of gold set with more glittering fire—a ruby the size of a pigeon egg. At the other end of the oval was another ornate knob with a recessed area, where a rod could be inserted.

"The Orb of Kezir," I breathed.

I could see it, mounted on a sceptre, wielded by a personage of great stature. I couldn't see it as a possession of Major Fallowes, and possibly he, too, had difficulty with that, or why hide it away all these years?

At the bottom of the drawer was a piece of paper, folded tightly; I would not have known it was there if I hadn't run my fingers around the space. I pried it out and opened it. The major's spiky handwriting covered the page.

> This gem, the Orb of Kezir, was pressed upon me by the Raja of Punwalli, in return for saving his life, although anyone would have done the same. I know it is extremely valuable; I learned a bit about gemstones during my India days, and both the diamond and the ruby are fine ones. I have left it just as the raja gave it to me, having no desire to display it on my own account, and indeed fearing that unpleasant discord could arise around it if it were generally known that I kept it.
>
> By this paper, I make the Orb of Kezir over to Mrs. Charlotte Dodson, my housekeeper and editor of my memoir. It is hers entirely, to keep or sell, or to dispose of in any way she wishes.
>
> Major Sir Arthur Fallowes

My eyes swam with tears. Through them, the Orb seemed to fill my vision. I wiped my eyes and put the Orb back in its drawer, which had plainly been constructed to receive it; lined in velvet, the drawer was just the right size to contain its prize. The major had commissioned both desk and Bible stand after his India postings; he had known he would need a secure place to store his treasure, and had taken care in its construction.

I shut the drawer, and not a minute too soon; Rose was knocking timidly at the library door. "Mrs. D? We are sitting down."

"I am coming." I gave the Bible's pages a final smoothing, my

fingers lingering on those shakily underlined passages. "The poor Bible got rather crumpled."

"Did you find the master's note? When will he be returning? I suppose they will let him finish his lease before they sell the house."

I walked with Rose towards the green baize door. "I am afraid he has already left, Rose. The note was to verify that he has gone to superintend the rebuilding of his own house, and that he found the staff here to be most efficient and thoughtful of his needs."

Supper conversation was occupied by much speculation about Mr. Holmes's sudden decampment. Violet was disappointed, as she had hoped to bask in her employer's celebrity. Tim wondered why it was so abrupt, and I made up more lies—Mr. Holmes was not comfortable staying after his alias had been exploded; Mr. Holmes had much to do in assisting Scotland Yard to track down Colonel Moran. These excuses were readily accepted.

After supper, I left the kitchen in Mrs. Clithoe's capable hands while I tended Stubby. He drank a little soup, and let me help him to the modern convenience. I gave him a sponge bath and settled him for the night, and then retired to my sitting room.

The solitude was welcome. I was still reeling from the discovery that Mr. Holmes had decamped, and the further discovery that I owned a very valuable jewel.

Thinking about Mr. Holmes brought nothing but hurt. At least I knew from experience that to lose a loved one is not fatal. And he wasn't dead; I did not have to mourn him to that extent. But he was as good as dead to me. I might read of his exploits, in the paper and in Dr. Watson's chronicles, all the while knowing that he had chosen to turn his back on any possibility of building a life with a woman who loved him. Despite his great courage in matters of action, such as confronting criminals and bringing them to justice, he was too much of a coward to confront the woman who was his complement, and bring her into his life.

At this point in my ruminations, I realised that I was angry. I took his letter from my pocket and read it again, and throughout the high-flown phrases, I detected a bachelor's fear of change to his easy, self-indulgent life. And despite his flowery protestations of being at my service, I noticed that he had given me no address wherein to reach him.

So be it, then. He wished to remain solitary. I would respect his wish. I did not embrace solitude as he did; I had been solitary, and found it no pleasure. Now, however, I would have some means; I would not need to spend every minute wondering how to pay for Stubby's school and keep body and soul together for myself. I would sell the Orb of Kezir; with the proceeds I would travel. I could even buy Larchbanks itself if I chose to do so. I did not need a man to assist me in living my life, any more than Mr. Holmes needed a woman to teach him what life was really about.

The anger was a warming emotion, compared to the cold bleakness his desertion had roused in me earlier. I knew that it would pass, that nights of restless aching would come, when my anger would not suffice to keep me from longing for the warmth of his touch. Perhaps I should have been magnanimous enough to wish that he not experience such discomfort, but instead I gloried in knowing that he would forever wonder what it would have been like to enjoy with me that blissful state that only the union of two equal souls can inspire.

And I took satisfaction in the thought that I had found the Orb, when Mr. Sherlock Holmes's best efforts had been for naught.

I knew how to communicate with him, even without an address. Taking a sheet of paper from my desk, I began to compose a notice for the Agony Column of *The Times*. I would let him know that he had no more need to be concerned about my subsistence. Of course, it was likelier that he would simply immerse himself in his bees and his monograph, and soon forget he could have gathered far sweeter honey than they afforded. I would publish to him

my independence, and then I would forget him, as he would soon succeed in forgetting me. I would forget him, that is, if I could.

And if I could not forget him?

Then I would hunt him down to the ends of the earth, and dare him to tell me to my face that he was too solitary to combine his life with me and mine.

My notice for the Agony Column was brief:

"*Mr. S.H. Do not trouble yourself about O. of K. I have found it. C.D.*"

Jerry Smith

About the Author

Lora Roberts lives a quiet life in Palo Alto, California, and for that reason finds more exciting and interesting things to write about than her tedious existence. She can be visited and e-mailed at www.NMOMysteries.com

MORE MYSTERIES
🕷 FROM PERSEVERANCE PRESS 🕷
For the New Golden Age

Available now—

A *Fugue in Hell's Kitchen,* A Katy Green Mystery
by Hal Glatzer
ISBN 1-880284-70-7
In New York City in 1939, musician Katy Green's hunt for a stolen music manuscript turns into a fugue of mayhem, madness, and death. Prequel to *Too Dead To Swing.*

Silence Is Golden, A Connor Westphal Mystery
by Penny Warner
ISBN 1-880284-66-9
When the folks of Flat Skunk rediscover gold in them thar hills, the modern-day stampede brings money-hungry miners to the Gold Country town, and headlines for deaf reporter Connor Westphal's newspaper—not to mention murder.

The Beastly Bloodline, A Delilah Doolittle Pet Detective Mystery
by Patricia Guiver
ISBN 1-880284-69-3
Wild horses ordinarily couldn't drag British expatriate Delilah to a dude ranch. But when a wealthy client asks her to solve the mysterious death of a valuable show horse, she runs into some rude dudes trying to cut her out of the herd—and finds herself on a trail ride to murder.

Death, Bones, and Stately Homes,
A Tori Miracle Pennsylvania Dutch Mystery
by Valerie S. Malmont
ISBN 1-880284-65-0
Finding a tuxedo-clad skeleton, Tori Miracle fears it could halt Lickin Creek's annual house tour. While dealing with disappearing and reappearing bodies, a stalker, and an escaped convict, Tori unravels the secrets of the Bride's House and Morgan Manor, which the townsfolk wish to hide.

Slippery Slopes and Other Deadly Things,
A Carrie Carlin Biofeedback Mystery
by Nancy Tesler
ISBN 1-880284-64-2
Biofeedback practitioner/single mom/amateur sleuth Carrie Carlin is up to her neck in snow, sex, and strangulation when her stress management convention is interrupted by murder on the slopes of a Vermont ski resort.

REFERENCE/MYSTERY WRITING
How To Write Killer Fiction:
The Funhouse of Mystery & the Roller Coaster of Suspense
by Carolyn Wheat
ISBN 1-880284-62-6
The highly regarded author of the Cass Jameson legal mysteries explains the difference between mysteries (the art of the whodunit) and novels of suspense (the hero's journey) and offers tips and inspiration for writing in either genre. Wheat shows how to make your book work, from the first word to the final revision.

Another Fine Mess, **A Bridget Montrose Mystery**
by Lora Roberts
ISBN 1-880284-54-5
Bridget Montrose wrote a surprise bestseller, but now her publisher wants another one. A writers' retreat seems the perfect opportunity to work in the rarefied company of other authors...except that one of them has a different ending in mind.

Flash Point, **A Susan Kim Delancey Mystery**
by Nancy Baker Jacobs
ISBN 1-880284-56-1
A serial arsonist is killing young mothers in the Bay Area. Now Susan Kim Delancey, California's newly appointed chief arson investigator, is in a race against time to catch the murderer and find the dead women's missing babies—before more lives end in flames.

Open Season on Lawyers, **A Novel of Suspense**
by Taffy Cannon
ISBN 1-880284-51-0
Somebody is killing the sleazy attorneys of Los Angeles. LAPD Detective Joanna Davis matches wits with a killer who tailors each murder to a specific abuse of legal practice. They call him The Atterminator—and he likes it.

Too Dead To Swing, **A Katy Green Mystery**
by Hal Glatzer
ISBN 1-880284-53-7
It's 1940, and musician Katy Green joins an all-female swing band touring California by train—but she soon discovers that somebody's out for blood. First book publication of the award-winning audio-play. Cast of characters, illustrations, and map included.

The Tumbleweed Murders, **A Claire Sharples Botanical Mystery**
by Rebecca Rothenberg, completed by Taffy Cannon
ISBN 1-880284-43-X

Keepers, A Port Silva Mystery
by Janet LaPierre
Shamus Award nominee, *Best Paperback Original 2001*
ISBN 1-880284-44-8

Blind Side, A Connor Westphal Mystery
by Penny Warner
ISBN 1-880284-42-1

The Kidnapping of Rosie Dawn, A Joe Barley Mystery
by Eric Wright
Barry Award, *Best Paperback Original 2000.* Edgar, Ellis, and Anthony Award
nominee
ISBN 1-880284-40-5

Guns and Roses, An Irish Eyes Travel Mystery
by Taffy Cannon
Agatha and Macavity Award nominee, *Best Novel 2000*
ISBN 1-880284-34-0

Royal Flush, A Jake Samson & Rosie Vicente Mystery
by Shelley Singer
ISBN 1-880284-33-2

Baby Mine, A Port Silva Mystery
by Janet LaPierre
ISBN 1-880284-32-4

Forthcoming—

Tropic of Murder, A Nick Hoffman Mystery
by Lev Raphael
Professor Nick Hoffman flees mounting chaos at the State University of
Michigan for a Caribbean getaway, but his winter paradise turns into a night-
mare of deceit, danger, and revenge.

Death Duties, A Port Silva Mystery
by Janet LaPierre
The mother-and-daughter private investigative team introduced in *Keepers*,
Patience and Verity Mackellar, take on a challenging new case. A visitor to
Port Silva hires them to clear her grandfather of anonymous charges that
caused his suicide there thirty years earlier.